# WOMEN'S STUDIES IN THE 1990s

*Women's Studies at York/Macmillan Series*

**General Editors**: Haleh Afshar and Mary Maynard

Haleh Afshar (*editor*)
WOMEN IN THE MIDDLE EAST: Perceptions, Realities and Struggles
  for Liberation

Haleh Afshar and Carolyne Dennis (*editors*)
WOMEN AND ADJUSTMENT POLICIES IN THE THIRD WORLD

Joanna de Groot and Mary Maynard (*editors*)
WOMEN'S STUDIES IN THE 1990s: Doing Things Differently?

Anna Reading
POLISH WOMEN, SOLIDARITY AND FEMINISM

Rebecca Stott
THE FABRICATION OF THE LATE-VICTORIAN *FEMME FATALE*

# Women's Studies in the 1990s

## Doing Things Differently?

*Edited by*

**Joanna de Groot**
*Lecturer in History, University of York*

*and*

**Mary Maynard**
*Senior Lecturer in Sociology,*
*Coordinator of the Centre for Women's Studies,*
*University of York*

150th YEAR
**M**
MACMILLAN

First published 1993 by
THE MACMILLAN PRESS LTD
Houndmills, Basingstoke, Hampshire RG21 2XS
and London
Companies and representatives
throughout the world

ISBN 0–333–57416–8

A catalogue record for this book is available
from the British Library.

Printed in Great Britain by
Ipswich Book Co Ltd
Ipswich, Suffolk

# Contents

# Acknowledgements

The idea for this volume originated from a conference on 'Methodology for Women's Studies' organised by the Goethe-Institut York and the Centre for Women's Studies, University of York, which was held at the University of York in June 1990. The editors are grateful to the Goethe-Institut York and its Director, Vera Bagaliantz, for support in organising and funding the conference. Thanks are also due to Vera Bagaliantz and to the Goethe-Institut York for help and financial support in the preparation of this book.

# Notes on the Contributors

**Anne-Marie Barry** gained undergraduate and MA degrees in politics from the universities of Leeds and Manchester and was awarded a PhD in women's studies from the University of York in 1990. Having undertaken research for the Centre for Health Economics at the University of York, she has subsequently worked on a project on women entrepreneurs at the University of Bradford.

**Fatmagül Berktay** is a journalist, translator and feminist writer whose collected articles have been published in book form under the title *Kadin Olmak, Yasamak, Yazmak* (To be a Woman, to Live, to Write) in Turkey. After studying at the University of Ankara (MA in Political Science), she has gained an MA in women's studies from the University of York. Currently, she is a lecturer in political philosophy at the University of Istanbul, and is also part of the staff of the Women's Research and Education Centre at the same university. Her articles published abroad include: 'In Turkey, Too, There Are Women', *Kontakt*, March 1989; 'Eine zwanzigjahrige Geschichte, Das Verhältnis der türkischen linken zur Frauenfrage', in A. Neusel, S. Tekeli and M. Akkent (eds), *Aufstand im Haus der Frauen, Frauenforschung ans der Türkei* (Orlando Frauenverlag, 1991); 'Institutionalization of the Turkish Women's Movement as a Historical Experience' (paper given at the European Conference of the Frauen Anstiftung, *Institutionalization of the Women's Movement: Chances and Risks*, November 1991, Bad Godesberg, Germany; volume collecting papers given at the conference forthcoming).

**Trev Broughton** is a lecturer in women's studies at the University of York. She has published on women's autobiography, most recently in *Prose Studies* and *Gender Studies*, and is interested in all aspects of the relationship between gender and life-writing. She is currently writing a book on *The Victorian Patriarch*.

**Joanna de Groot** lectures in history and women's studies at the University of York. Her interest in social and cultural history, in both a European and a Middle Eastern context, has led her to pursue the study of women and gender in relation to power relationships and social change generally. At present her particular concerns are the presence of women in political

movements and processes, and forms of cultural construction and representation of gender and ethnic identity, dominance and subordination. She is also concerned with questions of concept and method in history and women's studies.

**Catherine Kirkwood** is currently writing a book, based on her PhD thesis in women's studies from the University of York, about women's experiences of leaving abusive partners. She lives in Seattle, Washington, where she works for a domestic-violence agency in support of abused women. She is also currently training as a counsellor.

**Christine Kulke** is Professor of Political Science at the Technical University of Berlin (Berlin Institute of Technology) and Guest Professor at the University of Potsdam. Her recent work is on the *Dialectic of Enlightenment* from a feminist perspective. She is active in the Centre for Women's Studies at the Technical University, Berlin. Her interests are in political theory and philosophy and she has published widely in this area, particularly focusing on issues of relevance to feminism. Her works include 'Politics, Socialization and Gender Difference' (in the *Handbook of Socialization*). She is Director of a sponsored project on women and work in the east of Germany, visiting Professor at the South-West University of Chengdu, in the People's Republic of China, and a member of the International Society for Political Psychology.

**Mary Maynard** is a senior lecturer in sociology and Coordinator of the Centre for Women's Studies at the University of York. Her books include *Sexism, Racism and Oppression* (with A. Brittan), *Women, Violence and Social Control* (co-edited with J. Hanmer), and *Sociological Theory*. She is author of a number of articles on feminism and women's studies, most recently 'The Re-Shaping of Sociology? Trends in the Study of Gender', in *Sociology*, May 1990; 'Moving Towards a Fair Start: Equal Gender Opportunities and the Careers Service' (with B. Coles), in *Gender and Education*, November 1990; and 'Violence towards Women', in D. Richardson and V. Robinson, *Introducing Women's Studies*, forthcoming.

**Uta C. Schmidt** studied history and art history at Rühr-University in Bochum (MA), and her PhD thesis was on the topic 'Theoretical and Methodological Issues in Historical Scholarship from a Feminist Viewpoint', at the University of Bielefeld. She has lectured at the universities of Vienna, Berlin, Zurich, Klagenfurt and Glasgow. She is interested in the

history of feminist thinking, women as historians and the possibilities of female historiography. She is particularly interested in discovering the gender-specific practices of the historical sciences.

# 1 Doing Things Differently? A Context for Women's Studies in the Next Decade

# 1 Doing Things Differently? A Context for Women's Studies in the Next Decade

JOANNA DE GROOT and MARY MAYNARD

As modern feminist scholarship and the practice of 'women's studies' pass the end of their second decade it seems a timely moment for reflection and assessment. First, this allows those who have participated in those decades of development, and others who want to understand them, to gain a clearer sense of the issues, aspirations, problems and achievements involved. Secondly, reflection and evaluation can provide a basis for energy and understanding, allowing women's studies and feminist scholarship to move onward with more clarity about the future needs of our discipline, grown as it now has to some kind of maturity. In contradistinction to the end-of-millennium pessimism or disillusionment with which some analysts now contemplate our forebears' projects for social progress founded on richer, clearer, understanding of human needs and human experience, the contributors to this book offer a creative, positive response. For some, *post*-feminism, *post*-modernism, even *post* rationality may stand as warning markers, even gallows-posts, overshadowing reasonable hopes of pursuing the projects they critique; for the authors of this book these critiques are a stimulus rather than an inhibition. *E pur se muovere . . .*

The essays collected in this volume comprise, therefore, not a closing address to departing friends but a self-critique intended to open the way to further intellectual.endeavour. Their focus is on problems of epistemology and methodology. We want to share both our insights into the problems and challenges facing women's studies and also our sense of the creative energy and intellectual resources which we see as available to us as we engage constructively with the difficulties that we have identified. Some of our ability to do this comes from the fact that between the eight contributors we show some of the rich diversity which makes up feminist scholarship. Generationally our experience spans those who began some of the earliest initiatives to assert women's place on the agenda of scholarship, theory and the academy, those who were early beneficiaries of the courses, teachers and publications provided by those initiatives, and those now in the second or third generation of feminist scholars. Culturally we have been

1

formed variously in the educational and intellectual traditions of Germany, Turkey, England and America, and been exposed to disciplines ranging from literary criticism and social enquiry, to history and philosophy, practising both abstract theoretical analysis and close empirical and experiential research. Our academic work feeds and is fed by our activities in teaching, journalism, trade unions and the arts, as well as by personal political concerns ranging from the future of women's studies in united Germany to the problems of violence against women and the role of feminism in radical politics.

In making these points we do not claim any particularly distinctive status, since diversity and the tensions and interactions of various interests and identities are characteristic of women's studies and feminist scholarship. So, too, are the experiences of educational privilege, of various kinds of activism, and of difficult personal lives which shape the scholarship, teaching and theorising with which contributors to this book engage, as is the case with most others active in this field. Such common strands interweave with our diversities, and both commonalities and divergences have influenced our coming together on women's studies courses, in research activities, and in joint work at conferences, all of which provide the context for this book. Since we are not untypical in these respects, we are able to address some of the central epistemological and methodological debates and questions in women's studies in ways which should be relevant to the experience of others.

Any discussion of the present and future of women's studies and feminist scholarship needs to take account of its past. The re-emergence of women-centred and feminist interventions in various academic fields in the early 1970s was first and foremost a recuperative action that aimed to challenge the silencing, stereotyping, marginalisation and misrepresentation of women prevalent in historical, social scientific, and literary/cultural scholarship, whether theoretical or empirical. It questioned assumptions, discovered and disseminated empirical evidence, and grappled with the conceptual and explanatory implications of restoring the female half of humanity as a proper and necessary topic of social science, historical research and cultural analysis. Such a recuperative project had two corollaries; it raised questions as to why and how women had 'disappeared' from academic concern; it also stimulated creative endeavours to design concepts and theories, practical research projects and explanatory frameworks which might redress the situation. These endeavours influenced and were informed by the activist agendas of those who, during the 1970s, were involved in political and practical work around 'the condition of women', whether on unequal pay, anti-woman violence and pornography,

childcare issues, or political rights. This interaction of academic and activist approaches to women's position and problems became a significant feature of feminist scholarship and women's studies.

Both the critical energy involved in the intellectual challenge to gender-blind and gender-biased scholarship and the close links between scholarly and political agendas for women fed into the growth, diversification and effectiveness of what came to be known as women's studies. Increasing quantities of published research and discussion provided empirical and explanatory material which stimulated both academic and non-academic interest in women's situation in employment or family life, their experience of welfare, legal or development institutions, and their involvement in the various fields of cultural activity, whether historically or in the present. Discussion in the media, political action by governments and pressure groups, and an explosion of literary and socio-scientific publishing on women, all drew on this kind of work. From the UN Decade of Development for Women to the founding of women's refuges and rape crisis centres, from the ever rising visibility of women's writing to the construction of women's networks in political parties, workplaces, and social movements, self-expression and self-assertion by and for women moved (not without serious opposition and difficulty) onto various public agendas. At the level of the academy, American initiatives to expand research and teaching about women were paralleled, in purpose if not in scale, by similar developments in Europe, India, and Australia.

What has been involved here was both the development and dissemination of relevant information and arguments about women's cultural identities, their creative and political potential and interests, or their productive and reproductive roles, and also the opening up of new intellectual spaces for the discussion of such questions. Women's studies become a source of creative innovation in the concepts, theories and methods applied to social and cultural enquiry. Explorations of the links (or lack of them) between male/female inequality or difference, whether material or political, and other forms of social stratification has generated a major debate and ongoing research assessing the validity of concepts such as 'class' or 'gender' as terms addressing such issues. Analyses of women, sexuality, and gender as themes in both popular cultures and elite art, and of women's own creativity, have opened up reassessments of whole areas of cultural practice and of the gender issues raised within them. The transformation of histories of socio-economic change and political movements by consideration of women's participation in those histories has redefined our understanding of the possible historical meanings of phenomena such as 'family economy', 'citizenship', 'divisions of labour' or 'social protest'. These instances are

merely some of the most obvious cases where the *recuperative* project of
women's studies has equally been a *reconstructive* intervention intended
to re-evaluate and redesign the terms and topics which have structured the
practices of existing academic disciplines.

Indeed, from the late 1970s onward most disciplines, from literary stud-
ies to industrial relations, from social history to social policy, experienced
a range of women-centred initiatives of varying strength, breadth, and
impact pursuing both recuperative and reconstructive projects of different
kinds. These projects were embodied in research work, teaching activities,
conferences and publications, as well as in the coming together of groups
of scholars inside and outside academic institutions to create forums for
the discussion and development of this kind of work and supportive net-
works for each other. While this range of activities in the field of women's
studies and feminist scholarship had an uneven, though measurable, impact
in academic and cultural life at large, it certainly also generated self-
awareness, self-criticism, differences and debates among practitioners in
the field. This involved serious conceptual and theoretical disagreements
over questions such as the nature of patriarchy or male power, the rela-
tionship between gender power and inequality and other forms of domina-
tion and exploitation, and the interaction of cultural and material elements
in the formation of women's experience. It also raised questions about
the white, Western, privileged, and heterosexual biases (both political and
intellectual) of feminism and women's movements as they evolved between
the late 1960s and the mid 1980s. Whatever the outcome of these debates,
they added to the recuperative and reconstructive agendas of women's
studies a significant element of *reflexivity*, further reinforced by the impact
of post-modernist critiques of social theory and social analysis, which
challenge the crucial categories of 'women' and 'gender' central to the
whole enterprise.

This brief sketch is not presented as a fully rounded account of 20 years
of women's studies in Europe and North America, but as a means of
identifying approaches and themes taken up by contributors to this book.
Recuperation, reconstruction and reflexivity all remain important constitu-
ent elements of women's studies practice, even if they each emerged at
different times or in different areas of that practice. These three intertwined
agendas have helped to shape the character of women's studies, which often
faces in two different, although not necessarily opposed, directions. On
the one hand, women's studies and feminist scholarship is energised by the
drive to create and maintain an autonomous intellectual space within which
women's identities, activities and experiences can be explored and under-
stood as worthy topics for serious scholarly attention. This has involved

the creative definition of new projects and syntheses distinctive to women's studies, but also the interweaving of ideas and information generated elsewhere in ways often described as interdisciplinary, i.e. drawing on a variety of disciplines. On the other hand, feminist scholarship and women's studies also continue to be critically engaged with other disciplines in order to address gender bias/blindness, to generate debate within those disciplines, and to suggest and pursue transformative strategies for remedying deficiencies.

Within this framework we can see the continued importance of recuperating women from the marginality and misunderstanding with which much scholarship still treats them. Anne-Marie Barry's critique of the discussion of women in the work of political scientists on British Labour Party politics (a prelude to her own alternative strategy) vividly illustrates the relevance of this approach. One of the main aims of her contribution to this book is to show how the conceptual and methodological presumptions conventionally made by much writing on politics either do not allow for the consideration of women at all, or restrict discussion to inappropriate and limited areas of voting behaviour and conventional forms of participation. She recuperates women for political science both by a more relevant approach to empirical research (prioritising women's own accounts of their experiences of Labour Party activity) and by arguing for conceptual and theoretical shifts, from posing women as a 'problem' for party politics, to establishing party political structures as the problem for women. Both the research and analysis suggest that the 'invisibility' of women within political studies stems more from the way in which relationships between women and politics are conceptualised by political scientists than from any inherent characteristics attributable to women.

In the realm of political philosophy Christine Kulke's challenge to the 'critical theory' of Horkheimer, Adorno and other Frankfurt School writers also contains recuperative elements. Her analysis restores to their mainstream discussion of justice, rationality and equality in modern society and politics (core themes of political thought and social theory) the element of gender awareness which they ignore or suppress. She also focuses attention on the stereotypical views of 'femininity' which they deploy on those few occasions where gender difference and gender questions emerge in their analysis of power relationships. Kulke's arguments for the use of certain elements in critical theory (notably the negative dialectic as a strategy for incorporating the subordination and resistance of women into political analysis) only make sense in the context of her previous discussion of gender blindness in the overall approach of the critical theorists.

Nor is the need for recuperation, as seen by the contributors to this

volume, confined to those conventional disciplines which have remained relatively untouched by interventions from women's studies. In their more general survey of the present problems and prospects for women's studies, Joanna de Groot and Mary Maynard address misogynistic misrepresenting and marginalisation of women within recent fashionable post-modernist thought and the new fields of gender/men's studies. They argue that, however critical the stance of these new trends towards established scholarship may be, they silence or misconstruct women in ways that seem very close to existing conventions of scholarly gender bias/blindness. Post-modernist thinking tends to either relegate differences of gender to one among many instances of complex shifting diversity in the social and cultural world, or to suspect feminist scholarship as another variant of essentialist grand narratives which, according to post-modernists, tell untenable stories about prime causes and make unjustifiable connections between understanding the world and changing it. The rise of gender studies can take the form of making women *per se* invisible in the study of masculinity or male/female relations. Both these new developments ignore or minimise the questions of unequal power, resources or influence in their discussions of difference, thereby counteracting crucial insights and evidence provided by feminist scholarship.

The book's contributors reveal that recuperation, far from being an outdated element in women's studies, is an ongoing and necessary part of its agenda in an academic context where established disciplines continue to resist awareness of women and gender, and where new trends serve to reinforce old habits. Just as the recuperative efforts of women's studies over the last 20 years or so flowed into reconstructive and critical engagement with existing disciplines, so our contributors of the 1990s move from reinserting women into scholarship to wider-ranging initiatives. Rather than focusing on complaints about the neglect of women, or, indeed, on celebration of their rescue from neglect, they confront dominant disciplines and propose structural shifts in their underlying aims and approaches which might adequately express the full implication of incorporating concern for women and gender issues in social, historical and cultural thought. They suggest redefinitions of concepts, reformulations of questions and reconstructions of agendas, offering strategic and structural interventions which do not just 'add on' those issues but feminise and genderise scholarship and analysis in general.

Thus Cathy Kirkwood's exploration of how a researcher's involvement in social investigation can transform the project, the researcher, and the written presentation of the outcome, has implications far beyond her specific discussion of her own research into women who have left violent

partners. By connecting feminist practices of listening to and engaging with women for common purposes, and feminist analysis of human feelings as neither marginal nor subordinate to active thinking and doing, within the domain of scholarly and intellectual work, she suggests a transformative methodology for social enquiry. Transcending those dichotomies of 'subjective/objective' or 'thought/emotion', she constructs this methodology around the interaction of thought (feminist concepts of social enquiry), feeling (sad, angry, excited, fearful responses to challenging material) and action (the processing of feeling and thought into real strategies for research and the researcher). Such a methodology could be as relevant to historians dealing with the Holocaust or the effects of industrialisation, or to cultural analysts engaging with violent and degrading representations, whether verbal or visual, as it is to social scientists investigating sexual abuse, poverty or violence against women. Rather than negating aspects of feeling or personal engagement, or posing them dualistically against the 'thinking', 'objective' practices which are the accepted criteria for academic and intellectual legitimacy, she offers a creative new synthesis which is conceptually and methodologically clear and rigorous.

There are some interesting parallels here with Anne-Marie Barry's analysis of her work on women members of the Labour Party. Barry shows how her engagement with these women enabled her to generate concepts of women's relationships to political parties and public issues which transcend both the dichotomy 'feminist/non-feminist' (which, like de Groot and Maynard in this volume, she sees as problematic for women's studies), and over-schematic distinctions between 'political' and 'non-political'. Here there is both methodological and conceptual innovation: Barry's decision to treat the evidence of her respondents as having a *conceptual* contribution to make to her interpretation of that evidence establishes a methodological relationship between researchers and their material that is very different from existing conventions of 'interpreting evidence' in political science; her use of the term 'woman-centred', to identify precisely distinguished and delineated political responses to issues of women and gender in politics, offers a conceptual tool of great value in the analysis of how women (or indeed men) develop gendered approaches to politics. These innovations offer political scientists means of discussing the topic of 'women in politics' which go beyond the studies of voting or office holding, the use of questionnaire/interview material, or even the discussion of discrimination and disadvantage within which most work on that topic has taken place.

These contributions offer critiques of existing academic practice and also creative alternatives to that practice. Here Kirkwood and Barry are in

company with Christine Kulke's treatment of critical theory, both in the sense that she too proposes radical modifications to critical theorists' treatment of concepts of reason, equality and humanity, and in the sense that that modification involves a reformulation of the relationship between 'reason' and 'emotion', and between 'politics' and 'life'. Her call for a concept of corporealised rationality (feeling as well as analytic) uses the notion of the thinking, speaking, body in such a way as to move beyond essentialist mind/body distinctions, which of course have been central to the construction of gender hierarchies. Her work draws on French theorists, such as Kristeva and Irigaray, and is comparable to the recent philosophical work by Grosz.[1] It is significant that all three contributions use the repertoire of feminist empirical and theoretical work, not just to push debates in women's studies forward but to address critically and constructively the gender-blind practices of mainstream political and social enquiry and theory generally. Their critique moves from recuperating the neglect of women and gender, to arguing that these 'sciences of humanity' cannot in fact claim to be 'human' unless and until they are feminised and genderised, and to illustrating how this might actually work.

If political science, social investigation and philosophy have traditionally included discussions of concepts, methods and theories, this is far less often the case with historical research and writing, especially within the Anglo-American tradition. It is particularly interesting, therefore, to consider the theoretical and methodological implications of a feminist approach to history, as Uta C. Schmidt does in her contribution. Operating at the level of epistemology and methodology, she constructs a critique and analysis of the logic behind androcentric and gender-blind historical practices, and suggests some broad implications and some specific areas which should/could/would be affected by the introduction of feminist and gendered perspectives. Again, her argument is not merely about the absence of women and gender, but about assumptions and categories of thought which need to be questioned if the significance of histories of women for the whole discipline of history is to be understood. This involves a deconstruction of the whole post-Enlightenment tradition of conceptualising 'the human' and a reassessment of the meaning and use of notions of 'objectivity' and partisanship', as well as arguing for the full integration of feminist analysis and female experience into the mainstream of historical practice (as against just adding them on).

These contributions illustrate how women's studies flourish on a relationship between self-conscious attention to women who have been neglected as subjects for research, analysis and theory, and the reassessment and transformation of established disciplines from a feminised and gendered

perspective. Socially and culturally the relationship expresses tensions be-
tween the separate, specific needs of women, and their wish to intervene in
and change the world in general. On the one hand, women challenging their
marginalisation and misrepresentation need to build structures, relation-
ships and practices of their own which affirm and sustain their cultural and
social selves as women, intellectuals, and feminist thinkers; on the other
hand, such separate organisation and activity is rarely seen as acceptance
of a peripheral, ghettoised position but, rather, as a foundation and stimulus
for intervention within accepted social, cultural, historical and political
discourses and disciplines. Academically, the shape, growth and dynamism
of women's studies have flowed from both self-reliance and self-activity,
and also from close engagement with academic practices beyond its
own. The 'rediscovery' of women's experiences and activities (past and
present, material and cultural) is a resource for the self-development of
women-focused scholarship and for powerful critiques, not merely of
the absence of women from the list of topics for scholarly concern, but
of the underlying concepts, methods, assumptions and values which have
produced that absence. This critique confronts the old-established practice
of ignoring women, but equally challenges recent attempts to include them
as simply one (of many) acceptable topics for research and analysis which
sidestep the need to rethink the basic concepts, methods and theories
which construct and validate exclusion and gender bias.

It is in this context that the contributions from Trev Broughton and
Fatmagül Berktay address state-of-the-art debates on post-modernism, plu-
ralism and post-structuralism from the perspective of women's studies
and feminist scholarship. They reflect on recent developments in social
and cultural analysis, questioning how far they make useful contributions
to feminist thought and how far their critiques of established concepts and
theories have taken account of gender issues and feminist analysis.
Broughton's discussion of new trends in literary studies in relation to
women's studies suggests that the apparently self-critical and
deconstructionist approaches which now influence debates on literature, in
fact leave much of its core practice (including gender blindness and
androcentrism) untouched. 'New' arguments for pluralism and fragmenta-
tion as key norms are seen to encapsulate old claims and privileges for
critics and for literature. Berktay also raises questions about the ambivalent
effects of pluralism and cultural relativism on the study and conceptualisation
of women's circumstances and needs. She argues that, far from enabling
more effective analysis or evaluation of the diverse interests and conditions
of women, these approaches lead to a passive, 'whatever is is right', per-
spective on inequalities and exploitations which are part of women's ex-

perience, thereby providing intellectual legitimation for them. Her argument overlaps with the critique of post-modernist approaches sketched out by de Groot and Maynard as part of their reflection on the current challenges and opportunities for women's studies.

Kirkwood, Schmidt, Berktay and Broughton all deploy their own experience of research, teaching and study to flesh out general propositions about concepts, methods and theories, with a more direct sense of how female/feminist scholars engage directly and actively with emergent women's-studies practices and with other disciplines which have formed them. It has been a key proposition of feminist thought, both academic and political, that lived experience is not merely raw data to be processed for intellectual or political purposes, but a basic component of social and cultural awareness. It is also a crucial tool for challenging dominant ideological constructions of marginalised or subordinate lives and thoughts as 'marginal' or 'inferior'. As de Groot and Maynard argue, the close links between feminist scholarship and women's experiences can be highly problematic unless both analysis *and* experience inform that scholarship. The use made by our contributors of their individual personal experiences focuses precisely on the task of developing concepts and methods relevant to women's studies, rather than mere self-validation.

In the third decade of women's studies this use of personal experience by feminist scholars embodies not only the maturing of the challenge posed, by women's lives and their construction of their lives, to neglect and misrepresentation in academe, but also the growth of a trend towards self-reflection within women's studies. The processes of recuperation and reconstruction, which have been central to the project, have created debates and diversity within that project, rather than any homogeneous intellectual or theoretical position, let alone agreement among feminist scholars. In part, this is due to the fact that women's studies continues to be affected by developments and controversies within women's social and political movements outside the academy. As gay men and lesbian women problematised sexuality in society, as black women in Europe and North America and women from the so-called 'South' developed agendas for anti-racism and development, and other underprivileged groups questioned privilege, they challenged both the dominant practices of white western elites and the practices of the women's movements of the 'North'. As those women's movements developed, they also experienced tensions and disagreements over priorities and strategies, ranging from the issue of women's relationship to leftist politics, and the relative importance of sexuality, workplace interest or social policy, to competing philosophies and lifestyles for feminists. Indeed, the very relationship of 'women's

studies', as an intellectual and educational endeavour, to the wider political
or social concerns of women came into question.

The effect of these cultural and political developments was reinforced
by the evolution of research, writing and theory within women's studies
itself. The accumulation of research, analysis, writing, and teaching experi-
ence within the field has been a source not only of considerable diversity
but also of self-reflexivity, itself very much part of the feminist tradition
of linking awareness, experience and interpretation. The emergence of
systemic conceptualisations of 'patriarchy', 'gender inequity', or 'construc-
tions of femininity' owed much to such links, but equally expressed and
stimulated diverse versions of what these concepts might mean or how
they might be used. Interests diverged, disagreements evolved, emphases
shifted, whether at the level of bold generalisations about theory, or of
specific interpretative treatments of historical and social phenomena. Part
of this is the characteristic process of maturation and accretion, whereby
scholars build on debates, material and ideas as they accumulate. However,
there has also been a much more explicit process of self-assessment and
self-criticism, which has established a *reflexive* dimension to women's
studies. Whether this has been engagement with external challenges to
ethnocentrism or foundationalism from non-white/Western or post-
modernist scholarship, or re-evaluation of the theoretical and empirical
initiatives of early second-wave feminism, it constitutes part of the agenda
and practice of feminist scholarship.

Broughton's essay on the shifting relations of women's studies, literary
studies and feminist interests exemplifies several elements of that agenda.
She reflects on the changing experience of constructing courses in women's
studies over a decade and on the challenges facing both women's studies
and literary studies, in order to critique both and speculate on possible
future strategies. In doing so she challenges aspects of 'interdisciplinarity',
'pluralism', and 'relevance' which have become accepted concepts and
practices within women's studies, as well as some of the fashionable 'post-
literature' positions which engage feminists as well as literary critics. Inter-
estingly, her argument involves a committed restatement of some of the
core concerns with exclusion, privilege and inequality which energised
early initiatives in women's studies, but in the self-reflective mode of
greater experience and awareness. Her proposal for a re-negotiated relation-
ship between 'literature' and 'women's studies', based not on the collapse
of the former into the latter in the name of relevance or interdisciplinarity,
but rather, on a dialectical tension between the specifics of diverse discip-
linary practices, draws force from precisely this self-reflexive approach. As
she puts it, what may appear a 'churlish' challenge to women's studies

practices can be a useful, even necessary, stimulus to creative feminist thought and scholarship.

Berktay's exploration of the challenge and deficiencies of cultural relativism as a constructive approach for women's studies similarly engages with some of the currently fashionable concerns with pluralism, deconstructionism and post-modernism. Her discussion takes the form of a self-reflexive analysis of the demands for pluralist, non-ethnocentric, forms of feminist theory and practice. While acknowledging the significance of critiques of ethnocentrism for effective work in women's studies, she wants to distinguish their emancipatory from their disempowering implications. The former, she argues, stem from the ability to *overcome* differences as well as to recognise them, and from a willingness to learn and criticise and analyse experiences and cultures other than one's own. Mere acknowledgement of difference, and abstention from any analysis or evaluation, may well legitimise existing oppressions and inequalities in the name of cultural relativism and anti-racism. This she sees as seriously disempowering both of feminism as critical theory and practice, and of unprivileged and oppressed women, in any society, seeking the support and comprehension of other women. By asserting the efficacy of cultural comparison as a strategy for grasping both similarity and difference, and pointing out the dangerous consequences for women of being drawn into discourses of nativism and cultural authenticity, she establishes a creative self-reflective approach to the central problems of pluralism in women's studies. Her critical engagement with her own experience of feminist theory and practice in Britain and Turkey, with current debates in women's studies on anti-racism and pluralism, and with material on women's situation in various Middle Eastern societies, gives such self-reflection force and substance.

For the essay by de Groot and Maynard, self-reflection is both the topic under discussion and the strategy for undertaking that discussion. Their concern is to recognise the gravity and the complexity of the challenges facing women's studies and feminist scholarship, and also the potential for responses to those challenges. This means surveying the relationship of women's studies to recent developments in the fields of social, cultural, and philosophical enquiry and analysis, to critiques and demands directed specifically at women's studies, and to issues raised by the accumulated practice of the last two decades. It is precisely by reflecting on the history, positioning and epistemology of our work that both difficulties and opportunities can be identified. Furthermore, self-reflection allows us to avoid either succumbing to discouragement and loss of purpose or confidence, or neglecting problematic, challenging issues and questions. Explicit discussion of the implications of gender studies or post-modernist critiques

for the theoretical and practical concerns of women's studies, and of the difficulties posed by notions of 'feminist methodology', or cultural pluralism, within the field, enables us not just to acknowledge the importance of these issues, but to address them creatively.

It is the argument of the essay that the practitioners of women's studies will actually confirm and develop the dynamic within their project by reassessing its engagement with grand theory, its relationship to other academic disciplines, and its engagement with multicultural analysis. Considering priorities for women's studies in the next decade enables us to open up new possibilities, but also to illustrate the viability of those possibilities by reference to existing creative and effective work in the field. Future innovations, for example on the theorisation of diversity, or feminist critiques of post-modernist androcentrism/sexism, are shown to develop from the recognisable achievements and resources already within feminist scholarship. Moreover, the overall view of the essay is that, alongside the tensions and difficulties which undoubtedly face women's studies at present, there is the vitality and potential to engage with them constructively. The call for a confident, assertive response to the challenge of gender studies, to the problematic of post-modernism, and to the internal debates on theory, method and diversity, is based precisely on an appreciation that such a response is both necessary and possible.

The view that the future of women's studies is grounded both in the difficulties which it faces, internally and externally, and in the capacity of its practitioners to draw on the intellectual and cultural resources created in the field over the last 20 years to address those difficulties, is not confined to de Groot and Maynard's contribution. One of the themes which reappears throughout the volume is a continued commitment to *critiques* of women's studies, as much as of the other disciplines it challenges, linked to a sense of that critique as creative rather than destructive. If feminist scholars can push the boundaries of social enquiry and historical method (as Kirkwood and Schmidt argue), and both learn from and contribute to the evolution of critical theory and post-structuralism (as Kulke and Broughton suggest), their capacity for such interventions stems very much from that sort of commitment. Women's studies derived a lot of its founding energy from anger at the intellectual and academic marginalisation of women which led practitioners both to confront the disciplines responsible and to start creating a space for woman-centred scholarship. Perhaps after twenty years or so we can argue that, standing in that space while still engaging with other disciplines, feminist scholars have transformed marginality (at least in their own stance), exchanging it for that richly creative but difficult liminality which can be such a powerful position from which to interrogate

the world. While being marginal is still a key issue for some parts of the feminist intellectual project, the base from which we take that issue up is far more developed. The 'whinge factor' in early critiques of academic androcentrism and gender has been replaced by the ability to construct critical argument and substantive alternatives from the borderline position both within and beyond established disciplines. On that borderline feminist scholars speak with the confidence of travellers with proper documents.

If one element of the liminal stance of women's studies is its position between autonomy and critical engagement, the other is its 'interdisciplinary' approach. As Broughton's critical discussion shows, the use of this approach developed from energetic enthusiasm for encouraging cross-fertilisation between different intellectual and disciplinary traditions, which expressed and constructed the complexity of women's conditions, to a more complex awareness of disciplinary specificity or limitations within the interactive relationship. We should be as concerned to value the skills and practices of *particular* traditions (textual analysis, empirical survey research, archival work) as to encourage the stimulation of scholarship by the bringing of 'historical' skills or practices to contemporary social enquiry, or the use of material evidence in connection with textual or cultural critique. The joint approaches to writing, teaching and research supervision which feminist scholars, including some of the contributors to this book, regularly practice, now reflect both these trends. At the level of method and practice, this parallels the conceptual and theoretical construction of 'women' as subjects for research and analysis, and also the concern for pluralism which, as we have seen, is significant in current social thought. The difficult tension which we identify when we seek to express both methodological pluralism and specificity in our scholarship suggests an important area for work in women's studies in the 1990s, which will need to accompany further development of interdisciplinarity to incorporate new elements (natural sciences? information sciences?). Whether this concerns de Groot and Maynard's project for re-evaluating relations between the 'cultural' and the 'material', or Elizabeth Grosz's argument for reconceptualising 'the body' in its physical, social, cultural dimensions,[2] or further work on genetic manipulation, it is a challenging agenda.

Our argument here is for an optimistic or constructive interpretation of the present condition of women's studies, which suggests that to be caught up in tensions (between or within disciplines) or to stand on thresholds and borders is a source of vitality and creativity. However, this is not an argument for complacency. Women's studies may have faced silencing, incomprehension or marginalisation in the past; today one must add to those problems newer forms of misrepresentation based on arguments that

the project has served its purpose, is outdated, or can be just as well done by any ambitious scholar as by those formed in the critical traditions of feminist thought, scholarship and writing. The phenomenon of so-called 'post-feminism' at the level of journalistic discussion is paralleled in academic settings by attempts to separate scholarship on women from women's studies and/or feminist practice. Established courses and subjects 'add women' to their syllabuses, without confronting the necessary links between recuperation, reconstruction and reflection which have been shown to be crucial for transforming gender bias or gender blindness. The growth of 'gender studies', which is analysed elsewhere in this volume, can, at one level, represent a renewed invisibilisation of women as subjects, as actors and as academics. Even at the level of the availability of publications there are worrying indicators. A major London academic bookshop recently renamed its 'women's studies' section 'gender studies', even though the range of works displayed was little changed and, in fact, dealt by and large with women rather than gender. At a time of scarce resources for research, for education and for publishing, the vulnerability of women's studies to both old prejudices and new opposition should not be underestimated. It could well fuse with internal doubts and difficulties to encourage a retreat from the positions which have been developed over the last two decades.

Our anxiety is perhaps less that women's studies would actually be abandoned as that it might become apologetic or diminished in the face of telling outside criticism, or fissile and self-doubting under the pressure of self-criticism and loss of focus. Post-modern or deconstructionist critiques challenge our ability to use the category 'women', as do the critiques of ethnocentrism and elitism within feminist thought and scholarship. Arguments over whether or not women's studies has a viable relationship to the women's movements or political interest which initially stimulated it, or over whether the autonomy of the field should be prioritised over its active or transformative links to other disciplines, further complicate the question, 'what is women's studies?' One of the reasons for the production of this volume is to illustrate just how a range of scholars working in the context of women's studies can address this question in diverse ways. Kulke's concern with critical theory might be contrasted to Broughton's concern with deconstruction or Berktay's with pluralism, just as Schmidt's focus on epistemology for a whole discipline could be opposed to the close empirical work with small groups undertaken by Barry and Kirkwood. Yet, in reality, they all clearly situate themselves within a framework of women's studies while emphasising particular issues or aspects which interest them. Their diverse, but related, ways of addressing women's studies suggest a view of the field as being defined, not by a common theory or topic, but by

shared practices or questions or criteria which express and extend knowledge and understanding of women, and by a tradition of interconnected recuperation, reflection and reconstruction.

To say, therefore, that women's studies is beset from within and without by problems, challenges and tensions, is not to say that it has no basis of legitimation or no position from which it can develop further. Survival in a hostile environment over the last two decades has fostered a creative rather than a defensive approach to feminist thought and scholarship, while also changing them significantly. Grand theories of patriarchy give way to analyses of pluralism; feminist diversity is seen less as a matter of fixed stances 'for', 'against' or 'within' supposedly disparate theoretical or analytical 'positions', than as a complex interactive field of ideas, evidence and analysis; the limited impact of women's studies in the academy has produced inventive responses rather than either retreat or paranoia. Whether we examine the vigorous feminist responses to post-modernism, or the development of social enquiry and analysis in specific fields such as sexual abuse, socio-cultural histories of women, or feminist discussions of masculinity, the practice of engagement with the work of others, and critical reflection on one's own past experience and activity, is well in evidence.

It is this ability to use, reflect and move on from the existing work of women's studies and feminist scholarship which is evidence both of what already stands to their credit and what their potential might be. The risks and dangers which confront them, as they in turn confront much established social, historical or cultural studies, cannot be avoided or ignored, and defensive responses to new situations will condemn women's studies to the marginality which it has been centrally concerned to refuse. What the contributors to this volume show is that self-criticism can validate rather than deny the purpose and achievements of feminist scholarship, that autonomy and engagement are not mutually exclusive options, and that new situations can be addressed on the basis of both new and existing practice. In theory, in empirical research, in interpretative debates with other scholars, women's studies continues to have much to offer and hence to be a useful, identifiable discipline. Whatever changes or difficulties have been evidenced in this volume, they are matched by the evidence of a substantial past, a lively present and an interesting future.

## NOTES

1. See, for example, Elizabeth Grosz, 'Contemporary Theories of Power and Subjectivity', in Sneja Gunew (ed.), *Feminist Knowledge* (London: Routledge, 1990).
2. Elizabeth Grosz, 'Feminism and the Body' (paper presented to the Centre for Women's Studies, University of York, staff–graduate seminar, January 1992).

# 2 Investing Ourselves: Use of Researcher Personal Response in Feminist Methodology

CATHERINE KIRKWOOD

When women find the words and the patience to explain their various realities to me, I, as a woman cannot help but see my own experiences in a more clear and suddenly more important light. Everything shook my foundations when I started to study women. . . . When I discovered the reality of women's position in our culture suddenly everything in my own life became part of this reality. . . . I sometimes feel this overwhelming perspective must be part of the preoccupation of a first-time researcher, like someone who spends all day in the ocean only to find when she comes home the waves still seem to be moving beneath her. But I have the uncomfortable suspicion that it is less 'taking one's work home with one' than it is discovering that we are living in that ocean all the time, and that the waves are such an integral part of our lives that we do not always perceive them until one crashes down upon us, yet they lie below our every move and perception.

(passage from personal writings of the period in which
I conducted interviews)

The passage above illustrates my experiences of personal investment. I argue that these beneficially influenced the approach I used in my research on the experiences of abused women who had left their partners. I have found that my own personal responses to the research I conducted, although at times confusing and painful, as demonstrated above, were integral to forming an analysis of the interview material and to my understanding and use of a feminist approach to researching women. This chapter clarifies the issues around using one aspect of personal response, emotions, with which I have struggled and which I have seen hinted at or briefly discussed in other feminist work. In short, I assert that we can use such responses as

18

valuable, effective means of understanding women's lives in the context of feminist research.

I conducted 60 interviews with 30 women who had left their abusive partners, about their experiences during and after their relationships. During the period of the interviews I felt intensely emotional responses to the experiences women described. Simultaneously, I experienced both the pain of understanding the complexity and the extremity of the abuse they had suffered and a sense of inspiration about their achievements in overcoming enormous practical and psychological obstacles. After nearly every interview I could recognise a mixture of emotions, including feeling horrified, deeply moved and inspired. The fact that I felt these responses could not be ignored. They had a powerful impact on my day-to-day life, as I will describe later. They were also obviously related to the research I was conducting. They were part of the way I was understanding the experiences of formerly abused women. So, I began to consider the utility, wealth and diversity of my emotional responses, as well as my growing intellectual understanding, in relation to the analysis I was building.

This chapter is divided into two sections. The first examines the status of emotional response in traditional sociological research. The second begins with a look at how feminists have begun to use emotion in research methodology. In this section I then move on to examine my own process of recognising my emotional responses and using them within the research I conducted.

## PERSONAL RESPONSE AND SOCIAL SCIENCE RESEARCH METHODOLOGY

The concept of 'personal response' is very broad. In its most general interpretation it includes every aspect of how someone responds, including thoughts, behaviour, feelings, all of which are individual, or personal, to the person who experiences them. In this sense, everything an individual researcher brings to the research process could be identified as her 'personal response' to the research. In fact, the bulk of the work involved in research includes use of the researchers' behavioural and intellectual response to what they research. For example, methodology texts are filled with explorations of how to use behaviour in an interview situation – how to question, how to sit, how much information to offer the person interviewed (Brenner et al., 1985; Cicourel, 1964; Hyman et al., 1954; Richardson et al.,

1965; Smith, 1981; Whyte, 1982). These are ways of modifying and using behavioural response in order to create a particular environment for research. Even more central to the research is the intellectual response a researcher brings to understanding and forwarding an analysis of the raw data which she attains. A researcher may perceive connections between certain issues discussed by interviewees which another may not perceive. Each brings to the analysis her personal intellectual response and thus each will undoubtedly forward different analyses. These are the aspects of 'personal response' which are generally recognised as acceptable in the process of doing sociological research.

There is, however, another category of personal response. Like the intellectual and behavioural responses described above, it is simply part of the whole response of a human to doing research. However, this category is almost completely ignored with regard to its importance to the research method and analysis. It includes all the elements of personal response which relate to the feelings of the researcher and to the impact of the research on her own life and perspectives. When I speak of emotional response in the context of this chapter, I am referring to the aspect of the emotions which psychologists describe as the subjective feelings individuals consciously experience. It is the feelings such as fear, anger, sadness and joy that are defined by individuals, themselves, as elements of their personal emotional states, which I am speaking about. Although it is true that psychologists have used both behavioural and physiological changes to measure emotion, and that these two aspects are considered components of human emotion (Bindra, 1985; Drever, 1952; Eysenck, 1975; Izard, 1977; Strongman, 1978), I am interested in the subjective knowledge a researcher holds about her feelings in response to the research she conducts rather than these other elements of emotional response.

In my experience, which I will describe more fully, I felt emotionally moved by the interviews I conducted. This emotional response had an inevitable impact on my own views concerning relationships and my past experiences of them. I was undergoing an enormous personal transformation during the research process, which was initiated by the information I gathered and which was reflected back in my understanding of the research material. I believe this relationship between myself and my research allowed me to formulate a more vital and accurate analysis of women's experiences.

Yet, the relationship between sociological research and emotion is rarely recognised in literature. Because of this, Hochschild suggests the need for a sociology of emotion. She argues that the present lack of a sociology of emotion is a result of a cultural belief that feelings are irrelevant. It is also

due to the desire to create an objective science of sociology based on the principles of physical science. Thus emotions, which are hard to observe, measure and quantify in comparison to other aspects of human social behaviour, are not addressed. Hochschild argues that feelings are highly related to social behaviour, and thus important to consider in the field of sociology. For example, she points out that people are constantly assessing whether their emotional responses match with the normative social rules about what feelings are appropriate to certain situations, and that this assessment affects their expression of feeling. It is these types of relations that Hochschild suggests are significant to social science (Hochschild, 1975).

Moreover, just as human social behaviour cannot be fully understood without an analysis of emotion, neither can social research be conducted without recognition of the content of emotion, particularly in data gathered by women from women. For example, the emotions revealed in an interview may be related to the gender of the interviewer. Nader asserts that women are often chosen to conduct anthropological fieldwork because they are more 'people-oriented' and thus gain the trust of, and access to information from, informants more easily (Nader, 1986). Janet Finch demonstrates that this is also true for women interviewing women in the context of sociological research. The title of her work, 'It's Great to Have Someone to Talk To: the Ethics and Politics of Interviewing Women', acknowledges that a special relationship can exist between a female interviewer and a female interviewee, in which there is a greater degree of assumed mutual understanding. Finch writes:

> However effective a male interviewer might be at getting women interviewees to talk, there is still necessarily an additional dimension when the interviewer is also a woman, because both parties share a subordinate structural position by virtue of their gender. This creates the possibility that a particular kind of identification will develop.
>
> (Finch, 1984, p. 76)

In this article, Finch is examining the ethics of gaining information as a result of a bond or identification presumed by women being interviewed by women. Thus, women researchers, because of their association with, and socialisation to be more receptive to, subjectivity and feeling (Keller, 1985), are likely to elicit a different and more intimate relationship with interviewees than will male researchers. The existence of a relationship in which feelings are accepted and more easily expressed implies that, particularly for women interviewers, the emotional content of the interview will be

more present and thus available for analysis. Because such a research context is common in feminist research, the examination of emotional content is important to feminist analyses.

More importantly, in addressing the fact that emotionality is present, we must also challenge the notion that 'real' science is based only on reason and objectivity, traits often highly valued and associated with men. In order to acknowledge the importance of emotion we must challenge the gender hierarchy and the cultural values placed on traits assumed to be gender-related. The embodiment of the male/rational ideology in traditional research arises out of various circumstances. The paradigms have been created and developed largely by men, and thus skills socialised in and possessed predominately by women were not involved in the process of developing sociological methodology. The skills held to be most valuable were those of reason, logic, and objectivity, those generally attributed to men, and thus were central to the science of sociology which was developed by men (Hochschild, 1975).

The fact that high regard for objectivity and rationality is very much part of the traditional approach to research methodology has been illustrated in feminist critiques. Oakley argues that traditional interview methods rely on the interviewer's ability to mechanically elicit and record information. She likens the role of interviewers to that of either a tape recorder, passively collecting information, or that of a psychoanalyst, holding a specific hierarchical relation to the person interviewed (Oakley, 1981). Within this analysis Oakley is demonstrating that the power dynamics inherent in traditional research methods echo the unequal power relation between men and women in society.

But her critique also suggests that what is missing is the humanisation of the interview experience. The term 'mechanical' and 'tape recording' imply not only a power imbalance or a type of objectification, but also a lack of emotional presence. In fact, by becoming a responsive, interactive part of the interview, in treating the experience as a human, non-mechanical interaction, we must invest the very skills women have learnt so well: receptivity and sensitivity to emotions and personal response (Aries and Johnson, 1983; Berg, 1984; Bernard, 1987; Chodorow, 1978; Eagly, 1987; Feshbach, 1982; Gilligan, 1981; Henley and Freeman, 1979; Hoffman, 1977; Miller, 1976; Rubin, 1970; Weitzman, 1979). Chodorow and Miller, for example, examine the socialisation of women's psychology and assert that women are trained by their culture to strengthen the nurturing skills required by motherhood. This includes a socialisation to be more accepting and sensitive to others' emotions and to help others cope with their feelings. Correspondingly, others have demonstrated that women and female

children exhibit more empathy, or receptivity and acceptance of others' emotions in social interactions, and that women often offer additional counselling skills in aiding others to cope with or acknowledge their feelings to a greater degree than men (Berg, 1984; Feshbach, 1982; Hoffman, 1977). Moreover, Henley and Freeman studied interpersonal conversations and revealed that women spend a large degree of time listening, aiding men in conversation, and empathising with social dialogue (Henley and Freeman, 1979). Women, then, learn to become adept at offering empathy and recognising the emotions of others within Western society.

However, the exclusion of these 'female skills' from traditional sociological research is not simply due to a lack of women's presence in the development of research methods. Rather, the expertise women are socialised to develop, like the values placed on the genders themselves, are seen as weaknesses rather than important tools for understanding the nature of human behaviour. Emotionality and receptivity have been relegated to women and have been devalued as part of the subordination of women (Keller, 1985; Warren, 1988). This attitude towards women has roots in a long history and is exemplified by the legal status of women in relation to their husbands. Dobash and Dobash note that, historically, husbands have been seen as 'the head of the woman' (I Corinthians 11: 3) and have been given the right to correct the 'misbehaviour' of their wives. Thus, women were associated with illogical thinking and 'temperamental' behaviour, which men had the duty to control and correct through chastisement (Dobash and Dobash, 1978, pp. 428–9).

In this sense, then, devaluation of emotions is fundamental to the devaluation of women because emotional response is the very aspect of human experience which women learn to understand and perceive. It is the very subject which women possess skills and expertise in exploring. The challenge of recognising the utility of emotions and emotional receptivity is not simply the challenge of adding tools for understanding human behaviour that have not previously been seen as valuable skills. It is also the challenge of contesting the fabric of patriarchal culture, in which 'rational men' are valued more highly than 'emotional women'. In this sense, the exploration of emotions in research methodology is central to feminist aims to create research for women and to expose the ways in which women are devalued within cultural beliefs or attitudes. It is because the division of these aspects of human response are gendered, and correspondingly assigned the values and status associated with each gender, that the use of personal response in research is of particular importance to feminist research. Perceiving emotionality and receptivity to emotional response as a skill, rather than a flaw in reasoning ability, requires a major shift in attitudes that support the

subordination of women. Thus, the fact that, up to the present, emotional or personal response in the researcher has been defined as a weakness, a bias, both in research and in the researcher, is an issue central to feminist research. Moreover, this underlying perspective which associates women with emotions, and devalues both, underscores the difficulty we face in introducing the value of emotion in research. Clearly, because this struggle is important, it will no doubt meet profound resistance. I raise the issue of resistance as a potentially useful foresight for further work, rather than as a question to which my experiences provide explicit answers.

Therefore, the development of methodologies which are effective for understanding women's lives must include the utilisation and support of those skills in which women, albeit because of their socialisation, hold expertise. In addition, as feminist researchers who confront the issue of how research methodology is gendered, we face the task of re-evaluating and utilising 'female' skills within research. We must begin to create an approach to research that acknowledges the human traits which are often devalued and associated with the female – subjectivity and feeling – and integrates the whole of human response with regard to conducting social research.

## TOWARDS A REFLEXIVE USE OF RESEARCHER RESPONSE

I have argued, then, that emotional response, the skill of perceiving and exploring one's own response, and the transformation of this skill into something useful to the research process, is significant to feminist research. But how might this transformation be achieved? Volumes have been written about how to use behavioural response in an interview setting and how to organise and develop intellectual response in the analysis of research data. But what are the mechanisms of using emotional response? How might we use such responses *as* we conduct research, in the same manner as we consciously use behavioural and intellectual responses?

One example in the literature that begins to address the active use of emotion within the research process is provided by Liz Kelly. Although others have acknowledged that emotional response in researchers does exist and does have impact on the research conducted (Reinharz, 1983; Stanley and Wise, 1983 a and b), her work is the only case in which I have seen the explicit use of specific emotional responses in feminist work addressed and explored. Kelly drew upon the theoretical work of Reinharz (1983), in which 'reflective experiential analysis' referred to using the personal ex-

perience of the researcher in developing an analysis. In such analyses, human responses, such as feelings, are noted and used as information about how we are understanding social reality. Kelly applied this concept to her personal emotions and how they guided her research methods and analysis. She asserted the values of such responses:

> Moving between the interviews and my own experiences and reactions was an integral part of the research methodology. Had I 'tuned out' these responses I would probably not have noticed or fully understood the importance of aspects of women's experience of sexual violence.
>
> (Kelly, 1988, p. 19)

Thus, actively attending to her own reactions to the research, including her emotions about women's experiences and the memories they triggered of her own experiences, and moving back and forth between the content of the interviews and these reactions, was part of her methodological process of forming an analysis. This is one example in which emotional response seems to have been actively used during the research process.

I will now explore my experience of emotional and personal response to research and then describe the process of using my reactions which followed from this. I have divided the process into five aspects which are most significant to my experience and to the issues that have been raised in previous research: a sense of being overwhelmed by emotions; the lack of a vocabulary with which to express these emotions; the 'shock' of changing consciousness; the gaining of appropriate support for exploring my feelings; and the resulting insight into how research methods may be empowering or debilitating.

## FEELING OVERWHELMED

My initial response to the research I was conducting centred around women's descriptions of physical and emotional abuse. For almost a whole year I sat face to face with women whom I deeply respected and admired for their successes and struggles. The effect of getting to know these women, establishing a comfortable relationship between us, and then hearing about their experiences of extreme violence, life-threatening and permanently damaging injury, and intense fear, was potent for me.

The women often related these experiences without emotions, as if they could not bear to feel the intensity of the experience again. Likewise, I

found it extremely difficult to emotionally comprehend their experiences and to express the pain that accompanies knowing that these women had been so grossly violated and injured. As a result, I experienced a general numbness and depression, along with a fear of anything that might cut through the numbness and allow me to realise the pain associated with this work. I could not attend films which might have any forms of violence against women. I felt physically sick if television programmes which I had previously enjoyed presented emotional abuse such as verbal degradation, or intricately constructed deceptions, as a humorous and playful part of relationships.

In time, I began to feel alienated from mainstream culture and isolated from those around to whom my reactions seemed extreme or difficult to comprehend, and I was unable to understand why others enjoyed what I felt were repulsive images of women and relationships. Over this time I suffered from a sense of heaviness, exhaustion and continual illness and infections. It is only with hindsight that I can see that these were the physical symptoms of distress.

But with this sense of alienation, isolation, numbness and my experience of continual minor illnesses came a much clearer understanding of the kinds of experiences that women described. They often felt depressed and suffered from illnesses after leaving their abusers. Once out of immediate danger, the women were safe to allow their fear, anger and sadness to emerge, although, because of their intensity, the surfacing of these emotions required a long period of processing and support for some. Because I reacted so strongly to their accounts of their experiences, I could only begin to imagine the difficulty they might have experienced in coping with emotions about having been abused. I began to recognise the importance of the depression and the illness the women experienced. They were signs of the vast amounts of deep feelings which were bottled in order to survive within a relationship. These emotions began to seep out when women were safe, and were extremely difficult to express and acknowledge.

However, my inability to address these emotions had, in some ways, a negative impact on my analysis. Although my responses, because of their similarity to those described by the women, gave me some insight into the subjective reality of their experiences, I found, and still find, discussing the actual abuse extremely difficult. It is as if there is a block keeping me from engaging in this painful and intense information. Yet, with support, I was able to use my feelings to understand women's responses to abuse more fully and vividly. In sum, seeing the larger picture, the reality of how abuse affected women was extremely painful. In the context of conducting re-

search, pain may either inform analysis, if a researcher has the opportunity and willingness and support to explore this part of her response, or may, if unaddressed, block the potency and vitality of the analysis by forcing the researcher to withdraw emotionally from her work. In this sense, the impact of emotional response on research can be double-edged.

## NO VOCABULARY WITH WHICH TO SPEAK ABOUT THE EXPERIENCE

So, the questions that follow from the above discussion are: how does a researcher explore her emotional response to the research and, what are the obstacles that make this exploration difficult? Aside from the rejection of emotions as part of acceptable personal response in social research, as described previously, the language with which researchers, and the women researched themselves, can begin to describe and highlight their emotional reactions is limited. The lack of acceptable academic vocabulary that I confronted in conveying the issues raised in this chapter clarified the degree to which personal response is excluded from research. I felt continually that any instance in which I explicitly described an emotion, and its relation to my research method or analysis, might be perceived by others as a weakness in my ability to research. Yet, by not addressing the existence of emotions within the whole of my personal response, I would deny a central aspect of my experience in doing research. Within the analysis of the research I conducted, the lack of language I confronted prompted me to look more closely at the words women used and the underlying common themes of their diverse descriptions. I developed from this the basis of a vocabulary for emotional abuse, and explored the significance of terms such as 'victim' and 'survivor' to women's understanding of their experiences (Kirkwood, forthcoming). Moreover, this conflict motivated me to think clearly and precisely about what were the emotions in my response, what exact effect these responses had on my methods of analysis, and how this exploration was complicated by the implied rules of 'clean' or objective academic research.

This is pertinent to many areas of feminist research, simply because many issues of relevance to women are emotionally charged. Studies of violence against women, eating disorders, poverty, abortion rights, prostitution and pornography, for example, all entail models of extreme abuse of women and thus all are likely to illicit deep emotion from those who research them.

## THE 'SHOCK' OF A CHANGING CONSCIOUSNESS

In addition to numbness interspersed with intense emotions, and a lack of language to convey my experience, I felt, as my understanding of the nature of abuse grew, a sense of 'shock' in response to the process of understanding women's experiences. I had reviewed the vast amount of information and research on 'battered wives' before conducting interviews. Yet, despite the detail and graphic descriptions of violence found in this literature, I was not prepared for the reality of women's experiences of physical and emotional abuse. A familiar example of this is the cultural symbol of jealousy as an indication of true and deep love. Over and over, women I interviewed described how their experiences taught them that jealously was a primary indicator that someone might be abusive.

My reactions to such discoveries was a sense of shock. At one level, I simply felt confusion about my understanding of abuse. Over time, the term 'abuse' began to seem to me to describe a continuum which, at one end, manifested as physical violence but, at the other, seemed to fade into culturally acceptable behaviours and attitudes. This was a new understanding for me about the degree to which women's reality is silenced, and of how complex the problem of changing that reality would be. When I began to see abuse as part of the way that culture defines intimate relationships, I also began to wonder how we could work for change. The problem is infinitely more complex than changing the physically violent nature of some men.

At a second level, this change in perspective was not just part of my research analysis, but also part of the way I committed myself to making change for women, part of how I personally invested myself in a women's movement. For a time, this confusion and overwhelming shift in perspective resulted in a withdrawal from working for social change. Although there was a need for refuge and women's centre workers in the city in which I lived, I felt unable to offer my energy and skills in a way that felt comfortable and useful. This impact of emotional response to research, on action for change, has been noted in other work as well (Stanley and Wise 1983 a and b). I recognised that I would like to contribute, but felt overwhelmed by my confusion in a way that made active support difficult. Ultimately, I found that I needed to focus on personal change, a development of my knowledge about myself and an acceptance of the kinds of information I uncovered.

Again, this response is likely to be felt by researchers conducting almost any investigation into the position of women in society. Even studies removed from analyses of women's experiences *per se*, or those not utilis-

ing interview methodology, may uncover silenced truths about women in society which influence researchers' personal perspectives about their own relation with their culture. Statistical analyses of women's earnings in relation to men's, for example, may be profoundly shocking to the researcher about her own identity as a woman within the economic structure. It is precisely *because* feminist research strives to uncover such truths that the issue of 'ontological shock' will commonly be a feature resulting from feminist research.

As *feminist* researchers, we are not simply looking for a more effective way of exploring and describing women's experiences, we are also committed to bringing about change in the subordination of women. This commitment is fundamental to the way we conduct research, live our lives and channel our resources. As a result, we are engaged in our research in a deeply personal way. This brings about a variety of circumstances in which personal response is integral to the research we conduct and the way in which we act for change. In my experience, I felt the desire to be involved in the practical support of women, yet the sense of shock I experienced affected my ability to act on this wish.

The issue of a changing consciousness is a process feminist researchers continually face. Both in their work and in their personal lives, feminist researchers are working on their own understanding of women's position in society. Sandra Lee Bartky describes a common personal reaction to a developing feminist consciousness:

> In sum, feminists suffer what might be called a 'double ontological shock'; first the realization that what is really happening is quite different from what appears to be happening; second, the frequent inability to tell what is really happening at all.
>
> (Bartky, 1977, p. 29)

As feminist researchers, women who experience the subordination we study, we are constantly shocked or overwhelmed at the realities we uncover, at what lies under the silencing of women. This shock shakes our foundations and our understanding of ourselves. We realise how much change must occur to end the subordination of women. We also illuminate new directions for change and new depths of the change we seek. We are faced with both the possibilities of change and the shock of needing to find a way to bring about change.

These shocks, or ideological shifts, are part of the emotional reality of being a feminist researcher. In turn, the emotion energises our understanding and analysis of the conditions of women's oppression which we seek to

reveal through research. However, as I have described, the significance of this sense of shock, and changing perspectives, may affect the way in which we choose to act for social change. In my experience, while conducting research, I became more committed to producing work that was accessible to women who had been abused. I found that this was the focus of my action for change. Yet I also feared that, as well as being discovered to be a 'biased' or weak researcher, I would be revealed as not being a 'real' feminist because I did not currently engage in grass-roots action for change. My hope, in exposing this aspect of my experience, is that we can work toward a better understanding of what it means to be a feminist researcher and how we can each act most effectively to fulfil our commitment to change for women.

## GETTING SUPPORT

During the time of the interviews, then, I felt a number of intense emotions, suffered from numbness and illness that marked a lack of expression, and a sense of shock related to my increasing consciousness of the nature of women abuse and its impact on women. I also perceived that, in my day-to-day contact with others, there was no way in which I felt that full expression of these aspects of my life was appropriate. I partially explained my experience to a number of people – friends, colleagues, my supervisor. My explanations were partial because I was not sure of the depth at which I was willing to expose this part of myself, the response I would receive, and how to go about explaining my experience. All of these people gave me tremendous acceptance and support for the fact that I was reacting strongly to the research, but none had the skills or ability to offer the time and energy required to help me explore, in depth, my emotional response and the intensity at which I might express this. Or, perhaps, I was not willing to trust and accept the skills they did offer, I am not sure. I know that I felt deeply confused about how to gain the support I needed, and even what form that support would take.

Moreover, this research was complicated even further by my growing knowledge that my response was not simply related to the experiences of the women interviewed, but was also rooted in my emerging awareness of my own personal history and experience. What I needed was someone whose skills and commitment I trusted and who was willing to address the personal complexity of my emotional response.

It was only near the close of the interviews that I let myself seek

counselling. Similar to my sense that writing about emotional response was an indication of 'weak' research, was the feeling that seeking formal support was, in some way, an indication of my incapability of doing research. Thus I waited until my emotional response began to impair my relationships, research and sense of wellbeing before I sought the help I needed.

The rewards of such support were great, both for myself and for the quality of analysis which I eventually produced. First, I was able to find an avenue for expressing my deep feelings about the extreme violence and personal damage that the women I had spoken to had experienced. By expressing, recognising the intensity of, and feeling acceptance for these feelings, I was released to think more clearly about how to describe and analyse the material with which I was faced. Rather than being confronted by a sense of numbness and horror at the two thousand pages of transcripts which arose from the interviews, I found that I was able to be more engaged with the nature of abuse which women described and the ways in which they struggled to end abuse in their lives. My thinking capabilities were clearly freed and informed rather than hindered by my exploration of emotional response.

Secondly, I was able to distinguish more effectively which emotions were related to the research, and thus useful in informing my analysis, and which were rooted in my own personal history, and thus connected more to my sense of self than to the research. For example, I found that at times I felt a deep rage about the fact that the women I interviewed had been abused. This emotion was mixed with a sense of wonder and inspiration about their achievements and willingness to describe and be vitally active in their processes of healing. These feelings reflected the interaction between what I was understanding, intellectually, about women's experiences of abuse, and what I was beginning to understand about my own experience of relationships and childhood, as I describe below.

I believe my sense of inspiration was a response to a new understanding of 'battered women' which contrasted with the images of women as victims or of women as, personally, highly under-resourced in their efforts for change. Clearly, in the face of coercive abuse and the paucity of practical and social support available to them, these women had found an impressive wealth of personal resources to end abuse in their lives, to find the support they required, and to begin processes of healing from the effects of abuse. My feeling of excitement and admiration informed my research in that it encouraged me to look at how women transformed their experiences of abuse into wisdom and opportunity for growth. As a result, I saw a different side of the topic of women's experiences of violence, which is seldom

revealed in the work feminists have done. In conveying the enormity of the problem and the intense oppression which accompanies violence against women, we often do not have the scope to see also the amazing transformations women make through personal effort and growth. However, the sense of inspiration and joy I sometimes had, encouraged me to recognise that, in ignoring this aspect, we do not express the full picture of women's experiences and the vitality and fruitfulness of their efforts to live in a world where abuse is part of the social norm.

This excitement also encouraged me, at a personal level, to begin to explore my own experiences and how I might transform the rage I was feeling into an opportunity of growth for myself. Thus, the research fed into my personal experience, motivating me, on top of the need I felt, to seek counselling. Eventually, I began to separate out my feeling of rage, in counselling, and recognise its roots in my personal experience. As I have described above, I discovered that emotional abuse was difficult to distinguish from 'typical relationships', that is to say, much of what I was beginning to define as abusive, such as degradation and possessiveness, are the core aspects of humorous or romantic depictions of relationships in films and television. But, simultaneously, this recognition of abuse in 'typical' human relationships touched my perception of my own relationships. As I saw the continuum of abuse disappearing into socially acceptable norms and attitudes, I began to recognise elements of abuse which I had accepted in my own relationships with others. My rage, then, although triggered by the descriptions of women, was more in response to my own experiences. Experiences from my past came flooding back: the desperate possessiveness I perceived in my first partner, to which I responded by beginning to believe that merely feeling sexual attraction to others was infidelity or betrayal; memories of feeling the necessity of choosing between loyalty to one parent or the other, and believing that I could not love both and continue to receive their love in return. My rage at feeling forced to choose, to limit or deny my feelings and behaviour, was triggered by women's descriptions of their partners' extreme possessiveness and efforts to control women's attention and behaviour. Yet, this rage was about my own experience of limitation and being controlled or possessed.

As I was able to separate this feeling out from the research, recognise its origins, again, I felt an increased clarity of thought and ability to approach my work from an intellectual and analytical perspective. But, in this approach, I was also able to utilise the feelings about my own past. I was able to understand, at an experiential level, the kind and depth of rage women described about emotional abuse. Thus, when I began to analyse women's disclosures about wanting, at times, to seek violent revenge and an avenue

for the rage they felt, I had a sense of the depth of my own rage which I could use to empathise and understand women's subjective reality of abuse.

This continual untangling of my emotional responses, and the feedback from my own personal development and understanding to the analysis I formulated, was central to my experience of research. Not only did it allow me to think more clearly about and better understand women's experiences in a vast number of ways, but also, the actual untangling freed the energy that had been previously expended on coping with feeling overwhelmed, numb and ill. I began to approach my work with excitement and less of a sense of foreboding or fear about the numbness that I had felt previously. My interest in, engagement with, and commitment to understanding women's experience became the central motivating force in my work, rather than a desperation to produce an analysis regardless of the trauma I felt. Moreover, I felt a renewed energy to produce an analysis for women that would reflect the information they shared with me in a way that was helpful and informative to their own understanding of their experiences. As I feel this is at the heart of 'doing feminist research', creating research that is useful to women themselves, I can see in retrospect that addressing my emotional response was absolutely vital to my work and my commitment to feminism.

## EMPOWERMENT

A final step in the process of using my emotional response focused on empowerment. By 'empowerment' I mean the process through which an individual discovers the potency and value of her own resources and abilities. I noticed that, as the women's experiences and insight into themselves inspired me to untangle my own responses to doing this research, I became increasingly aware of how empowerment, both of the researchers and of the women they study, could be central to feminist methodology. Clearly, within the process I underwent as described above, exploring my own emotions and valuing what these responses were telling me about myself and my research was empowering to me. Rather than feeling drained and overwhelmed by the research subject matter and the demands of writing an academic thesis, I began to feel more excited about the material and what I could learn for myself as well as contribute to the body of knowledge about abuse of women.

I believe that empowerment of the researcher is extremely important to the quality of feminist work. Much of the literature on empowering research

methodology focuses attention entirely on empowerment of the women participating in the study (Lather, 1988). Although, as I will go on to discuss, this is vital to feminist research as well, I also believe that researchers, themselves, must be empowered by the work they do in order for their analysis to reflect the wealth and depth of the information collected. In other words, if I had not gained the support which allowed me to address my own needs and the issues triggered by the work, if I had approached the final phases of work with a confusion about my feelings and the relation of myself to my work, then I do not believe I would have seen or been able to express as clearly the intricacies of women's experiences. My own empowerment – the use of my ability to respond in thought and feeling without being impaired by confusion, numbness, or a sense of being overwhelmed – was crucial to the quality of the analysis I produced. However, simultaneously with this, I looked more closely at the impact of the research on the women with whom I spoke. I am now aware that, in interviewing formerly abused women, I was becoming part of their process of healing, discovery of their own self-worth and empowerment. I was struck by the responses women had to the interview experience, as most were related to how the interviews fit into this process. In a follow-up questionnaire I asked the women to comment anonymously on their perceptions of the interview and the impact the experience had on them. Sixteen out of the thirty responded. Their comments ranged along a continuum. Two felt that I did not probe deeply enough to allow them to really express their feelings and that, because of this, I had not received an accurate picture of their experiences. Eleven expressed their appreciation and relief at being able to discuss their experiences with someone who listened and accepted what they shared. Finally, three felt that the interviews pushed them too deeply into the emotional responses to abuse. Two suffered from nightmares, and one women was unwilling to complete the second interview because of the intensity of her response. She actually contracted many of the infections and illnesses from which she suffered during her relationship with an abuser.

What, then, is the role of the interviews in women's processes of empowerment, given this variety of response? In considering this question, it struck me that nearly all the women who answered the questionnaire responded at the level of its role in their own process of healing. All of them expressed their response in terms of how well it met the need to review their experiences and feelings – the interviews either probed too deeply, not enough, or met this need. Clearly, then, the interview experience, from the perspective of women, can play a very specific role in the process of untangling their own feelings and experiences.

For the eleven women who gained from the experience of the interview, my sense was that I had offered them the opportunity to gauge their own level of disclosure – I always asserted that if they felt uncomfortable answering a certain question they were free to decline answering it – and a genuine acceptance of what they did disclose. These aspects of response are often noted as the basic skills offered by counsellors which encourage a client to begin to accept her own self and feelings (Egan, 1982; Kirschenbaum and Henderson, 1990; Mearns and Thorne, 1988). Although it was not my intention, or even within my knowledge at the time, to offer a relationship with some of the qualities of counselling, in retrospect I can identify the skills I did offer. In this light, it becomes clearer why women responded to the interview with regard to their process of healing, and why two were dissatisfied with a relationship which offered just the basic foundation of a counselling relationship without the invitation to express their feelings fully.

However, what is also clear is that this type of interview relationship, which does not include a long-term commitment to letting women explore fully what they feel is safe to reveal, can be extremely painful for some. Other researchers have commented upon the potentially unethical nature of interviewing, with regard to how an interviewer may invite trust and disclosure of highly traumatic experiences without offering the skills and commitment to allow women to grow from this exposure (Finch, 1984; Kelly, 1988; Stacey, 1988). Clearly, this was an issue for three of the women in my study.

My experience suggests, then, that an interview relationship can offer the potential for empowerment – for women to explore and accept aspects of themselves. This contrasts with the impression I have gleaned from feminist assertions that interviews are exploitative. Such critiques often seem to ignore the fact that women who are interviewed do have some control over what they disclose and what they gain from the experience (Finch, 1984; Oakley, 1981; Stacey, 1988). In depicting women as purely exploited by interviews we ignore the fact that they have agreed to be interviewed and come with their own expectations of what they might gain. For example, women told me that they wanted to contribute to knowledge about woman abuse, that they wanted their articulation of their experience to be useful and recognised, that they wanted to gain insight by reviewing their pasts with someone who did not know them, and that they hoped that I could offer information about abuse. I felt that my ability to offer sensitivity was hindered by my own sense of confusion and numbness. It was only once I had clarified my own confusion that I could look back and see how what I had done might or might not have been empowering.

Because of this hindsight, I believe that it is crucial for researchers to have the opportunity to explore and untangle their own emotional responses in order to be able to offer an interview situation which affords women the opportunity for empowerment to take place. In addition, had I come to the interview with a better idea that the women might have realistic needs which could be met within it, I would have allowed them to define more clearly what they wanted and checked with them at the close that these wishes had been fulfilled. In this way I could have played a supportive role in recognising and valuing the expectations and control women, themselves, brought to the interview relationship.

## CONCLUSION

I have described some ways in which personal response can be useful in the research process, by using my experiences of interviewing formerly abused women. Because personal response is part of feminist research, and because I have found that this response can be extremely useful in guiding analysis, I argue that it is vital for feminist researchers to learn to address, express, and use the energy that accompanies emotional response. There are three reasons why this is necessary.

First, we need to open up the possibility of developing analyses which are not blocked by confusion, numbness, or a sense of being overwhelmed by feelings.

Secondly, researchers need support so that they are not overwhelmed and damaged by the work they do. Although my experience was one of seeking individual counselling, there are many other ways of achieving this, such as setting up support groups or networks of those willing to offer each other mutual support. It is crucial to stress, however, that there is a need for skilled training, mutual and explicit commitment and structure in a relationship which is set up to untangle the kinds of personal emotions and responses described above. I stress this because I have, at times, sensed a feeling in myself and others that, because we are feminist researchers and share a commitment to women and research for women, we should automatically be able to provide all the support for each other that is needed. Yet, this would only contribute to the emotional overload researchers might be experiencing.

Finally, the outcome of exploring the content and pertinence of our responses to researching will lead to a more holistic relation between feminist researchers and their work, one in which the personal is acknow-

ledged, understood and integrated with research methodology. Such an outcome can only create a more healthy context for conducting feminist research, for both researchers and research participants, and thus more vital and profound research.

## REFERENCES

Aries, E. J. and F. L. Johnson (1983), 'Close Friendship in Adulthood: Conversational Content between Same-Sex Friends', *Sex Roles*, 9, pp. 1183–96.

Bartky, Sandra Lee (1977), 'Toward a Phenomenology of Feminist Consciousness', in Vetterling-Braggin, Elliston and English (eds), *Feminism and Philosophy* (New Jersey: Littlefield, Adams).

Berg, J. H. (1984), 'Development of Friendship between Roommates', *Journal of Personality and Social Psychology*, 46, pp. 346–56.

Bernard, J. (1987), *The Female World* (New York: Macmillan).

Bindra, J. (1985), 'Emotions and Behavioural Theory: Current Research in Historical Perspective', in P. Black (ed.), *Psychological Correlates of Emotion* (London: Academic Press).

Brenner, Michael, Jennifer Brown and David Canter (1985), *The Research Interview: Uses and Approaches* (London: Academic Press).

Chodorow, Nancy (1978), *The Reproduction of Mothering: Psychoanalysis and the Sociology of Gender* (Berkeley: University of California Press).

Cicourel, Aaron V. (1964), *Method and Measurement in Sociology* (New York: The Free Press).

Denzin, Norman K. (1970), *Sociological Methods: A Sourcebook* (Chicago: Aldine).

Dobash, R. E. and R. P. Dobash (1978), 'Wives: The "Appropriate" Victims of Marital Violence', *Victimology*, 2, 3–4, pp. 426–42.

Drever, J. (1952), *A Dictionary of Psychology* (Harmondsworth: Penguin).

Eagly, Alice H. (1987), *Sex Differences in Social Behaviour: A Social-Role Interpretation* (London: Lawrence Erlbaum Associates).

Egan, Gerard (1982), *The Skilled Helper* (Monterey, CA: Brooks/Cole).

Eichenbaum, Louise and Susie Orbach (1985), *Understanding Women* (London: Pelican).

Eysenck, Hans J. (1975), 'The Measurement of Emotions: Psychological Parameters and Methods', in L. Levi (ed.), *Emotions – Their Parameters and Measurement* (New York: Raven Press).

Feshbach, N. D. (1982), 'Sex Differences in Empathy and Social Behaviour in Children', in Eisenbach (ed.), *The Development of Prosocial Behavior* (New York: Academic Press).

Finch, Janet (1984), '"It's Great to Have Someone to Talk to": The Ethics and Politics of Interviewing Women', in Bell and Roberts (eds), *Social Researching: Politics, Problems and Practice* (London: Routledge and Kegan Paul).

Gilligan, C. (1981), *In a Different Voice: Psychological Theory and Women's Development* (Cambridge, Mass.: Harvard University Press).

Golde, P. (ed.) (1986), *Women in the Field: Anthropological Experiences* (Berkeley: University of California Press).

Henley, Nancy and Jo Freeman (1979), 'The Sexual Politics of Interpersonal Behaviour', in Jo Freeman (ed.), *Women: A Feminist Perspective* (Palo Alto, Calif.: Mayfield Publishing).

Hochschild, Arlie R. (1975), 'The Sociology of Feeling and Emotion: Selected Possibilities', in Millman and Kanter, *Another Voice* (New York: Anchor Books).

Hochschild, Arlie R. (1983), *The Managed Heart: Commercialization of Human Feeling* (Berkeley: University of California Press).

Hoffman, M. L. (1977), 'Sex Differences in Empathy and Related Behaviors', *Psychological Bulletin*, 84, pp. 712–22.

Hyman, Herbert H. with William J. Cobb, Jacob Feldman, Clyde W. Hart, Charles Herbert Stember (1954), *Interviewing in Social Research* (London: University of Chicago Press).

Izard, Carroll E. (1977), *Human Emotions* (London: Plenum Press).

Keller, Evelyn Fox (1985), *Reflections on Gender and Science* (Yale: Yale University Press).

Kelly, Liz (1985), 'Women's Experiences of Sexual Violence', PhD thesis, University of Essex.

Kelly, Liz (1988), *Surviving Sexual Violence* (Cambridge: Polity Press).

Kirkwood, Catherine (forthcoming), *Leaving Abusive Partners: From the Scars of Survival to the Wisdom for Change* (London: Sage).

Kirschenbaum, Howard and Valerie Land Henderson (1990), *The Carl Rogers Reader* (London: Constable).

Lather, Patti (1988), 'Feminist Perspectives on Empowering Research Methodologies', *Women's Studies International Forum*, vol. 11, no. 6, pp. 569–81.

Mearns, Dave and Brian Thorne (1988), *Person Centred Counselling in Action* (London: Sage Publications).

Mies, Maria (1984), 'Towards a Methodology for Feminist Research', in Bowles and Duelli-Klein (eds), *Theories in Women's Studies* (London: Routledge and Kegan Paul).

Miller, J. B. (1976), *Toward a New Psychology of Women* (Boston: Beacon Press).

Nader, Laura (1986), 'From Anguish to Exultation', in P. Golde, *Women in the Field* (Chicago: Aldine).

Oakley, Ann (1981), 'Interviewing Women, a Contradiction in Terms', in Roberts (ed.), *Doing Feminist Research* (London: Routledge and Kegan Paul).

Reinharz, Shulamit (1983), 'Experiential Analysis: A Contribution to Feminist Research', in Bowles and Klein (eds), *Theories in Women's Studies* (London: Routledge and Kegan Paul).

Richardson, Stephen A., Barbara Snell Dohrenwend and David Klein (1965), *Interviewing: Its Forms and Functions* (London: Basic Books).

Rubin, Z. (1970), 'Measurement of Romantic Love', *Journal of Personality and Social Psychology*, 16, pp. 265–73.

Smith, H. W. (1981), *Strategies of Social Research: The Methodological Imagination* (Englewood Cliffs, New Jersey: Prentice-Hall).

Stacey, Judith (1988), 'Can There be a Feminist Ethnography?', *Women's Studies International Forum*, vol. 11, no. 1, pp. 21–7.

Stanley, Liz and Sue Wise (1979), 'Feminist Research, Feminist Consciousness and Experiences of Sexism', *Women's Studies Quarterly*, vol. 2, no. 3.

Stanley, Liz and Sue Wise (1983a), *Breaking Out: Feminist Consciousness and Feminist Research* (London: Routledge and Kegan Paul).

Stanley, Liz and Sue Wise (1983b), '"Back to the Personal" or: Our Attempt to Construct "Feminist Research"', in Bowles and Klein (eds), *Theories in Women's Studies* (London: Routledge and Kegan Paul).

Stanley, Liz and Sue Wise (1990), 'Method, Methodology and Epistemology in Feminist Research Processes', in Liz Stanley, *Feminist Praxis* (London: Routledge).

Strongman, K. T. (1978), *The Psychology of Emotion* (Chichester: John Wiley & Sons).

Warren, Carol A. B. (1988), *Gender Issues in Field Research* (London: Sage).

Weitzman, Lenore J. (1979), 'Sex Role Socialization', in Jo Freeman (ed.), *Women: A Feminist Perspective* (Palo Alto, Calif.: Mayfield).

Whyte, William Foote (1982), 'Interviewing in Field Research', in Robert G. Burgess (ed.), *Field Research: A Sourcebook and Field Manual* (London: George Allen & Unwin).

# 3 'Woman-Centred Politics': A Concept for Exploring Women's Political Perceptions

ANNE-MARIE BARRY

## INTRODUCTION

The last decade has seen a growth in social science literature explaining women's experiences as social actors. Alongside this development, disciplines such as sociology have also witnessed a rethinking of key concepts, such as class, to take into account the significance of gender. It is, therefore, surprising that within political science there exists only a small literature on women and politics and little attempt has been made to redefine concepts and underlying assumptions to take account of the experiences of women. Political studies has traditionally had little to say about women's involvement in politics. As a result, either women have been rendered invisible or their political behaviour has been portrayed as a deviation from the male norm. Female scholars within the discipline have recognised this but, I would argue, have so far been unable to develop a satisfactory alternative.

This chapter suggests a different approach to the study of women and the political process by introducing the concept of a 'woman-centred' politics. It is based on my research of women's participation in the British Labour Party during the period 1979–87. The Labour Party seemed a particularly appropriate context within which to explore women's relationship to politics because it has become increasingly concerned with the role played by women, both as members of the Party and as voters. An examination of the literature produced by the Party indicates a growing awareness of the needs of women and of their changing experiences in terms of employment, pay and demands for equal rights (Barry, 1990). This interest has culminated in a commitment to creating a Ministry for Women under the next Labour government.

My study was based on interviews with 34 women, all members of their local Labour Party branch, and 7 women Labour MPs. As my analysis of

the interview material progressed, however, I became increasingly aware that existing formulations of what did or did not constitute political participation, together with the tendency to define women politically as either pro- or anti-feminist, hardly did justice to the views my interviewees were expressing. The concept of a woman-centred politics, then, grew out of my desire to understand, in their own terms, women's ideas about and attitudes to the political process. It helps to locate women as political people and to discuss the implications of this in other than the usual normative terms.

The chapter is organised in four sections. The first draws attention to some of the difficulties raised, for the study of women, in the existing literature on politics, and to alternatives which are being developed. The second briefly discusses my research on women and the Labour Party. In the third I show how the concept of a woman-centred politics grew out of Labour Party women's views about separate women's organisations. The final section contrasts the meaning of woman-centredness with that of feminism.

## WOMEN AND THE POLITICAL PROCESS: WHAT DOES THE LITERATURE SAY?

As previously mentioned, the inadequacies of academic political studies have been acknowledged by women working in the area who have been critical of the ways in which women have been rendered invisible (Lovenduski, 1981; Randall, 1982; Walby, 1989). There seem to be three ways in particular through which this occurs.

First, the study of politics is not gender-neutral. Academic political studies have been criticised for adhering to a definition of the political which takes into account only those institutions and the distribution of power which exist in the public sphere of society (Lovenduski, 1981: Shapiro, 1981). This can be seen, for example, in the literature on the Labour Party. Here 'power' is used to denote formal control over the structures of the Party, and is mainly concerned with its decision-making machinery. There is an emphasis on the role of trade unions, on the effects of the annual conference, and on the workings of the constitution (Crouch, 1982; Kogan and Kogan, 1982; Minkin and Seyd, 1977; Taylor, 1976). Women are necessarily excluded from these discussions as a result of the parameters set by their particular agenda and the definition of the key concepts used. Because women are under-represented in, and largely absent from, the decision-making bodies of the Labour Party (as in the other major

political parties in Britain), they do not feature in such analyses. Commenting in general on studies which have an institutional bias and which perceive the study of power in terms of decision-making, Lovenduski states that women are rendered invisible because they 'usually do not dispose of public power, belong to political elites or hold influential positions in government institutions' (Lovenduski, 1981, p. 89). It is for this reason that women are generally absent when matters of power are being discussed.

A second aspect which contributes to women's invisibility in the study of politics is that this absence tends to be neither noticed nor questioned. The distribution of power within political organisations is a topic in which concern for women's representation should be prominent, precisely because women lack power. But this is not the case, since the discussion is concerned with the exercise of power and not with the equally important subject of *powerlessness*. In addition, although existing studies of political participation do point to men being more involved than women, and thus being in a better position to exercise power at whatever level, this is only so if we take political activity to imply 'electoral campaigns', 'communal activity' or other forms of citizenship contact with government or government officials – activities more likely to be performed by men because they have more free time (Randall, 1982, p. 39). As my research demonstrates, however, there are other forms of political activity which need to be taken into account when defining what political participation entails (Barry, 1990). These involve such elements as sustaining the local Party branch (through fund-raising, attending meetings, attracting new members and staffing positions of responsibility) and putting across the views and policies of the Party. The women I interviewed were all involved in such activities, although the time they were able to spend on them depended on their position in the life cycle and domestic responsibilities. By and large, however, these kinds of activities are not those with which political studies are primarily concerned. Where they do become the focus of attention, they tend to be treated in a marginal fashion, so that any contribution of women to them is similarly devalued.

Randall has argued that women's invisibility in political studies stems from the tendency of the discipline to concentrate on constitutional politics and inputs into the formal political system. In contrast, she argues for a wider definition of politics which takes into account *all* articulations of power relations and does not separate what is regarded as political from the rest of the social world (Randall, 1982, p. 8). There is, however, also the need to rethink some of the concepts and assumptions upon which political studies is premised. The tendency, for instance, to see political participation and commitment in terms of male political behaviour means that women's

experiences and involvement are neglected. In its unquestioning acceptance of women's invisibility, the study of politics ignores gender as an important element in determining who is politically active, in which ways and with what sorts of consequences. Political studies, then, are not only not gender-neutral, they are also not gender-sensitive.

A third way in which women are rendered invisible in political studies relates to the standard field-research techniques which are used. These are usually those of attitude testing or structured interviewing, requiring only responses to predefined questions set by the researcher. Thus, the views, ideas and experiences as expressed by individuals themselves are seldom elicited in conventional political research. This means that politics lacks a basis from which to challenge political analysis or rethink key terms and concepts. It is for this reason that an alternative body of knowledge, which does focus on women and politics, has been developed. Within this alternative 'women and politics' literature, three main areas of concern can again be identified.

One emphasis has been to 'fill in some of the gaps' in relation to the study of politics, by highlighting where women are present in, and how they contribute to, the political process, as conventionally defined (Currell, 1974; Vallance, 1979). The aim of Currell's book, *Political Women*, for example, is to ' . . . record representation in the political elites at specific levels' (Currell 1974, p. 85). However, although women are given a political profile in such work, the gendered nature of political institutions tends to be neglected (Rasmussen, 1981; Hills, 1981). The study of political elites, as has already been noted, generally works against the inclusion of women, since women are less likely to belong to elites or to hold positions of power. Consequently such studies often only succeed in highlighting the absence of women.

Another concern of the literature on women and politics has been to challenge some of the assumptions underlying our understanding about women and the political process. Female scholars within political studies have successfully demonstrated that much of what has been written about women's political behaviour is based on conjecture and myth (Evans, 1980; Goot and Reid, 1975). In relation to voting behaviour, for instance, women have been described as perpetual or occasional abstainers in elections, and as ' . . . more right wing than men by a small but sizable proportion' (Blondel, 1967, p. 60). Yet Evans, after examining a number of factors influencing women's voting behaviour, concludes that there are only slight differences between men and women. The differences which do exist, for example in the slightly higher support for conservative parties amongst women, can be attributed to age as much as to gender (Evans, 1980, p. 212).

A further feature of this body of literature is its emphasis on the need to accept women's political behaviour as valid and analysable in its own terms, rather than comparing it with that of men (Bourque and Grossholtz, 1984, p. 104). Within the conventional study of politics, women's political participation is seen simply as a reflection of their social role as wives and mothers. Women's absence from the politics of the public sphere is explained in terms of their location within the private, but the social roles women fulfil there, and the influence this has on women as political actors, are neither questioned nor analysed. This is because political studies tend to accept the social division of labour between men and women, thereby devaluing women's contribution to politics, which is seen as inferior to that made by men (Siltanen and Stanworth, 1984, p. 186).

There is, however, a growing body of literature which explores women's relationship to the political process from an explicitly feminist perspective. Much of this literature is concerned specifically with the British Labour Party and trade union movement, because of the presence of many socialist feminists within these organisations (Segal, 1987). A feminist approach to the study of politics is embodied in a critique of the Labour Party in terms of both its policies in relation to women and the structures and practices which inhibit women's participation in it (Phillips, 1983; Wainwright, 1987).

This body of literature critically assesses the role of women in the Labour Party and the gendered nature of the Party's political culture. Perrigo, for example, describes the difficulties women face, not just in attending branch meetings but also in going to women's meetings, when they have to combine the responsibilities of a full-time job and caring for children. She comments that ' . . . being active in the Labour Party and its women's organisations entails enormous commitment in terms of time and energy' (Perrigo, 1986, p. 106). Feminists have also challenged the Labour Party's claim that it speaks for the whole of the working class, regardless of gender and race (Wainwright, 1987).

A feminist perspective on women and politics represents a development in our knowledge and understanding of the subject. This literature addresses certain key issues, such as the role of women in the Labour Party in terms of its organisation and power structure, and the treatment of women in policy issues (Phillips, 1987; Wainwright, 1987; Perrigo, 1986). To this extent it marks an advance on much of the existing literature on women and politics because it challenges the accepted thinking and practices of a political party.

There are, however, still problems with this alternative feminist approach. First there is a tendency within the literature to focus exclusively on

feminism and the experience of feminists (Perrigo, 1986; Segal, 1987). In discussions on the recruitment of women in the Labour Party, for example, there is an assumption that those who did so in the late 1970s came via their participation in earlier independent women's groups, and from a background in socialist feminist politics (Wainwright, 1987). My own research indicates that, while such statements might accurately reflect the experiences of some women, they cannot be generalised. Despite the fact that the majority of women I interviewed joined the Party in the late 1970s and early 1980s, they did not have a background in either women's groups or socialist feminist politics. Another problem is the interchangeable use of the terms 'women' and 'feminists', often without any attempt to distinguish the differences that might exist between the two (Phillips, 1987). A third difficulty lies in the failure to define the term feminism or to distinguish between what might be considered feminist and women's interests, or to ask whether the experiences of feminists can be generalised. The responses of my interviewees clearly indicated that distinctions were being drawn between the interests and experiences of 'women' and those of 'feminists'. Thus, it appears to me that some key issues remain to be addressed by those working from within the 'women and politics' framework.

Recently, however, another approach to studying women's relationships to the political process has been developing, one which uses a more theoretical framework. Such work addresses the question of how to use and define the term 'political', acknowledges the relationship between the social and political spheres, and argues for the need to integrate fully the concept of gender into the study of politics. The position of Sylvia Walby is illustrative of such an approach.

Walby's arguments are premised on the need for a ' . . . full integration of the analysis of gender into the central questions of the discipline itself' (Walby, 1989, p. 215). She argues for a gender politics which is formed from the content of the politics and not just the gender of the actors. 'Politics includes gender politics. There are structured power relations between the interests of each gender which are contested in formal political arenas as well as in other social relations' (Walby, 1989, p. 229). It is therefore clear that gender politics spans both public and private spheres. By this token all areas of politics have a gender aspect, including party politics and electoral politics. Walby also highlights the complexities involved in the study of a gender politics, and in particular the difficulties unleashed in describing all women as the same. She comments that gender politics is more than a 'simple division between varieties of feminist and anti-feminist political forces because there is a very important third position – that of pro-woman, non-feminist' (Walby, 1989, p. 229).

Walby's approach has much to commend it and played a major role in the development of my own research. Of particular significance is the way in which it enables us to see how existing political institutions and organisations are themselves problematic for women. In the early formulations of the 'women and politics' literature, it was women who were presented as the 'problem'. There was no analysis of the practices, policies or political culture of the organisations discussed, in terms of their gendered nature. Assuming organisations are gender-blind shifts the burden of explanation to those social groups trying to gain access to them, in this case women (Siltanen and Stanworth, 1984). Examining the other side of the relationship, the internal dynamics of the political party or organisation itself, entails asking a very different set of questions, as Cockburn has demonstrated in her 'Women, Trade Unions and Political Parties' (1987). While Cockburn acknowledges that there are structural barriers to women in the trade union movement (for example rules which specify a number of years' service for particular posts), she also attempts to analyse factors such as 'confidence' as presenting real barriers for women. Cockburn's analysis goes beyond seeing 'confidence' in personal terms or in terms of women's socialisation. Instead she brings into play the concept of masculinity and, by analysing this, demonstrates how it can act as a barrier to women. This kind of emphasis will be important when investigating the role women play in the political process in future research.

## RESEARCHING WOMEN AND THE LABOUR PARTY

The preceding section has provided a critical overview of existing approaches to understanding women's position in the political system, within the context of political studies more generally, and has pointed to some of the questions and difficulties these raise. A number of elements drawn from these approaches helped to frame the way in which my research on women and the Labour Party developed, and informed the methodological strategy adopted. For instance, I wanted to problematise conventional, taken-for-granted notions of what being politically active involves and to develop an understanding based on the ideas of women themselves. I adopted a critical approach to the nature of the Labour Party organisation, at both local branch, regional and national levels, again with a view to taking account of the experiences of women members. The research was concerned with a range of women, selected on the basis of educational background, age and level of Party involvement. This meant including women working at the

grass-roots level of the Labour Party, rather than focusing on elite participation or on feminists, as was the case in previous work. Finally, it was necessary to use a qualitative, non-schedule, standardised approach to interviewing, one which allowed respondents the space to contribute freely but within a set framework.[1] This enabled an exploration and analysis of women's experiences based on their own accounts, something which the discipline of politics has largely been unwilling or unable to do.

The results of such an approach bore considerable fruit (Barry, 1990). The research presents a picture of women who are active in many areas of their Party and who possess sound knowledge of the procedures and practices of the Labour Party and its organisation. It shows that women's perceptions of the values and beliefs of the Labour Party are couched mainly in terms of its inferred principles of caring, equality and freedom and that these play an important part in defining what type of party Labour is for them. This is in contrast to other approaches to understanding Labour Party values, which have tended to concentrate on its socialist, economic and reformist tendencies (Coates, 1980; Miliband, 1972). The women interviewed had a number of principal policy concerns relating to issues such as women's health, equal access to paid work, child care and improvements in low pay; concerns which they share with the official Labour Party itself. However, although the majority of them had a clearly worked out perception of what women's issues were, this perspective was not necessarily brought to bear on their analysis of the Labour Party as a whole. While most of the respondents had a set of pro-woman priorities, many of them could not be said to have a pro-woman perspective on policy more generally, one that would introduce a gender dimension to areas, like the economic, not traditionally seen as of specific relevance to women. This final point is one which I will pursue for the rest of this chapter.

I was continually faced, in my research, with women who articulated their political views and experiences in terms of a concern for women, in various ways, but who either denied that they were themselves feminists or who held views which it was difficult to define as feminist. Existing feminist literature, especially that which explores women's relationship to the labour movement, has tended to treat the debate about women's political positions in terms of a polarised pro- and anti-feminism, or of the relationship between socialism and feminism. Such approaches are unhelpful since they posit an either/or dichotomy and, I argue, neglect important aspects of women's own views and experiences. Although, as indicated earlier, Walby has touched upon the significance of non-feminist but pro-woman women, I found it necessary to develop the concept of a 'woman-centred politics' in order to understand my respondents' ideas about women and politics (Barry,

1990; Walby, 1989). In the following section I will discuss a specific example (women's attitudes to separate women's organisations in the Labour Party) of how this helped me to explore important middle ground, before going on to consider the similarities and differences between a feminist and a woman-centerd position.

## 'WOMAN-CENTRED' POLITICS AND WOMEN'S ORGANISATIONS WITHIN THE LABOUR PARTY

Women have had separate sections in the Labour Party since 1918, when the Women's Labour League emerged with it. Although there is now a considerable array of organisations for women, the merger meant that women in the Party lost their power to appoint their own officers and to be represented at, and to submit resolutions to, the Annual Conference. The 1987 Labour Party Rule Book states that women's organisations are made up as follows: women's sections, women's councils, regional women's committees, National Committee of Labour Women, Women's Conference, as well as reserved seats on the National Executive Committee. A consultative paper of the same year outlines the function of women's organisations as: outside the Party, to attract the female electorate; inside the Party, to formulate policy relevant to women; and to improve the role of women within the Party and encourage their greater participation and representation (National Committee of Labour Women, 1987).

The majority of the women interviewed favoured some forms of separate organisation, but their attitudes were more complicated than simply for and against. Broadly, thirteen women were in favour of separate sections, eleven were against, and fourteen expressed a questioning commitment towards them. This last group is the one whose perspective can best be understood in terms of woman-centredness.

Support for separate women's organisations embodies a feminist stance and has five main elements. Firstly, support is based on a recognition of women's inequality. In the words of one respondent, women 'are not yet equal in our society . . . and so it's reasonable to have a group that . . . gets together to discuss its own issues'. Linked to an acknowledgement of women's inequality is a recognition of the need to overcome this situation. Separate women's organisations are thus understood as a means for women to support one another within the Labour Party, and on this basis to improve not only the representation of women but the profile of women's issues. According to the women interviewed, separate organisations are a way to

'find your feet in the Party' and provide 'a way of feeling stronger in the Labour Party and perhaps on that basis being able to actually move on'.

A strong commitment to separate women's organisations is also based on a feminist perception of politics which takes into consideration power relations within both the public and the private spheres. This was evident in the remarks made by one woman in relation to the health service. Debates on the National Health Service in her local branch revolved around matters 'of finance, pay and conditions'. In contrast, this woman argued that more important were 'the sort of personal, individual experiences and their (people's) interactions with the system'. Stress such as this on the power inherent in social institutions and personal relationships has been an important part of feminist debates on power and politics.

Recognition of women as a separate group with a distinct set of interests also formed the basis of support for women's organisations. In the words of one woman 'women have got their own point of view and they seem to get put into the back seat because of men'. Separate women's organisations are, therefore, seen as important in defining and promoting issues which are of particular significance to women, such as pay, employment, childcare and health. The purpose of women's organisations is considered as being to 'bring things forward that otherwise would not be brought forward'. Talking of discussions over childcare, one woman remarked that with men there was 'less consideration than perhaps the women wanted there to be or that it (childcare) wasn't relevant to them'. Another respondent illustrated the importance she attached to women developing a consciousness of themselves as a group, by saying, 'it's good for women to help build up each others confidence . . . and security . . . whilst discussing and helping to sort out the issues that are very relevant to women'.

Finally, amongst those women who were in favour of separate women's organisations there was a further recognition of the unequal distribution of power within the Labour Party, in the form of its pervasive male political culture. These women felt that the Party's political culture was hostile to feminism. This hostility was felt to manifest itself in the form of suspicion, ridicule, and in a downgrading of the importance of women's sections. For example, one woman remembers the constituency women's section being referred to 'in a rather jokey way . . . that they thought it a bit way out'. Perhaps one of the most telling illustrations comes from a member of another constituency women's section, whose fellow Party member asked. ' . . . what goes on at these women's sections? Are they all lesbians? And he was perfectly serious . . . I said, well what a reactionary thing to say! I don't ask them about their sexual preferences I just go to the meetings.' The respondents argued that the lack of importance attached to women's sec-

tions could be clearly seen in reactions to reports from those sections when brought to the branch as a whole.

The culture of the Party, however, relates to more than attitudes. It is also present in the political practices and forms of organisation used by it. Implicit in the comments of those women supporting separate sections is the idea that women have a different way of organising politically. One interviewee contrasted the supportive atmosphere of her women's meeting with the competitive constituency meetings, 'but when men are involved in meetings they can't wait, they're like kids, I want to say it now and not when you have finished'. These women interpreted the culture of the Party as hostile to them and it was on this basis that they argued that women required a separate space within it. Another opined, 'I think they (men) can easily get in on the discussion and dominate it.' Underlying their statements is a recognition of the need for women to organise collectively, rather than relying on individual action alone.

The women I interviewed who were against separate organisations were generally hostile to feminism and feminists. Their attitudes can be described in terms of four characteristics.

First, they rejected the idea that women, as a group, experience a specific form of inequality. Instead there is a commitment to the notion that, as one woman put it, 'all people are equal and should be treated so'. Consequently these women did not believe that they formed a distinct group with interests different from men, either on the basis of the discrimination they faced or because of their shared experiences. This stance was summed up by a respondent who said, 'the interests that I have are with the general aims of the Party . . . rather than any specific aims that women's sections have'.

Secondly, it was not felt that women required any special assistance to advance in the Party, and the view was expressed that there was nothing to prevent women getting on in it. Such arguments are illustrated by those women who said, 'I don't think there is any barrier to going forward' and 'if they are so minded, I'm sure that it (advancement) is available to them'. 'Getting on' in the Party was seen by these women in individual terms, which can be contrasted with the views expressed by the feminists, described above, whose support for separate women's organisations was founded on an understanding that women form a group with a distinct set of interests that can only be represented and defended through their collective action. Interestingly, two of the women who were hostile to feminism had experience of women-only groups and spoke positively about them. They were not prepared, however, to generalise from their personal lives to admit the need for the same type of support within the structure of the Party overall.

A third reason why some women were hostile to separate organisations was their conviction that they are divisive. This leads in turn to the fourth, that all the members of the Labour Party should be working together. As one woman argued, 'I don't see why women should have a section in anything. . . . I think we are all people and I don't see what women can do singularly that we can't all together.' The perception was that anything organised separately runs the risk of alienating Party members and of deflecting political energy.

In addition to those women who were definite about their support for separate women's organisations and those who were against them, a third position also emerged. These interviewees had a questioning commitment to such forms of organising politically, and it is their position I describe as being 'woman-centred'. Although they expressed some support for separate sections, they did so on what I would refer to as reluctant grounds. Unlike the whole-hearted supporters, they were not totally convinced about discrimination against women as a group, although they were prepared to acknowledge its existence at an individual and personal level. They were also apprehensive of the consequences of women organising separately, whilst acknowledging the need for women to become more active participants in the Party. The reluctance to give whole-hearted support to women's organisations within the Party stemmed from two factors in particular: a belief that women's organisations and the issues they might raise would become marginalised, and their potential to be counterproductive.

With regard to marginalisation, it was felt that women's issues should not be dealt with at women's sections alone. Unlike those hostile to separate organisations, they accepted that women had particular interests and needs. All felt that women were at a disadvantage within the Party in relation to holding positions of authority and the formulation of policy. They also believed that women's issues were neglected by the Party at all levels. But this only served to reinforce the concern that separate organisations might ghettoise and limit women's profile in this regard. One respondent, after admitting that she believed women's issues existed and was interested in them, went on to say, 'but I don't see why I have to go to a women's committee to discuss them'. The women believed strongly that, after meeting separately, women's groups 'need to come back into the main Party so it actually gets dealt with as part of Party politics'.

The fear of marginalisation was accompanied by an apprehension that separate women's organisations might be counterproductive. In contrast to those interviewees who were hostile to them on the grounds that 'we are all people' and 'should be working together', these women were anxious about the consequences *for women* of being set apart from the mainstream. They

were worried that making a special and reserved space for women's concerns would have the very opposite result to that intended: their relegation to the sidelines and consequent devaluation.

Although this approach amounts to less than a whole-hearted commitment to separate organisations, the ambivalence expressed means that it cannot be described as whole-heartedly 'anti' either. The women interviewed hold pro-woman views. They are prepared to identify women as having particular interests and special needs. One woman, for example, while agreeing to the necessity of women's sections in the short term only, still wanted to make clear the extent to which women require something 'extra' in order to compete with men. She went on to list a range of very extensive measures, ranging from equal pay to parental leave. Another respondent, although expressing reservations about separate women's sections, was still clear that she wanted to be seen as a 'woman' rather than as a person or a Party member, saying, 'I do want to be treated as a woman and I do feel I have certain rights.'

The interview material suggests that the woman-centred respondents see women as an interest group who are not properly represented in the Labour Party, although they do not have a clearly worked out idea of how this might be improved. Such women seem reluctant to translate their support for women into support for women's organisations and collective action. One, having agreed that women have extra responsibilities, so that specific policies related to their needs are necessary, added, 'that's not the same as placing a woman in a position because she is a woman'. Several interviewees indicated that they would prefer not to have to think about such matters at all, saying, 'I mean I would love, perhaps I am too much of an idealist, not to have even to consider these issues' and that it would be better if 'women had an equal voice and were equally active so that this just wasn't an issue at all'.

It is significant that much of the apprehension about the consequences of separate women's organisations was expressed at an individual level. One woman distanced herself from feminism in terms of being 'frightened' and unable to relate to feminists. Another said, 'to see people who seem very capable of coping, not only with their own lives but wider issues, can be quite frightening . . . it can make you feel quite inadequate'. Thus the women who offered reluctant support to separate women's organisations commented on how members of these groups were confident, articulate women who, paradoxically, did not seem in need of the support they advocated. The notion of a woman-centred politics marks them out from the other two groups of women discussed in relation to the issue of separate

women's organisations in the Labour Party. Unlike the feminists, they are not committed to separateness as a strategy with which to challenge the disadvantages that women face, nor do they advocate collective action. On the other hand, unlike those who are anti-feminist, they do acknowledge the fact that women are disadvantaged compared with men and that they can be identified as a group with some specific interests and needs. It is because their attitudes are identified with women in this way that I use the term 'woman-centred' to describe them.

## FEMINISM AND 'WOMAN-CENTRED' POLITICS

In the above discussion, I have illustrated, in the context of one specific debate, how the concept of a 'woman-centred' politics emerged from the views and experiences described by the women in my research. The concept is used to highlight and explore the pro-woman but non-feminist middle ground that exists between the pro- and anti-feminist positions, and that has been neglected in the existing political literature. It now seems appropriate to move one stage further, and attempt to codify the nature of a woman-centred politics by contrasting it more directly with what is meant by feminism.

Defining feminism is a problematic and contentious affair, as many writers have pointed out. Ramazanoglu identifies three problems with the concept which make it difficult to arrive at a single definition. Feminism is not only a social theory but also a political practice. Therefore, although the question of women's inequality is central to all ideas of feminism, the remedies and the resulting influence on society of women's emancipation are all open to dispute (Ramazanoglu, 1989, p. 9). Further, there are different explanations of the relations between the sexes, which Ramazanoglu characterises broadly as liberal, radical and Marxist. Each explains women's inequality differently and suggests different solutions. In addition, there are contradictions and differences in the nature of women's lives and experiences, for example, along the lines of race, class and sexuality. It is, therefore, difficult to find a way of defining feminism which will be meaningful to all women (Ramazanoglu, 1989, pp. 9–19).

I favour Ramazanoglu's solution to these problems, outlining elements of feminism rather than attempting to produce an all-embracing definition. Drawing from my own research and from other writers in the field, I suggest that the main components of feminism are as follows:

1. a belief that relations between men and women are unequal and should be changed;
2. an understanding that changes to existing relations between men and women would have fundamental consequences for a wider range of social relationships;
3. an understanding that relations between the sexes are politicised;
4. an analysis resting on a particular conception of politics that does not distinguish between the political and private spheres and, therefore, acknowledges that political power operates at a personal as well as at a social level;
5. an ethical commitment to the previous four points;
6. a systematic analysis of gender divisions to provide an explanatory social theory.

In contrast, a woman-centred politics comprises the following central elements:

1. a belief that there are differences and disadvantages between men and women which should be changed;
2. an understanding that such changes would have consequences for a wider range of social relationships;
3. a focus on women's interests, rather than structured inequalities, which are not perceived as 'political';
4. a perception of politics maintaining a distinction between public and private spheres, in which only the former is designated as political;
5. an ambivalence towards feminism, particularly in any organised form;
6. a set of beliefs about women's position in society without attempting systematically to connect its various elements.

Although both feminism and woman-centred politics share an apparent commitment to a belief in gender inequality, there are differences between them. Most definitions of feminism, for instance, begin with an acknowledgement of women's inequality and the need to improve the quality of women's lives. Radcliffe-Richards, for example, states that 'there are excellent reasons for thinking that women suffer from systematic social injustice because of their sex' (Radcliff-Richards, 1980, pp. 13–14). Jaggar defines feminists broadly as 'all those who seek, no matter on what grounds, to end women's subordination' (Jaggar, 1983, p. 5). However, although those who adopt a woman-centred perspective do talk in terms of women not being equal to men in our society, the underlying connotation of the term 'inequality' is that of 'difference' and of 'disadvantage', rather than of struc-

tured subordination *per se*. Whereas feminists see equality issues in terms of their being the common property of women as a group, as well as having consequences for individuals, the woman-centred approach tends to focus on the individual level alone, although it can be no less vociferous in its calls for the amelioration of individual disadvantage.

In both feminism and 'woman-centred' politics there is the recognition that any changes to existing relations between men and women would have fundamental consequences for a wider range of social relationships. There are here, also, however, some differences in emphasis between the two. Amongst feminists there is a clearer recognition of the extent to which changes in gender relations would alter other social relations, such as that of class. Rowbotham, for instance, illustrates the wider implications many see feminism as having. According to her, feminism is 'the movement against hierarchy' which 'goes beyond the liberation of a sex. It contains the possibility of equal relations not only between women and men but between men and men, and women and women and even between adults and children' (Rowbotham, 1985, p. 214). bell hooks also emphasises the wider implications of feminism as 'a radical movement that would eradicate domination and transform society' (hooks, 1987, p. 64). Feminism, therefore, marks a commitment to 'reorganising society so that the self development of people can take place' (hooks, 1987, p. 69).

Where a woman-centred politics differs from feminism is in its emphasis on the more specific changes which would be necessary for disadvantage to be eliminated. Amongst the most prominent changes suggested by the women interviewed were provision of childcare and greater access to paid work. These were put forward as being in order to arrive at a situation where 'we are all people rather than men and women'. Although this would clearly entail substantial changes in working hours and the provision of caring facilities, it falls short of the more all-embracing changes which now routinely form part of the feminist perspective.

Whereas feminism accepts the unequal distribution of power which exists between the sexes as being essentially political and not just a result of personal attributes, a 'woman-centred' perspective does not. Instead, as we have seen, it tends to characterise relations between men and women as being individual rather than political. The feminists I interviewed described their experiences of the Labour Party, using the gendered concepts of maleness and masculinity. They referred to the language, professed knowledge, and culture of meetings, which drew attention to the way in which these were male-defined and exclusionary of women. In contrast, those who had a woman-centred approach perceived all of this in terms of a specific type of person. In the words of one woman. 'I don't know whether there

are a *group of people as much as individuals* who are just good in that type of set up'. Factors contributing to a high level of participation in political matters were also identified as individual characteristics, rather than as being related to gender. This was despite the fact that the majority of the most 'skilful' and 'confident' people described turned out to be men.

An integral part of the concept of feminism is that it extends our understanding of the nature of power to cover both the public and the private spheres. Politics is thereby also transformed into the articulation of all power relations, whatever their arena (Randall, 1982). The implications of this wider feminist definition of politics can be seen, for instance, in the work of Rowbotham. She argues that a feminist theory of democracy would develop existing definitions to 'include domestic inequality, identity, control over sexuality', as well as those more conventionally found in descriptions of citizenship (Rowbotham 1985, p. 94).

In contrast, the idea of a 'woman-centred' politics retains the boundary between the public sphere, which is perceived as potentially political, and the private sphere, which is not. The division between the public and the private is maintained by drawing a number of distinctions between different aspects of women's lives. Thus, on one level, many of the woman-centred respondents were aware of the disadvantages women experience on an individual basis. On another level there was some, albeit limited, acknowledgement of the way in which women were discriminated against in the Labour Party. On a third level, however, there was a failure to extend the analysis of the first two points to society as a whole. It is the absence of an attempt to make connections between different aspects of women's disadvantage which results in the failure to politicise relations between the sexes. This reveals a perception of politics which does acknowledge 'power' at a personal level but which does not classify it as 'political'.

Feminism and the concept of a 'woman-centred' politics also differ significantly in their attitudes towards clearly articulated support for 'women' as a political group. While feminism entails a political and ethical commitment to its characteristic elements, a 'woman-centred' politics rests on a degree of ambivalence towards feminism, especially in organised forms.

Feminism involves some form of political commitment, although not necessarily of an organised type, as Delmar recognises (Delmar, 1986). Elizabeth Wilson, for example, has suggested that feminism 'is a political commitment – or in some of its forms more an ethical commitment – to giving women their true value' (Wilson, 1986, p. 8). bell hooks also stresses the extent to which feminism must have some element of commitment as a defining feature. For her this is made clear in replacing the

statement, 'I am a feminist' with 'I advocate feminism' (hooks, 1987, p. 70).

The majority of women whose views could be described as 'woman-centred' subscribed to the belief that feminism is in some way 'extreme' and is characterised by a set of standards which other women do not share. There was a reluctance, amongst the majority of these women, to be thought of or to think of oneself as a feminist. This reluctance was the result of two things. There was a lack of knowledge as to what being a feminist might mean, and that extended also to a lack of knowledge about what happened in the women's sections of the Labour Party. There was also a tendency to identify women's organisations within the Party specifically with feminism. Feminism was also associated with particular life-styles and attitudes which the women felt to be at odds with their own situations. Thus many respondents felt distanced from those actively involved in women's politics. For these reasons their personal support for women's issues tended not to develop into organised collective action channelled to promote and defend them.

Finally, feminism provides social theory through which to understand and explain women's lives and experiences, whereas a 'woman-centred' politics comprises a set of beliefs which are not systematically connected. Feminism cannot, however, be understood as a single theory because, as Ramazanoglu reminds us, not only are there different explanations of relations between the sexes, but women have different experiences of inequality based on race, sexuality and class (Ramazanoglu, 1989). Different approaches to feminism do, though, attempt to provide a theory of women's oppression in so far as they establish a framework of explanations for women's subordination. Theory is, therefore, an important element in a feminist approach. Theorising is

> the act of systematically connecting various aspects of women's subordinate position to reach an inter-related framework of explanations. On the basis of such a framework, the origins of, reproduction of, and possibility of, changes in women's position can be explored.
>
> (Maynard, 1989a, p. 238)

The important point is that, as Maynard states, a theory connects in a systematic way a set of beliefs and makes it possible to generalise on that basis about the lives of women, without 'having to reduce everything to the individual experience of a particular woman' (Maynard, 1989a, p. 238).

In contrast, a woman-centred politics consists of a set of beliefs about

women's difference from, and disadvantages in relation to, men, without any attempt to connect these, and remains grounded in individual experience. It is, therefore, possible for women who adopt this position to hold views of a contradictory nature, which can be contrasted to the more systematic characteristics of feminist thought.

CONCLUSION

The concept of a 'woman-centred' politics takes issue with existing dichotomies which simply polarise feminists and non-feminists. In relation to my own work on the British Labour Party, a 'woman-centred' perspective provides the means critically to assess and move beyond the current debate on feminism and politics which is conducted mainly in pro- or anti- terms. This debate does not accurately reflect the range of views and experiences among the women I interviewed. It became necessary, therefore, to conceptualise what they had to say in a different way. The notion of a 'woman-centred politics' is the result of such a reconceptualisation. It provides an empirical grounding to the idea of pro-woman, non-feminist women, which is absent in other literature. It also points to the possibility of providing a basis from which to assess what women have in common, as well as where they might disagree.

The development and application of the concept of a 'woman-centred' politics clearly has had special implications for my own work on women and the Labour Party, but it also raises several important issues for political studies more generally. I would argue, for instance, that it is important for politics to pay more attention to the views and experiences of political actors themselves, and hence there is a need for more research of a qualitative nature. Too many concepts and models of political behaviour are based on a male norm. An understanding of women's political activity, therefore, particularly requires that account is taken of what women themselves have to say on the matter, if existing exclusionary terms and concepts are to be challenged and reworked. The idea of a 'woman-centred' politics provides one example of how this might be done.

NOTE

1.  In its non-schedule, standardised format, the interview is standardised but the phrasing of questions is in language familiar to respondents and an attempt is made to use terms which have relevance for them. It is the content of the questions which is standardised rather than their sequence, which is determined by the respondents. Rather than attempting to produce standardisation of responses, the emphasis is on obtaining equivalent meanings. Hence, answers are open-ended and are not pre-determined by the researcher. The interview agenda allows respondents sufficient space in which to develop their own thoughts and views and to engage in dialogue with the researcher.

REFERENCES

Barry, A-M. (1990), 'Women, Politics and Participation: A Study of Women and the Labour Party 1979–1987', unpublished PhD thesis, University of York.
Bashevikin, S. (1985), *Women and Politics in Western Europe* (London: Frank Cass).
Blondel, J. (1967), *Voters, Parties and Leaders: The Social Fabric of British Politics* (Harmondsworth: Penguin).
Blondel, J. (1978), *Political Parties: A Genuine Case for Discontent* (London: Wildhouse).
Bourque, S. and J. Grossholtz (1984), 'Politics as an Un-natural Practice: Political Science Looks at Female Participation', in *Women and the Public Sphere*, ed. Siltanen and Stanworth (London: Hutchinson).
Campbell, B. (1987), *The Iron Ladies: Why Do Women Vote Tory?* (London: Virago).
Campbell, B. (1988), *Unofficial Secrets: Child Abuse – The Cleveland Case* (London: Virago).
Coates, D. (1980), *Labour in Power? A Study of the Labour Government, 1974–79* (London: Longman).
Cockburn, C. (1987), 'Women, Trade Unions and Political Parties', *Fabian Research Series*, no. 349.
Cook, C. and I. Taylor (1980), *The Labour Party: An Introduction to its Structure and Politics* (London: Longman).
Coote, D.' (1986), 'Re-reading Political Theory from a Women's Perspective', *Political Studies*, vol. 34, no. 1 (March) pp. 129–48.
Crouch, C. (1982), 'The Peculiar Relationship: The Party and the Unions', in D. A. Kavanagh (ed.), *The Politics of the Labour Party* (London: George Allen and Unwin).
Currell, M. (1974), *Political Women* (London: Croom Helm).
Delmar, R. (1986), 'What is Feminism?', in *What is Feminism?*, ed. Mitchell and Oakley (Oxford: Basil Blackwell).
Evans. J. (1980), 'Women and Politics: A Re-appraisal', *Political Studies*, vol. 28, no. 2, pp. 210–21.
Foote, G. (1985), *The Labour Party's Political Thought: A History* (London: Croom Helm).

Goot, M. and E. Reid (1975), *Women and Voting Studies* (Beverley Hills: Sage).

Hills, J. (1981), 'Candidates: The Impact of Gender', *Parliamentary Affairs*, no. 34, no. 2, pp. 221–8.

hooks, b. (1987), 'Feminism: A Movement to end Oppression', in *Feminism and Equality*, ed. A. Phillips (Oxford: Basil Blackwell).

Jagger, A. M. (1983), *Feminist Politics and Human Nature* (Sussex: Harvester Press).

Kavanagh, D. A. (ed.) (1982), *The Politics of the Labour Party* (London: George Allen and Unwin).

Kavanagh, D. A. (1982), 'Representation in the Labour Party', in *The Politics of the Labour Party*, ed. D. A. Kavanagh (London: George Allen and Unwin).

Klein, E. (1984), *Gender Politics: From Consciousness to Mass Politics* (Cambridge, Mass.: Harvard University Press).

Kogan, D. and M. Kogan (1982), *The Battle for the Labour Party* (Glasgow: Fontana).

Lister, R. (1989), 'The Female Citizen', The 1989 Eleanor Rathbone Memorial Lecture, University of Leeds, copy supplied by the author.

Lovenduski, J. (1981), 'Toward the Emasculation of Political Science', in *Men's Studies Modified*, ed. D. Spender (Oxford: Pergamon Press).

Lovenduski, J. (1986), *Women and European Politics: Contemporary Feminism and Public Policy* (Brighton: Wheatsheaf).

Maynard, M. (1989a), 'Privilege and Patriarchy', in *Sexuality and Subordination: Interdisciplinary Studies of Gender in the Nineteenth Century*, ed. S. Mendus and J. Rendell (London: Routledge).

Maynard, M. (1989b), *Sociological Theory* (London: Longman).

Maynard, M. (1990), 'The Re-shaping of Sociology? Trends in the Study of Gender', *Sociology*, vol. 24, no. 2 (May).

Middleton, L. (ed.) (1977), *Women in the Labour Movement: The British Experience* (London: Croom Helm).

Miliband, R. (1972), *Parliamentary Socialism: A Study in the Politics of Labour*, 2nd edn (London: Merlin Press).

Minkin, L. and P. Seyd (1977), 'The British Labour Party', in *Social Democratic Parties in Western Europe*, ed. W. Paterson and A. H. Thomas (London: Croom Helm).

Minkin, L. (1978), *The Labour Party Conference: A Study in the Politics of Intra-Party Democracy* (London: Lane).

Mitchell, J. and Oakley (eds) (1968), *What is Feminism?* (Oxford: Basil Blackwell).

National Committee of Labour Women (1987), *Consultative Paper*, NCLW.

Perrigo, S. (1986), 'Socialist–Feminism and the Labour Party: Some Experiences from Leeds', *Feminist Review*, no. 23 (Summer) pp. 101–8.

Phillips, A. (1983), *Hidden Hands: Women and Economic Policies* (London: Pluto Press).

Phillips, A. (1987), *Divided Loyalties: Dilemmas of Sex and Class* (London: Virago).

Phillips, A. (1987) (ed.), *Readings in Social and Political Theory: Feminism and Equality* (Oxford: Basil Blackwell).

Radcliffe-Richards, J. (1980), *The Sceptical Feminist* (London: Routledge).

Ramazanoglu, C. (1989), *Feminism and the Contradictions of Oppression* (London: Routledge).

Randall, V. (1982), *Women and Politics* (London: Macmillan).

Rasmussen, J. (1977), 'The Role of Women in British Parliamentary Elections', *Journal of Politics*, vol. 39, pp. 1044–54.

Rasmussen, J. (1981), 'Women Candidates in British By-Elections: A Rational Choice Interpretation of Electoral Behaviour', *Politics Studies*, vol. 29 (June) pp. 300–15.

Rasmussen, J. (1983), 'Women's Role in Contemporary British Politics', *Parliamentary Affairs*, vol. 36.

Rendel, M. (1981), *Women, Power and Political Systems* (London: Croom Helm).

Roeloffs, S. (1987), 'In Labour . . .', talking to Lynn Anderson, *Trouble and Strife*, no. 12 (Winter) pp. 33–5.

Rogers, B. (1983), *52%: Getting Women's Power into Politics* (London: Women's Press).

Rowbothams, S. (1985), 'Feminism and Democracy', in *New Forms of Democracy*, ed. D. Held and C. Pollitt (London: Open University, Sage).

Rowbotham, S. (1985), 'What Do Women Want? Woman Centred Values and the World As It Is', *Feminist Review*, no. 20 (June) pp. 49–70.

Segal, L. (1987), *Is the Future Female? Troubled Thoughts on Contemporary Feminism* (London: Virago).

Seyd, P. (1987), *The Rise and Fall of the Labour Left* (London: Macmillan Educational).

Shapiro, V. (1981), 'When are Interests Interesting? The Problems of the Political Representation of Women', in *American Political Science Review*, vol. 75, pp. 701–17.

Siltanen, J. and M. Stanworth (1984), 'The Politics of Private Woman and Public Man', in *Women and the Public Sphere*, ed. by Siltanen and Stanworth (London: Hutchinson).

Stacy, M. and M. Price (1981), *Women, Power and Politics* (London: Tavistock).

Taylor, R. (1976), 'The Uneasy Alliance: Labour and the Unions', in *Political Quarterly*, no. 47 (Oct.–Dec.) pp. 398–407.

Vallance, E. (1979), *Women in the House* (London: Athlone Press).

Wainwright, H. (1987), *Labour: A Tale of Two Parties* (London: Hogarth Press).

Walby, S. (1986), *Patriarchy at Work: Patriarchal and Capitalist Relations in Employment* (Cambridge: Polity Press).

Walby, S. (1989), 'Gender Politics and Social Theory', *Sociology*, vol. 22, no. 2 (May) pp. 215–32.

Wilson, E. (1986) (with Angela Weir), *Hidden Agendas: Theory, Politics and Experience in the Women's Movement* (London: Tavistock Publications).

# 4 Cross Purposes: Literature, (In)discipline and Women's Studies

TREV BROUGHTON

> But I should need to be a herd of elephants, I thought, and a
> wilderness of spiders, desperately referring to the animals that
> are reputed longest lived and most multitudinously eyed, to
> cope with all this. I should need claws of steel and beak of brass
> even to penetrate the husk.
>
> (Woolf, 1984 [1929], p. 27)

## 1. THINKING (IN)DISCIPLINE

This chapter grew out of a series of reflections on my uprooting from a
Department of English and transplantation to a Centre for Women's Stud-
ies. For practical and institutional reasons, I have not, unlike many aca-
demics working on women's-studies courses, retained a foothold in a
'parent' department, but have moved, lock, stock and typewriter, to my new
home. This experience has been both exhilarating and disconcerting, and
provides the starting point for these musings in the form of an arpeggio
of questions: What am I? . . . doing? . . . here?

When Virginia Woolf set out on her symbolic journey to the British
Museum, she was accompanied by a 'swarm' of questions:

> Why did men drink wine and women water? Why was one sex so
> prosperous and the other so poor? What effect has poverty on fiction?
> What conditions are necessary for the creation of works of art?
>
> (Woolf, 1984 [1929], p. 26)

These days, from my perspective within women's studies, I sometimes
observe rather wistfully that Woolf's swarm of questions, however over-
whelming, is nevertheless a purposeful swarm, a disciplined swarm pro-
ceeding in an orderly fashion out from and back toward a blank page headed

'WOMEN AND FICTION'. In other words, Woolf's feminist enquiry has its origin in her serene assumption that fiction is a good and desirable thing, and her conviction that any obstacle between women and literature is a bad thing. The insistent peripheral buzzing of related issues is never allowed to distract her from that heading at the top of a blank page.

Other swarms, larger and more dispersed, but still determined and intent, accompany more recent agendas for feminist criticism:

> We need to attend to the relationship between the continuities and discontinuities in the form and experience of oppression and subordination, especially as determined by race and class. Having grasped that relationship, we must see how it determines both access to writing and publication and the narrative and representational spaces within which women writers work.
>
> (Batsleer et al. (1985) pp. 113–14)

It strikes me, though, that perspectives like this and Woolf's, revolutionary as they are, are only possible as long as one sustains a primary, unshakeable faith in the identity, 'literary critic'. From the point of view of the literary critic, it is worth developing an eager and acquisitive relationship with feminist work in other disciplines, but that relationship may well be basically parasitic, or indebted. Hence, as literary critics, we tend to stretch our interdisciplinary activity as far as the 'text/context' relationship, with excursions into sociology, history, linguistics, art history, film criticism, and perhaps psychoanalysis, while we willingly ignore, as irrelevant, feminist work in the 'hard sciences' (around technology and medicine, for instance), or in the 'hard' world (around development and applied social policy). The heading WOMEN AND FICTION rescues us from the terror of *carte blanche*, and we recognise gratefully that a line has to be drawn somewhere.

But what happens to the interdisciplinary bargain when that literary-critical identity comes under threat? The founding of women's studies as a relatively autonomous 'centre' changes everything. It represents, I discover, a revaluation of the relationship between literary criticism and feminist scholarship and not necessarily a simple consolidation or extension of it. (An unquestionably brilliant student tells me she is not interested in novels. Sweating slightly and dizzy, I grip the back of my chair.) For interdisciplinary study means more than expanding the boundaries of one's own discipline, or adding on extra disciplines in footnotes. It reduces the reassuring heading 'WOMEN AND FICTION' to 'WOMEN AND . . .', or, in these postmodern times, to the even more unnerving 'THE FICTION "WOMEN" AND . . .'

I have experienced this challenge as a healthy shock to the system, but also as a loss of bearings: on the level of subjectivity – of allegiance, identification and priorities – as well as on the levels of social organisation, economy, pedagogy and methodology. It is the shock experienced by many university English graduates who come to women's studies secretly expecting compensation, rather than challenge; expecting more women's fiction rather than more scepticism about its centrality.

As it turns out, my move to women's studies coincides with the acceleration of a set of theoretical and educational arguments which leave many customary academic identities in jeopardy. One of the pervasive assumptions of my undergraduate and postgraduate education – perhaps also of my school career – was that I was being equipped to be a teacher of 'English'. The divergence between this training and the direction of current thinking about literature in higher education is a constant source of surprise and alarm. For one thing, to say my subject is English Literature is to commit a huge blunder, since according to contemporary theory, *I* am the subject of the discipline of English Literature. Add inverted commas to taste. This being the case, my status and usefulness as 'teacher' of anything is open to question. For another thing, the fact that the texts I work on are in English (if only by translation) is at best a happy coincidence, at worst an ignominious contingency. And if I were in danger of lapsing into fogeyish cynicism about 'trends', there are historians of education and students of culture to remind me that many of the problems around 'English Literature' are neither local, nor recent, nor abstract, but arise from specific chauvinisms of policy and practice. To take an obvious example, the vigorous promotion of the English literary 'heritage' in educational policy has roots in colonial expansion and cultural imperialism. Again, the currency of 'literature' as a common-sense category results from the success of the education system and its agents in isolating the conditions of literacy from the credentials of 'culture' (so that one can be well-read or ill-read, but not simply 'read'). And of course, English as an academic subject has traditionally defined both its canon and its coverage at the expense of the writing and experiences of women, racial and ethnic 'others', and working-class men (Batsleer et al., 1985, passim; Spivak, 1986).

From my women's-studies vantage point, I can acknowledge, however begrudgingly, that academic 'English' has been in trouble, either as ideologically suspect or simply as a non-subject, for a long time, with numerous persuasive calls being made in the last decade – from within and without the discipline – for its replacement by cultural studies (Batsleer et al., 1985), rhetoric (Eagleton, 1983, 206–17), feminist poststructuralism (Weedon, 1987, 136–75) and postmodern self-deconstruction (see below).[1]

Faced with this theoretical and culturalist onslaught, it is tempting to withdraw to a more modest, provisional position: that of *feminist* literary critic. There is still a need for 'situated' literary knowledge; for women to engage in active dialogue with the phallocentrism of literary history without substituting a logos of our own. Practically, though, this position is difficult to sustain outside a literature department. The identity, 'feminist literary critic', depends for its coherence and momentum on its challenge to the dynamics of literary humanism. Severe and dispassionate though it likes to appear, it is the identity of the lover, cleaving to the long, eccentric curves of literary history and to the mysterious dance of genres; addicted to the wild pleasure of chance meetings and promiscuous adventures; and savage in the face of rejection, neglect and scorn. To put it bluntly, in an inter-disciplinary context, constraints on time and energy and the sheer size and urgency of the project at hand force a focusing of priorities; there is very little time left for romance.

As a last resort, I appeal to my literary-critical 'skills' to redeem my collapsing *métier*. This, as we shall see, is one of the fronts on which literary criticism has most successfully fought back; invoking poststructuralism and deconstruction to recast other disciplines as 'texts', thus rendering them susceptible to 'close reading'. Surely interdisciplinary courses can benefit from a finely-tuned ear for sense and sound, a nose for narrative and nonsense, and an eye for linguistic jiggery-pokery? After all, the most prestigious theories of the day – those of Lacan, Kristeva, Irigaray, Derrida and Lyotard for example – frequently originate in observations about the written word.[2] But the list serves also as a caution: if my experience in women's studies has taught me anything, it is that it is a gross mistake to annex to literary criticism all the skills of the 'feminist reader', as if no other discipline involved critical sense, consciousness of form or ambiguity, awareness of competing perspectives, or, least of all, familiarity with con-temporary theory.

Seen from one perspective, then, my few steps down the road from English to women's studies can be seen as paradigmatic of sweeping changes in the humanities at large, with high (read European, mainly French) theory and interdisciplinary practices being heralded as the way forward for viable teaching and research on the one hand, and for political reform in the curriculum on the other. So, it transpires that so small a question as 'What am I doing here?' has reverberations beyond the seminar room, as part of a revved-up re-evaluation of the integrity and compatibility of the disciplines in the light of theoretical developments and of demands from the student constituency. Naturally, the possible consequences, either for the feminist presence in higher education or for literary scholarship

*per se*, of the move away from traditional disciplines towards more theoretically-toned, interdisciplinary 'approaches' have yet to be fully realised, though new directions are being adumbrated in countless prospectuses, course evaluations and feminist and educational journals. The stories they recount and the futures they imply will have repercussions for feminists both inside and outside traditional faculties. Before examining more closely, by way of case study, the evolving relationship between literature and women's studies at York, I would like to offer two of these stories – both from 1990, and both involving women, literature, interdisciplinary approaches and contemporary theory – and to discuss them as narratives of academic 'progress'.

## (a)  The Salvation of Literature

The first narrative is part (admittedly a small part) of an article outlining, in refreshingly pragmatic and forthright terms, welcome new experiments in interdepartmental collaboration in two American universities. In 'Interdisciplinary Approaches to Developing Cross-Cultural Courses', Kathleen Mullen Sands offer an upbeat account of the potential released by the postmodern critique of Enlightenment knowledges:

> Because several disciplines are currently focusing on language and writing as a means of understanding how other cultures are represented, an interest in the development of interdisciplinary strategies for teaching cultures is growing. . . . At the same time, in literary studies, an expansion of the idea of text – interest in the literatures of cultural minorities and postcolonial cultures, recognition of women's genres of writing as legitimate modes of literature, wide interest in various forms of personal narrative, and examination of texts from the social sciences – and the intense interest in and broad application of postmodern theories (Marxist theory, feminist theory, black aesthetic theory, and, particularly, deconstruction) have created a climate for a less territorial attitude towards the production and study of texts. Paradoxically, postmodern fragmentation is creating common ground for scholars and teachers who are interested in the representation of cultural groups.
>
> (Sands, 1990, 100–1)

The sweeping confidence of the passage is inspiring. However, I note that, while literary studies are supposedly becoming 'less territorial', the metaphors used to denote this change are expansionist: wider still and wider. The claim seems to be that because other disciplines are now interested in

representations of cultures, and because teachers of literary studies are prepared to extend their definition of legitimate texts, postmodernism will reinforce rather than undermine the *raison d'être* of semioticians, critics and literary theorists. But a number of questions come to mind. Why has it become necessary to justify cross-cultural study in terms of its providing a bridge between disciplines, rather than the other way round? (Given this passage, one might expect the essay to be called 'Cross-Cultural Approaches to Developing Interdisciplinary Courses'.) Since when (and I pose the question seriously) have Marxist, feminist and black aesthetic theories, with their long and often divergent histories, become postmodern? Why (to what end) are scholars and teachers primarily interested in the way 'other' cultural groups are *represented*, rather than in any other facet of their existence? Does the primacy of 'representation of groups' as an academic concern elide the material implications of cultural and political marginality? Could it be that the textualisation of social criticism, which guarantees both its fragmentation and its assimilation into a newly dominant mode of theorising, leaves the relationship between political subjects unchanged?

Read in this way, the narrative of 'postmodern fragmentation' as redemption contains within it a hidden story of the victory of literary studies in a power struggle between disciplines. The empowerment of 'groups' becomes a side issue; and human agency, political subjectivities and oppression figure only as secondary terms, if at all. Any benefits accruing to 'cultural groups' from the changes taking place are 'paradoxical' or even accidental.

The second narrative, and one which requires even closer reading, might be called the story of

## (b)  The Fall of English: Confusion worse Confounded

The flyer for the 1991 conference of the organisation HETE (Higher Education Teachers of English) begins rhetorically with the question, printed in large, confident lettering: 'The End of the Grand Narratives?' and continues in buoyant mood with a challenge from Jean-François Lyotard: 'Let us wage war on totality . . . let us activate the differences'. The phrase is, of course, the undisputed motto of postmodernism, and forms part of the most frequently-quoted (and po-faced) passage in the postmodern repertoire: 'Let us wage a war on totality; let us be witnesses to the unpresentable; let us activate the differences and save the honour of the name' (Lyotard, 1989 [1982], p. 82). After this striking, if selective, opening, the call for papers proceeds more queasily:

The shift of 'English' to 'Literature' and/or 'Cultural Studies' signals just one 'grand narrative', one totalizing discourse, which has been fragmented in the course of the last two decades.

The development and dissemination of courses which address colonial literature, popular literature, women's literature; the increasing stress on 'interdisciplinary' work, particularly the text/context, literature/history relationship; the acknowledgement of the screen media as other forms of 'text'; the incorporation of modes of textual analysis into other disciplines (History, Political Science etc.) and, in turn, their informing presence in the practice of 'Literature' – all suggest that the defining principles of 'the discipline' have been rejected/lost for a future which is pluralist/confused.

Papers are then invited which will 'exemplify . . . the reality of the claim' that we (Higher Education Teachers of English) have come to 'the end of English'. Contributors, we might note, are not asked to 'test' this claim, nor, on the other hand, are they expected to contest or underwrite it. They are asked somehow to embody it: to 'exemplify its reality', as if to claim that such a claim had been made at all were a radical breakthrough.[3]

It is noteworthy that of the one hundred and seventy-odd words of the invitation, nearly a seventh are shackled either to the self-consciousness of inverted commas, or to the ambivalence of a '/'. More interesting still is the way ambivalence and self-consciousness are in turn conflated as the prose gathers steam. Both these typographical devices have important consequences for the claimability of the argument on offer: that we have come to the 'end of English'.

The ubiquitous, coyly postmodern-looking '/' is made to fulfil a number of crucial but blurrily different functions. The first use here is relatively simple. The phrase 'and/or' is a typographical convenience: a straightforward transcription of the unpalatable gargle 'and, or or'. In the formulations 'Text/context' and 'literature/history' the '/' is clearly meant to signal an important, if-as-yet-undecidable, mutual determination. But what of the final clause, in which, to paraphrase, it is asserted that new developments in the theory and practice of Literary Studies suggest that everything that constitutes the discipline, as such, has been 'rejected/lost for a future which is pluralist/confused'? The use of '/' here presents the reader with a number of dilemmas. The pair 'rejected/lost', for instance, cannot comfortably be read as a set of pure alternatives, as we might like. In the first place, why not just say 'or'? In the second place, the phrase 'lost for a future' is only remotely grammatical. We conclude that the formulation must signal the

undecidedness of 'and, or or'. But this leaves us with the necessity of discovering how something can be rejected *and* lost. For this to make sense, we would have to turn to psychoanalysis. We might draw, for instance, on Freud's interpretation of parapraxis as the attempted reconciliation of conflicting intentions. Loss becomes compatible with rejection, on this level, because 'parapraxes are the outcome of a compromise: they constitute a half-success and a half-failure for each of the two intentions (Freud, 1986 [1916], p. 94). In special conditions, pertaining to the more 'obscure regions of mental life', an unconscious rejection of something (e.g. principles) can lead to its being mislaid, despite the best efforts of the conscious mind to retain it. Of course, 'With the extinction of the motive the mislaying of the object cease[s] as well' (Freud, 1986 [1916], p. 83).

Similar problems of interpretation arise with the equation 'pluralist/confused'. The implicit parallelism with 'rejected/lost' – and the question 'why not "or"?' – both lead us back to the solution 'and, or or'. Again we are presented with the option of equating pluralism with confusion: of inhabiting a position half way between the two.

The inverted commas alert us to other difficulties. It is revealing, for example, that while 'the discipline' of English is put into quotation marks and hence into question, the status and cohesion of the other disciplines (History, Political Science etc.) are left intact. We have, it would appear, a suspicion that 'it' does not exist, indeed may never have existed, in the same way that these other, real, methodologies incontestably have and do. Nevertheless, 'it', we concede, must at some point have had some defining principles, which are now being effectively dispensed with. The insecurity about whether we admit or deny the historical existence of English, visible also in the sudden shift from the past tense to a present designated 'future', is symptomatic of a slippage between two very different conference agendas: that of deconstructing the myth of English as a discipline, and that of illuminating change within it.

My purpose here is not to criticise the style, or impugn the convictions of a challenging and controversial call for papers (evidently it hit the nerve it was meant to), nor is it to suggest that all teachers of English in higher education individually subscribe to a HETE line. It is merely to draw attention to the fact that, in March 1991, a large number of such teachers, myself included, might meet to discuss the relative merits of a small number of possible subject positions, the dominant one of which proposes that 'The defining principles of this possibly unprincipled, undefinable and undisciplined discipline have been rejected and lost in favour of pluralism and confusion.'

This may be a fair summary of English now. As a history of literary studies, however, it poses problems. I can only speculate on the circumstances which might make such a quasi-narrative appealing. One interpretation assumes that we have taken our Lyotard to heart, and has to do with deconstruction's internal dynamics. In order to pre-empt the appearance of a new Grand Narrative – a narrative in which multiplicity and difference would provide the redemptive finale of the drama of the Great Tradition – it is necessary to construe pluralism as confused and confusing. In other words, we have to be ambivalent about pluralism, otherwise we risk reintroducing certainty (pluralism is a good thing) into an arena in which it is discredited and outmoded (a little confusion is a good thing).[4] Further problems arise, however, as soon as ambivalence is rehabilitated as an end in itself: if, for example, the ability to entertain conflicting perspectives or plural cultures is deemed desirable. Again, the spectre of a metanarrative appears. In the meantime, pluralism, multiplicity, interdisciplinary projects, women's studies, cultural studies and media studies look more attractive on a prospectus than confusion.

What we are witnessing, in other words, is the uncanny reappearance, here disconcertingly and arbitrarily displaced from a tense present into a confused 'future', of a narrative at the very moment of its repression. We might recall that one of the four properties Lyotard finds in narrative knowledge is its ephemeral temporality, inhabiting the space between the 'I have heard' and the 'you will hear'; a temporality which is both 'evanescent and immemorial'. Because 'scientific' – or disciplined – knowledge desires legitimation as part of its momentum, 'It is not inconceivable that the recourse to narrative is inevitable.'

If this is the case, it is necessary to admit an irreducible need for 'history understood, as outlined above – not as a need to remember or to project . . . but on the contrary as a need to forget (Lyotard, 1989 [1982], p. 28). As soon as a story happens, a forgetting happens. I offer one final thought on the HETE passage. If the principles of the discipline have suffered a temporary misplacement, then it is also worth noting that the subjects of the narrative (the agents of change, dissidents of whatever stamp) have disappeared completely. 'Development and dissemination' of alternative courses do not just happen. Where are the teachers who have struggled, and who continue to struggle, to reform the curriculum? Where are the workers' groups and adult educationalists who have been waging a tactical war with 'literature' from outside the academy for decades, and who have stressed the material constraints on artistic production? Where are the black writers and critics and theorists? Where are the women? The HETE narrative can

be read as a lethal *aide-mémoire*, reminding us that literary criticism's learned scepticism of narrative knowledge might easily become a history of self-relegitimation, and hence of forgetting.

## 2.   FORGOTTEN, BUT NOT GONE

Both these narratives seem to assume that, whether their effects on traditional disciplines are invigorating or fatal, the advent of interdisciplinary methods and poststructuralist practices augur well for women. There prevails a sense of optimism that these developments are epistemologically and, by dubious extension, politically revolutionary in ways which will ineluctably benefit anyone concerned about gender and other forms of systematic oppression. Indeed, the idea is gaining ground that the disciplines will spontaneously combust under the glare of deconstruction, leaving maximum academic space for women's studies, black studies, gay and lesbian studies and other worthy programmes. Interdisciplinarity – and the sheer awkwardness of the coinage should give us pause – has been naturalised as the *sine qua non* of women's studies and, indeed, of feminist-academic discourse in general, with the result that it seldom appears now, in its own right, as an object for discussion, much less criticism. It has become 'common sense' to regard interdisciplinarity as, in and of itself, a jolly good thing, despite the fact that interdisciplinary courses exist which are indifferent to gender issues or even downright misogynist. (In some quarters, let us not forget, an 'interdisciplinary' tag is regarded more or less cynically as a guarantee of funding.) The same process of familiarisation and acceptance is well under way with regard to poststructuralism and postmodernism, with the same access of prestige to their practitioners (Christian, 1989). Since women are supposed to be among the beneficiaries of these developments, it is worth posing several questions: What is the likelihood of disciplines, and the ideological values they embody, simply disappearing? What might women gain if they did disappear? What might they lose? And in both cases, which women are we talking about?

As we have seen, current trends in higher education celebrate interdisciplinary work and postmodern critique as ends in themselves, as epistemologically symbiotic and as politically progressive.[5] Of course, if the logic of postmodernism is played out, the category 'women', the concept 'identity' and the position of 'subject' are emptied of all determinate meaning, and the 'death of women's studies' becomes inevitable, even

desirable. 'Literature' in turn would have to take its bat home, and abandon itself to textual play, difference-mongering, and the choreography of surrender. However, as Bella Brodzki and Celeste Schenck have pointed out:

> The issue of identity is precisely the ground on which feminism and deconstruction part company, for deconstruction aims to undo essential selfhood where feminism recognizes the political necessity of affirming subjective agency.
>
> (Brodzki and Schenck, 1989, p. 202)

Furthermore, Susan Bordo reminds us that

> Most of our institutions have barely begun to absorb the message of modernist social criticism; surely it is too soon to let them off the hook via postmodern heterogeneity and instability. This is not to say that the struggle for institutional transformation will be served by univocal, fixed conceptions of social identity and location. Rather, we need to reserve *practical* spaces for both generalist critique (suitable when gross points need to be made) and attention to complexity and nuance. We need to be pragmatic, not theoretically pure, if we are to struggle effectively with the inclination of institutions to preserve and defend themselves against deep change.
>
> (Bordo, 1990, p. 153)

Not only is it strategically necessary that these categories be retained, but it also remains to be seen whether postmodernism can adequately account for *systematic* oppressions and repressions,[6] even within its own terms. In the rush to act out the war on 'totality' and the 'activation of difference', intellectuals ('let *us* wage war . . .') have been only too eager to abandon the theoretical space occupied by systems, large and small, and by longstanding and pervasive mechanisms of allocation and regulation (Skeggs, 1991). Systems do exist, even if they don't explain everything about an institution. The systematic division of academic activity into discrete units – 'subjects' in competition with each other over resources and legitimacy – exists, even though it may not account for all the modes of learning and teaching in any given institution, nor for the myriad ways individuals and groups find to ignore, resist or subvert the system.

To take the example of literary study again, a move away from practical criticism, textual appreciation and the 'Great Tradition', to a broader poststructuralist analysis of 'culture' – the journey from English to women's studies, perhaps – destabilises the category 'literature' as a legitimate

object of enquiry as distinct from hi-fi manuals and shopping lists. In many ways this is clearly advantageous to women, whose characteristic cultural forms have often been derided or ignored in favour of canonical works credited with embodying Great Universal Truths. But what if, with the bathwater of Truth, we throw out baby Beauty? The cursory treatment of aesthetics in feminist thought; the way expressions of preference or enthusiasm for an imaginative work sound hopelessly insubstantial or middlebrow; the nostalgic compulsion to coerce Virginia Woolf's prose into participating in otherwise monotone arguments about theory: all hint that there may be losses for some women in what has been called the 'Exploding' of 'English' (Bergonzi, 1990). Might it be that this is a controlled explosion, sacrificing passion and poetry for the appearance of neutrality, or even, as I have suggested, sacrificing sympathetic engagement and political intervention for theoretical agility?

Recognising myself as one of the women for whom the Exploding of English is a mixed blessing, I turn at last to the narrative of curricular change with which I have had most to do – the history of women's studies in British universities – to ask what contribution can or should a feminist of English Department provenance, weaned on C. S. Lewis and F. R. Leavis, make?

Historically, university women's studies in Britain has been the result of a felicitous, but essentially sporadic and *ad hoc*, series of encounters between academic women from various disciplines and of various political outlooks, all interested in gender, or 'women', or sexuality, or feminism, or sexism, or equal opportunities, or oppression, or some aspect of culture's dealings with one of the above, and all looking for a legitimate context in which their concerns might be shared, supported and developed. Feminist critique in, and/or of, higher education has systematically demonstrated that, left to themselves, the traditional disciplines are likely to marginalise, misconstrue or altogether exclude women as objects and subjects of enquiry. Hand in hand with this pessimistic dismissal has gone a correspondingly optimistic sense that it is in the engagement between disciplines, and in the concerted challenge to their self-sufficiency and integrity, that gender relations, women's subordination and the 'subject of feminism' can be articulated and theorised.

Passionate serendipity, fierce commitment on the part of students and teachers, pioneering spirits and faith in the catalytic effect of collision between disciplines have all characterised the first ten tentative years of organised women's studies in British universities. The gradual transition from informal to formal networks and the going-public of women studying women have lent credence and clout to our collective desire, still not as

metaphorical as it might be, for five hundred pounds a year and a room of our own. Not only has student demand for gender-conscious curricula been authority and encouragement, but new courses have been generated at all levels of adult, further and higher education, and feminist research has been stimulated, recognised and even, in some cases, funded. This institutionalisation was a small but vital component of a wider development: a burgeoning of feminist scholarship, learning, teaching and publishing in the unpromising soil of Thatcher's eighties. Many of these projects are still tender, and vulnerable to the vagaries of a male-dominated 'market academy'. But in some small pockets of activity the battle for institutional recognition has, for the moment at least, been won. Thus, when a new character in the BBC's *East Enders* introduces herself as a teacher of women's studies, the titter in the Queen Vic lasts only seconds. Within weeks, the nation too is reassured that, for all her houseplants and prickly independence and penning of erotic short stories, Rachel is just another attractive woman with boyfriend troubles, and perfectly in keeping with the lifestyle of a national soap. A year later, she is on short time.

Rachel's rapid admittance to the life of the Square gratifies me as a soap fan and disappoints me as a feminist. It serves to remind me of a second possible history of women's studies: a dystopian version that must stand alongside the upbeat one. The success, however partial and penurious, of women's studies in establishing itself as a feasible (read marketable and examinable) academic project, coupled with the continued reluctance of the mainstream academic disciplines to make any but the most begrudging concessions to the idea, much less the politics, of 'difference', have perhaps combined to construct women's studies as that feminist bogey, a haven in a heartless world. The space we have carved out for ourselves may be constituted *by* academic sexism as well as against it, and hence be normalised as part of the establishment, domesticated as feminine space, and neutralised as a force for change. Through women's studies, feminism may become familiar, and hence negligible. Furthermore, excitement and innovation may have characterised the 'gender franchise', but they have not succeeded in eliminating racism, heterosexism, ageism or elitism from academic feminism. An economic and professional climate which fosters individual over collective accomplishment, single-authored books, academic specialism, performance and overproduction has exacerbated acquisitive habits brought over from impoverished, gender-starved curricula. In this atmosphere there is a danger that feminist effort might take the form of a mutual parasitism ratified for political purposes as 'collective', endorsed for practical purposes as 'interdisciplinary' and glamorised for theoretical and aesthetic purposes as 'polyphonic' or 'postmodern'.

I place this dour tale alongside the success story simply to highlight the fact that, given its present institutional base in the academy, women's studies both opens options and is open to co-option. One of the many dangers confronting a flourishing project is reification: the possibility that its methodologies and practices may come to be seen as ends in themselves rather than as means. If placing a question-mark over the trajectory of women's studies seems churlish at this early stage, it might also stimulate us to continue to challenge assumptions and monitor the direction of change.

For understandable reasons (public image, residual siege mentality, course management, conscientious scrutiny of our own assumptions, idealism, friendship, etc.) women's studies likes to construct itself as 'seamlessly' interdisciplinary: as gratifyingly inclusive and expansive and internally conflict-free. In invoking the disciplines only as contributory 'discourses', it is easy to forget that they have their own structures, traditions and valencies with state power; easy to blind ourselves to the fact that these discourses and the subject positions they favour are bound to be in competition and conflict sometimes, even in the rarefied atmosphere of women's studies. It is worth reaffirming that interdisciplinary work is important as a process rather than an achieved or achievable goal; and furthermore that it will always be a power struggle on some level, whether over resources, time, vocabulary, energy, allegiance, survival or taste. To take a crude example, from my point of view as a literary critic, it sometimes appears that in the reshuffle of disciplines we risk a regime in which sociological perspectives (albeit deconstructed of their classism, sexism and racism and reconstructed as 'issues') can, in the urgency of their rhetoric, assert a hegemonic influence over other disciplines, which are reduced to case-study or 'illustrative' status. As in this chapter, literary examples are furtively smuggled in under the cover of 'experience', 'voices of', 'comparison' or 'historical context'. One of my discoveries has been the importance of acknowledging disciplinary differences in our course work, rather than repressing them for the sake of harmonious unity. (The repressed returns: my craving for Dickens, my yearning for John Donne, my secret loathing of dark green Virago jackets, my mistrust of translations, my pedantic delight in 'root meanings'.) In what follows, I hope to tease out some of the implications of this discovery.

The context in which these issues have been most conspicuous to me is a very specific and local one, though I have heard the same questions rehearsed whenever and wherever women's-studies foundation courses are being devised. The collaborative impulse, the vastness of the ground to cover in a short time, and the fact that the participants have educational backgrounds as diverse as medicine and fine art, Russian studies and library

studies: these and other pragmatic and pedagogic factors have encouraged many women's-studies teams to focus their efforts around a year-long 'core' course. In the most general terms, a core course is a resource base; a state-of-the-art introduction to feminist problematics and methodologies; a place in which new routes between disciplines can be mapped out, and their points of departure interrogated.

Obviously, the term 'core course' itself inscribes a complex dynamic of resistance ('core') and motion ('course', and its cognate 'curriculum'). 'Core' ideally should evoke the heart: vital organ, turbulent, volatile centre of activity. In practice, it sometimes connotes just the reverse: a 'hard core' where desire has congealed into content; and it is not surprising that 'core' has been cited by postmodernists as part of the 'forbidden vocabulary' of modernist, humanist, rationalist discourse (Di Stefano, 1990, p. 76). The problem (and one not confined to women's studies) is that while, in theory, a core course should open up possibilities, the very mechanics of curriculum development tend to close them off.

At York, the express aim of this course, from the first modest reading list in 1984 to the latest thirty-two page 'hand-book', has been

> to provide a context and foundation for other more specialised work in Women's Studies as well as a space for thinking about general problems of method and theory in this field.

The 'blurb' goes on to state that the core course

> will offer an opportunity to deal with concepts and disciplines different from those with which you are already familiar, to make connections between insights/information from several 'conventional' disciplines, and to discuss ideas and approaches which can help us describe and understand women's experience. We will be using history and novels as well as sociological studies and philosophical ideas to help us to think through the shape, content and direction of Women's Studies.

Here, 'inter'-disciplinary means multi-, trans-, anti- or neo-disciplinary, depending on whether the stress falls on content, method or aims. A foundational approach to understanding and research jostles with a potentially antifoundational scepticism about existing explanations. Representation and interpretation collide and regroup, and metaphors of shape, form and containment strain against metaphors of movement. The tone of the passage is extemporaneous and provisional, and positively wide-eyed compared with the congested rhetoric of much of our current theorising.

Optimistically, the passage makes little attempt to conceal its contradictions and ambivalences, and stands as a reminder of the risks our founders were prepared to take in hammering our course together.

Looking at the way our MA core syllabus has changed since 1984, I am struck by the slow but determined erosion of recognisable disciplines from its ostensible format. In the first year, a proposed seminar on Harriet Martineau's *Deerbrook* called unblushingly for 'close reading' and gestured towards authorial motives and historical 'background' as worth discussion. Those early seminars on 'images of women in literature', 'literature and domesticity', 'the political economy of gender' or 'Victorianism and philosophy', with their shamelessly canonical set texts (Brontë, Martineau, Mill) look positively brazen when compared with today's modestly thematic sessions, with their cautious comparative structures, their self-reflexive 'discourses' and their prodigious reading-lists.

The move towards deliberately polyvalent themes such as 'representation', the 'public and private', 'care', and so on, is part of a continual process of restructuring in the face of the ever-increasing scope and complexity of feminist scholarship. If the potential scope of women's studies is at least as vast as its counterpart, 'male thought', then it goes without saying that a pragmatics of selection, of metonymy and condensation will be in play. Many factors contribute to the structure of the course (availability of expertise, student demand, new developments etc.), but certain 'common sense' assumptions cut across all these: assumptions which have implications for the coding ('coring') of feminist enquiry. Instead of beginning from an acknowledgement (fundamental, after all, to the women's-studies rationale) that the disciplines embody conflicting and contradictory formulations of gender, significance, theory and so on (Jacobus, 1982), we have sought out, and organised our course around, mutual interests, compatibilities, thematic connections, and relevances. Could it be that, in our efforts to make the material more tractable and accessible to interdisciplinary approaches, we are smoothing down some necessary rough edges? Sites of agreement in one idiom are common-places in another: could it be premature to embrace a principle of relevance at this stage in our short history? As Gillian Beer has noted, 'The problem with the concept of relevance is that it assumes an autonomous and coherent subject' (1989, p. 67). Following on from Beer's point, it occurs to me that the momentum of relevance may lead us in four potentially unhelpful directions – towards circularity, solipsism, lack of historical understanding, and functionalism – and that these four overlapping features will correspond to four overlapping formulations of the 'subject' of women's studies.

The silliest of these, and the easiest to overlook, is the assumption that

women's studies itself can be a 'stable and autonomous subject' dictating its own orbit of pertinence. The circularity of this argument (symbolised by the metaphor of the 'core') results in a centrifugal motion, consigning some areas of enquiry to the margins or beyond. Such areas as spirituality, age, disability and, oddly, masculinity are among the current victims of this process. On the last point, the work of Marion Shaw on Tennyson (1988), and of Eve Kosofsky Sedgwick on the male homosocial continuum (1985), persuade me that there is no longer any good reason to delay a concerned feminist analysis of the male text, and in particular of the cultural construction of manliness as part of a dialectical understanding of gender. (Neglecting this as a subject of women's studies effectively cedes the terrain to Men's Studies.) Relatedly, the whole area of technology and hard science is often regarded as beyond our orbit, thus perpetuating a shoring up of the Humanities as fictionally separable from engineering, informatics and genetics. Donna Haraway (1990 [1985]) has argued cogently for a 'socialist-feminist politics addressed to science and technology' (p. 214) and for an epistemology which might explore the possibilities for feminism within and between the (academic) dichotomies human/animal, human/ machine and physical/non-physical. Such a move would make mincemeat of many of our most cherished and invisible assumptions about the subject of women's studies. Interestingly, Haraway uses literature – in this instance feminist science fiction – as a lever against the resistance of hard science to feminist intervention. The strategy of pitting literature *against* other disciplines is an appealing one.

The second criterion of relevance which needs deconstructing is that the subject of women's studies is 'we women'. Hence, the second hidden agenda of the core course might be symbolised as Course = Core + Us. The treacherous slippages between 'women', 'we' and 'I' that have character-ised white academic feminism resurface too easily in a programme enshrin-ing a principle of relevance to self, whose teaching constituency is still predominantly white, middle-class and hierarchically structured. Almost inevitably, 'we' choose themes and topics we feel comfortable with; we set questions to which we think we know answers; we set books we admire and read them in our own image. Our cultural and theoretical agenda has an inherited predisposition towards using 'Third World' issues and texts as correctives, or as contrasts, or for 'information-retrieval'; a tendency grimly exposed by Gayatri Spivak (1986, p. 262). Alison Light (1990) has written unflinchingly of her difficulty in 'coming to terms' with the utopian ele-ments of *The Color Purple* in the context of a class of white women whose only theoretical purchase on black women's experience was as victims rather than survivors:

Clearly, for white academics, part of the problem is that *The Color Purple* is not about 'us' at all. Nothing is harder than for those who trade in knowledge to admit ignorance. What is even more threatening is to feel that those outside of 'our' dominant culture do have a knowledge and strength of their own precisely *because* of being outside. . . . Wanting *The Color Purple* (as I did) to lead into a discussion of racism is certainly easier than seeing myself as marginal to its concerns.

(Light, 1990, pp. 90–1)[7]

If I regard myself as the (autonomous and coherent) subject of women's studies, then women's studies will solipsistically inscribe me and my trappings in a way that reflects but does not counteract the self-inscriptions of dominant ideologies. As Light's essay reveals, it is not enough to teach 'different' texts if their otherness is pre-empted by a preconceived theoretical formulation such as 'difference equals oppression'.

A third configuration of the 'subject of women's studies' congratulates itself by association with the here and now. Its subject, its achievement, its engagement, is the present. As Gillian Beer puts it, 'The present . . . is conceived as absolute; all else as yielding relativistically to it – and unacceptable unless it yields (in both senses)' (Beer, 1989, p. 67). Unless we consider gender to be a product of industrialisation, the difference of the distant past may be at least as challenging and instructive to women's studies as the nuances of more recent history. Elaine Hobby's work on lesbian writers of the seventeenth century, for instance, illuminates dissimilarities as well as continuities in the expression of a lesbian erotic, and reminds us that women have always theorised their position in society, though in idioms and genres we may fail to recognise as 'theory'.[8] In the context of feminist literary history, Beer, like Light, alerts us to the possibility that the controversies and desires of texts may not be concerned with us, so that in order to engage with and learn from the *difference* of the past we need to work with whatever challenges rather than confirms our criteria of relevance, and to question whether, in our necessary search for the silences in a text, we are not unconsciously desiring spaces in which to insert our own meanings and preoccupations (Beer, 1989, p. 69).

The fourth appeal to relevance is more dynamic, and on the surface less prone to foreclosure. It refers us back to our vaunted interdisciplinary disposition and casts the disciplines as *relevant to each other* in a conversation between equals towards an analysis of gender. In effect this postpones, rather than disposes of, the question of the subject, assuming on the one hand that disciplines are ideal, disembodied, ideologically neutral locations, and on the other that they are self-conscious, fixed, internally consist-

ent presences. In practice, of course, the subjects are both thoroughly embodied (in staff, students, books) and yet precarious, contradictory subjectivities struggling for self-legitimation. I am more and more convinced that we might profitably work *with* this paradox rather than against it. Rather than dismantling our educational 'backgrounds', we might be as uncompromising about whatever is partisan, compelling, even visceral about our disciplinary subjectivities as we are about our politics.

I find myself reformulating the question thus: What do I *want* to do here? As a literary critic and lover of literature, what skills and insights do I want to contribute to women's studies? Given the constraints on time and resources, what is the least I can do? An answer begins to take shape. I want to insist on the resonance of genres other than non-fiction and abstract theory, and on the challenges posed by fantasy, desire and imagination; I want to sketch out as many strategies for feminist reading as possible; to explore, and hence short circuit, the mechanisms of ideology by exposing the mechanisms of representation; to participate in the revival of neglected women writers, women's texts, women's cultures, and point to the conditions that make them possible, and to the forces that go into their suppression; I want (and I am aware this sounds like a credo) to celebrate pleasure in language and to invite creativity.

I acknowledge that other, competing idealisms inform what other disciplines may want literature to 'do'. A text may be required to 'flesh out' historical change; to elaborate themes; to substantiate generalisations, and to bear witness to the nuances of experience – of fragmentation, of sexuality, of mentality, of the private life – inaccessible to the public discourse of statistics, unreadable by machine. A text may be needed to offer alternative 'voices', or to 'speak' difference.

Unless the divergence between these agendas is firmly underlined and respected, the presence of literary texts on the course will become radically overdetermined. The problems of canonisation evident in the English Literature syllabus proliferate when texts have a number of illustrative and exemplary functions and must 'serve' several overt and covert purposes. Susan Lanser has alerted us to the politics of this tendency in relation to Charlotte Perkins Gilman's *The Yellow Wallpaper*: a text which 'is not simply one to which feminists have 'applied' ourselves; it is one of the texts through which white, American academic feminist criticism has constituted its terms' (Lanser, 1989, p. 415).

In the context of an interdisciplinary course, the net result is a brand of convenience super-texts with all the right ingredients: contradiction, appeal to experience, deployment of as many codes of difference as possible, a few

silences and gaps, a fugitive relationship with genre and a manifest relationship with feminist historiography, and the odd burst of poetic language. Audre Lorde's *Zami* will serve as a prime example here, as it is so often forced to do in women's-studies courses, but other texts – Toni Morrison's *Beloved*, Zora Neale Hurston's *Dust Tracks on a Road*, Maxine Hong Kingston's *The Woman Warrior* – 'lend' themselves in similar ways. Prevailing on texts to 'perform' or 'yield' (in Beer's terms) leads to short cuts, simplifications, and ready-made, gristly digests of complex, irreducible ideas and intertextual relationships. More seriously, it leaves little room for the pleasures of surprise, the puzzlement of challenge, or for the vestigial *jouissance* which has often been so crucial to women's cultural survival.

I do not want to underplay the political importance of joyful recognition and identification: the self-affirmation which has been part of 'saving our own lives' for many marginalised readers (Christian, 1989, p. 235; after Walker, 1984) merely to question whether literature in the form of 'set texts' is *necessarily* the locus for this, and whether the process – the work – of discovery is not as vital here as the reflection it affords. In an article 'On Becoming a Lesbian Reader' (1988), Alison Hennegan has written movingly of her life-long quest for books which would help her 'recognise, respect and enact' her sexuality: a search which, with its sidetracking into the literature of the male homoerotic, its ransacking of children's and popular fiction, and its jousts with antiquity and with the European 'classics', has granted her, as a by-product, a privileged insight into the culture of the British élite. 'A privilege grounded in deprivation', Hennegan insists, but one which compelled her to 'explore the teasing bonds and barriers which separate and unite homosexual women and men' (Hennegan, 1988, p. 189). Whatever the frustrations of the quest, the stretching of sympathies and imagination it entails, and the very discipline of research it requires, can provide a basis for activism and a stimulus for change.

I do not know how we can stop feeding a canon which threatens to shoot down feminist possibilities almost before they get off the ground. But I do think we should resist squandering our precious textual quality-time illustrating comparative modes of socialisation, Lacanian splitting and the effects of private-sphere ideology. We should resist expending our critical energies combatting the kinds of literalism that a syllabus driven by relevance inscribes and even reinforces. And we should resist providing textual hostages *in place of* a thoroughgoing critique of racism and heterosexism.

This may mean putting as much hermeneutic pressure on the differences between our own readings and reading histories as we now exert on 'other' texts. Reader response theory has received scant attention in feminist work

in Britain, partly because of its early alliance with the more distinctively American end of the psychological spectrum, and partly, I suspect, because it was so forcefully dismissed by Terry Eagleton as presupposing and confirming a liberal humanist subjectivity (Eagleton, 1983, pp. 79–80). Since feminists' status as liberal humanist subjects is already in jeopardy, useful links might be forged between what we know about ourselves as readers and the many theories on the subject available to feminist thought (see Gagnier, 1991, pp. 8–14). The existence within women's studies of a splendidly diverse community of readers, each with her own passionate *biographia literaria*, represents an untapped resource far more rich and complex than can be contained in any feminist canon or reading list.[9] Perhaps these histories should provide our 'set texts'?

Alternatively, we might open up the woman's-studies syllabus to texts which do not readily accommodate feminist 'issues', or which do not obligingly self-deconstruct at the drop of a hat; we might spend more time over texts from the distant past, poems, works by men, and so on. Like it or not, this would entail a consideration of some of the finer points of literary style and context, points which have been demoted as 'aesthetic' or 'elitist'. Like Gillian Beer, I would argue for

> a reading which acknowledges that we start now, from here, but which re-awakens the dormant signification of past literature to its first readers. Such reading seeks intense meaning embedded in semantics, plot, formal and generic properties, conditions of production. These have been over-laid by the sequent pasts and by our present concerns which cannot be obliterated, but we need to explore both likeness and *difference*. Such reading gives room to both scepticism and immersion.
>
> (Beer, 1989, p. 69)

And if my appropriation of Beer's methodology looks suspiciously like an excuse to return to old-fashioned close reading, well, that, to some degree, is what I'm doing here.

Women's studies began as a coming together of plotters in search of a plot. Whether this newly formed collectivity remains a nest of conspirators or becomes – to coin a phrase – a mastery of narrators, is a moot point. Having learned, from poststructuralism, to be sceptical about the narratives we produce about ourselves – relevance to self, interdisciplinary utopia – and, from feminism, to distrust the narrative of 'redemption by post-structuralism', we may need to continue to renegotiate the terms of our alliance, aware always of the possibility of creative contradiction between the disciplines we represent. Gayle Green suggests a way forward:

Perhaps it would liberate us to think not in terms of contradiction, but of dialectical relation. To acknowledge this interaction of competition and cooperation in our behaviour might unlock the hold of an either-or category and allow us to envision new possibilities.

(Green, 1989, p. 86)

Literature's contribution to such a project might usefully be the irreverence of irrelevance.

## NOTES

Versions of parts of this chapter were delivered at the HETE Conference at Stafford Polytechnic in March 1991, and the Northern Network meeting at Newcastle University in March 1992. Thanks to the organisers for both those opportunities. The paper has benefited greatly from discussions with Vicki Bertram and Dr Beverley Skeggs of the University of York, and with Dr Richard Allen of New York University. Thanks are also due to John David and Karen Young for providing the Green shade.

1.  Another provocative example is Bernard Bergonzi's seductive call for degrees in poetry as a last bastion for literary sensibility and talent (while abandoning the rest of the textual field to 'Cultural Studies'). This may, willy-nilly, turn out to be at the expense of women writers, who have often been excluded by education from the technology of poetic composition, and who are included in Bergonzi's sketch only as the negative pole in a classroom debate about poetic greatness.

2.  Of course, many of feminism's most influential proposals and formative statements have come in the form of literary criticism, notably in the work of Virginia Woolf, Kate Millett, Alice Walker, etc.

3.  I am reminded of Rita Felski's warning, in *Against Feminist Aesthetics* (1989, pp. 61–2), that:

    the political status of a particular discourse cannot simply be read off from the epistemological claims which it seeks to make; a skeptical, relativistic, or ambiguous discourse is not necessarily more radical than one which claims the authority of certain conviction.

4.  Ihab Hassan (1987, p. 23) argues, for instance, that:

    (a) critical pluralism is deeply implicated in the cultural field of postmodernism; and (b) a limited critical pluralism is in some measure a reaction against the radical relativism, the ironic indetermanences [sic], of the postmodern condition, an attempt to contain them.

5.  Although, see Beverley Skeggs (1991), 'Postmodernism and the Sociology of Education'.
6.  An interesting version of this debate can be found in the letters-page discussion of Nicholson (ed.), *Feminism/Postmodernism* in *Women's Review of Books*, vol. VIII, no. 6 (March 1991) pp. 2–3.
7.  Thanks to Anne Kaloski-Naylor for this reference.
8.  Paper given by Elaine Hobby at the 1991 HETE Conference, Stafford Polytechnic. See also her *Virtue of Necessity: English Women's Writing 1649–88* (1988).
9.  Unfortunately, within academic feminism the term 'Reader' is ever more likely to refer to a set of received opinions crystallised in an eponymous critical anthology, than to a forcefield of desires and demands in human shape.

# REFERENCES

Batsleer, Janet, Tony Davies, Rebecca O'Rourke and Chris Weedon (1985), *Rewriting English: Cultural Politics of Gender and Class* (London and New York: Methuen).

Beer, Gillian (1989), 'Representing Women: Re-presenting the Past', in Catherine Belsey and Jane Moore (eds), *The Feminist Reader: Essays in Gender and the Politics of Literary Criticism* (Basingstoke and London: Macmillan).

Bergonzi, Bernard (1990), *Exploding English: Criticism, Theory, Culture* (Oxford: Clarendon Press).

Bordo, Susan (1990), 'Feminism, Postmodernism, and Gender-Scepticism', in Linda J. Nicholson (ed.), *Feminism/Postmodernism* (London and New York: Routledge).

Brodzki, Bella and Celeste Schenck (1989), 'Criticus Interruptus: Uncoupling Feminism and Deconstruction', in Linda Kauffman (ed.), *Feminism and Institutions: Dialogues on Feminist Theory* (Oxford: Basil Blackwell).

Christian, Barbara (1989), 'The Race for Theory', in Linda Kauffman (ed.), *Gender and Theory: Dialogues on Feminist Criticism* (Oxford: Basil Blackwell).

Di Stefano, Christine (1990), 'Dilemmas of Difference: Feminism, Modernity, and Postmodernism', in Linda J. Nicholson (ed.), *Feminism/Postmodernism* (London and New York: Routledge).

Eagleton, Terry (1983), *Literary Theory: An Introduction* (Oxford: Basil Blackwell).

Felski, Rita (1989), *Against Feminist Aesthetics* (London: Hutchinson).

Freud, Sigmund (1986/1916), *Introductory Lectures on Psychoanalysis*, translated by James Strachey, Penguin Freud Library, vol. 1 (Harmondsworth: Penguin Books).

Gagnier, Regenia (1991), *Subjectivities: A History of Self-Representation in Britain 1832–1920* (New York and Oxford: OUP).

Green, Gayle (1989), 'The Uses of Quarrelling', in Linda Kauffman (ed.), *Feminism and Institutions: Dialogues on Feminist Theory* (Oxford: Basil Blackwell).

Haraway, Donna (1990/1985), 'A Manifesto for Cyborgs: Science, Technology, and Socialist Feminism in the 1980s', in Linda J. Nicholson (ed.), *Feminism/Postmodernism* (London and New York: Routledge).

Hassan, Ihab (1987), 'Pluralism in Postmodern Perspective', in M. Calinescu and D. Fokkema (eds), *Exploring Postmodernism* (Amsterdam, Pa: John Benjamins).

Hennegan, Alison (1988), 'On Becoming a Lesbian Reader', in Susannah Radstone (ed.), *Sweet Dreams: Sexuality, Gender and Popular Fiction* (London: Lawrence Wishart).

Hobby, Elaine (1988), *Virtue of Necessity: English Women's Writing 1649–88* (London: Virago).

Hurston, Zora Neale (1986/1942), *Dust Tracks on a Road* (London: Virago).

Jacobus, Mary (1982), 'Is There a Woman in This Text?' in *New Literary History*, vol. 14, pp. 117–41.

Kauffman, Linda (ed.) (1989), *Gender and Theory: Dialogues on Feminist Criticism* (Oxford: Basil Blackwell).

Kingston, Maxine Hong (1981), *The Woman Warrior: Memoirs of a Girlhood among Ghosts* (London: Picador).

Lanser, Susan S. (1989), 'Feminist Criticism, "The Yellow Wallpaper", and the Politics of Color in America', *Feminist Studies*, vol. 15, no. 3, pp. 415–41.

Letters page, *Women's Review of Books*, vol. VII, no. 6 (March 1991).

Light, Alison (1990), 'Fear of the Happy Ending: *The Color Purple*, Reading and Racism', in Linda Anderson (ed.), *Plotting Change: Contemporary Women's Fiction* (London: Edward Arnold).

Lorde, Audré (1984), *Zami: A New Spelling of My Name* (London: Sheba Feminist Publishers).

Lyotard, Jean-François (1989/1982), 'Answering the Question: "What is Postmodernism?" ', translated by Régis Durand, in *The Postmodern Condition: A Report on Knowledge, Theory and History of Literature*, vol. 10 (Manchester: Manchester University Press).

Morrison, Toni (1987), *Beloved* (London: Chatto).

Sands, Kathleen Mullen (1990), 'Writing Cultures: An Interdisciplinary Approach to Developing Cross-Cultural Courses', *Women's Studies Quarterly*, vol. XVIII, no. 3/4, pp. 100–18.

Sedgwick, Eve Kosofsky (1985), *Between Men: English Literature and Homosocial Desire* (New York: Columbia University Press).

Shaw, Marion (1988), *Alfred Lord Tennyson* (New York: Harvester Wheatsheaf).

Skeggs, Beverley (1991), 'Postmodernism and the Sociology of Education', in *British Journal of the Sociology of Education*, vol. 12, pp. 255–69.

Spivak, Gayatri Chakravorty (1986), 'Three Women's Texts and a Critique of Imperialism', in Henry Louis Gates Jr (ed.), *'Race', Writing, and Difference* (Chicago and London: University of Chicago Press).

Walker, Alice (1984), *In Search of Our Mothers' Gardens* (London: Women's Press).

Weedon, Chris (1987), *Feminist Practice and Poststructuralist Theory* (Oxford: Basil Blackwell).

Woolf, Virginia (1984/1929), *A Room of One's Own* (London: Granada).

# 5 Problems of Theory and Method in Feminist History

## UTA C. SCHMIDT

In this essay I want to offer some reflections on the subject of 'feminism' and 'historical scholarship and understanding'. The relationship between these two is problematic and troubled as well as interactive and stimulating. I will dare to claim that feminists cannot avoid historical study as part of the process of shaping their own identity any more than historians can avoid the challenge of feminism to write better, that is more fully human, history. My approach is a theoretical one which explores (a) key elements of a 'feminist' perspective, focusing particularly on the relevance of history as a focal point linking past, present and future, and (b) how a feminist perspective revitalises the fundamentals of historical thinking, presentation, study and understanding. One the one hand I want to establish the conceptual arguments against the androcentrism and gender-blindness which structure historical scholarship. On the other hand I want to argue for a critique of the 'women's-history' perspective on history. The first group of arguments concerns the gendered character of history, while the second group deals with the conceptual and methodological components of properly constituted feminist history.

In order to make it quite clear that I intend to discuss more than historical work about women, I shall avoid the term women's history. My concern is a *feminist perspective* on all history, which is an accepted topic for discussion in Anglo-American culture, but in Germany is still felt to be a provocative concept.[1] It is curious to note how many men still react to the term 'feminist' as a threat to masculinity. For me it is also annoying to see how intellectual women twist and turn in order to avoid being seen as connected with feminism, thereby giving the impression that feminist arguments lack intellectual value. It is for this reason that I want to stress the critical and political value of the term 'feminism' and its critique of patriarchy.

Comparison of the expressions 'women's history' and 'feminist history' makes it obvious that the latter refers to far more than the enlargement of the field of historical research (women in history) or of the number of females doing such research (women as historians). A 'feminist perspective' takes in *all* aspects of the dominance of men and subordination of women, and the means whereby these have been established and main-

tained. It is concerned with all levels of historical knowledge, awareness, thought, study and explanation. It is an approach which deals with the experience of female textile workers during industrialisation, but also with the fall of the Roman Empire. It analyses the significance of gender for the very process of understanding history itself, and the linguistic difficulties in conceptualising women's history as 'a history of their own'. A feminist perspective is committed to the historical experiences of women and men in both their divergences and their interactions, and argues that 'gender' is a combination of lived experiences and of cultural and symbolic expressions changing through history. The use of the Latin root word *femina* makes it clear that this perspective derives from the specific contemporary situation, viewpoint and interests of *women*, which does not mean that it is taken only by women.

While we still know so little about what women did and experienced in the past, feminist history will deal mainly with women as its subject matter and may thus be known as 'women's history'. Like 'women's studies', 'women's history' is a necessary stage in the adventurous journey towards changes in the actual structures of knowledge about men and women in the past. However, it is not itself a concept which goes far enough to realise our general claim for the revision and reformulation of the whole of historical thinking and scholarship in a non-male-centred way. By contrast, the concept of a 'feminist perspective', which does indeed have such a claim and aim, will have implications and effects for every aspect of historical practice.

It is my concern here to explore such effects. I am not proposing a single concept with universal validity, but rather, one which synthesises diverse effects without systematising them one-dimensionally – a somewhat difficult balancing act to perform. It may seem odd for a historian to pursue this subject rather than accepting the established practice of studying what Ranke, a founding father of academic history, called 'what actually happened'. However, the whole point is that we need to question who it is that in fact decides 'what actually happened', and this empirical question takes us straight to the heart of high theoretical discussion, linking practical work as a historian to theoretical concerns.

## THE BASIS OF MY APPROACH

I will illustrate the relationship of theoretical and empirical practice with examples from my own experience. Some years ago I was doing specialist

work on the medieval French writer Christine de Pizan, who in 1405 produced a book on female education, *Le livre des Trois Vertus*. I was interested in her because she was presenting ideas on a topic largely dominated by men, and used history to argue against the misogynists of her day. In her hands history served to celebrate women's past accomplishments, to rebut the accusations of misogynists, and to encourage female contemporaries to greater achievement. Her writing on education helped to develop a conception of women as human beings and has thus contributed to the development of gender relations towards the present.

After finishing my research I spoke about Christine de Pizan at various seminars and meetings, many of which were associated with the women's movement. I realised with a certain horror that the topic was eagerly taken up but that de Pizan was understood not in her own context but in that of the present day. She got transformed into a single working mother involved in feminist writing, like some precursor of a modern feminist. However much I tried to convey the difference between our own times and the fifteenth century, the desire of my listeners for appealing models from the past constantly diminished it. Poor Christine de Pizan was co-opted by the need of today's women's movements to place themselves in history, which for me raised some powerful questions. What *are* the connections between women's past practice and women's present need to define themselves? What about the historically specific character of gender experience and the demands of historical accuracy? How does one deal with the question of the differences and similarities between us and the women and men of the past, let alone the diversity and complexity of both past and present experience?

These questions, which arose directly from my own experience, were the starting point for my interest in theory. This was further stimulated by the character of established historical practice itself. When I looked for women in history and for the interaction of gender and historical change, my outlook was dominated by apparently universal categories such as 'power', 'progress' or 'class', which determined the 'right' or 'wrong' issues for historical discussion and set the criteria for the exclusion or inclusion of particular topics for historical study. Yet how could I understand women or femininity in past society if my thinking was shaped by preconceptions based on modern society's distinctions between economy, politics and culture (and especially the modern separation of public and private) (Wagner-Hasel, 1988, p. 19)? How could I accept the old view of Burckhard that the Renaissance advanced some aspects of gender equality, granted my knowledge about Christine de Pizan (Schmidt, 1987, p. 51)? Last but not least, modern society is founded on a characteristic dual application of women's work as a force both of familial and social reproduction and of commodity

production for the capitalist system. How could I apply the nineteenth-century construction of 'separate spheres' for men and women, and associated notions of power/powerlessness, as a late twentieth-century historian of the condition of women (cf. Kuhn, 1989)?

On these and many other urgent questions it is crucial that feminists raise their voices, that is, at the precise point where conventional historical scholarship establishes its basic categories and definitions. Feminist historians need to take on the current debates about historical generalisation, interpretation and periodisation. They need to rewrite accepted historical accounts and show how historical scholarship reproduces views of the past which are male-centred, even though they claim to be universally valid. This is to engage in a largely (though not solely) theoretical debate.

In addition, I was forced by problematic trends within contemporary women's studies to reflect both on the relationship between 'feminism' and 'historical scholarship' and also that between 'theory' and 'practice'. Judith Bennett's 1989 article points to both a decline in the influence of history within women's studies, and a depoliticisation of women's history (Bennett, 1989, p. 256), and, while women's studies is more highly institutionalised in the USA than in Germany, her analysis also applies to the situation there. In Britain as well as in Germany women's history was powered by the political impetus of the women's movement and by new approaches developing in social history (Rendall, 1991). Both these influences have created certain problems, and as far as developments in Germany are concerned I particularly want to question four tendencies.

First, the concept of 'women's history' is becoming displaced by those of 'gender history' or 'gender in history', as is happening in the USA (Bennett, 1989, p. 258). Gisela Bock has offered some convincing arguments for the term 'gender history' as applied to the *content* of historical study: 'It is not less problematic to separate the history of women from history in general than to separate the history of men – and even more so truly general history – from the history of women' (Bock, 1989, p. 10). According to Bock the conceptualisation of women as a socio-cultural group has been the most important of all efforts to link the history of one half of humanity to the other, and both to history in general. The introduction of 'gender' as a fundamental category of social, cultural, historical reality and change has meant that 'men also become visible as sexual beings, so that the new perspective turns out to be not just about women and women's issues but about all historical issues' (Bock, 1989, p. 10). Thus, 'gender history' is the term which refers to context-specific and context-dependent thinking about relations both between and within the sexes (Flax, 1986, p. 199). 'Gender', as an analytic tool, helps us to discover neglected

areas of history and the gender-blindness of traditional historiography (Bock, 1989, p. 11).

Unfortunately the meaning of this concept can also be manipulated and distorted. 'Women's history' can be renamed 'gender history' in order to dissolve the specific experiences of women within a concept which appears to be more universal. Used like this within established (male-dominated) practice, the term 'gender history' blunts the challenge of women's history by developing a kind of neutral discourse about gender in order to eliminate those specific aspects of a feminist approach which are uncomfortable for men — i.e. its critique of male supremacy in all its material and symbolic forms, and of the structural subordination of women through male agency. This tendency is obvious in Germany, although the confrontation between 'gender history' and 'women's history' is not at the same level there as in the USA (Hassauer, 1990, pp. 70ff).

A second tendency is for women's history to become a discipline focused on research and publication rather than critical analysis. Most existing studies focus on the activities and experiences of women and men without examining the male-centred paradigms of social history. Women are seen as a new topic for academic study, or a resource for exploitation, according to the perceived opportunities in the academic marketplace, as has also happened with histories of labour, mentalities, poverty or spirituality. Thus the challenging aim of women's history, to eradicate misogynistic and androcentric traditions of historical and academic thought, disappears.

The third tendency, which is linked to these two developments, is an interesting process of detheoreticisation. In current discussions on women's history I hear it argued that it is more important to produce in-depth case studies than to waste time on theoretical issues (although of course other views are also expressed). Yet historians working in that way reproduce the old assumption that any 'scientific' definition of historical knowledge depends exclusively on the use of 'proper' historical methods, that is, the evaluation of sources. This view was put forward by leading historians of the nineteenth-century 'scientific' school, whose present-day successors uphold German traditions of historicism, positivism and philistinism created in that era. The tragic irony is that such historians are actually rapidly retreating from newer approaches and widely accepted standards of historical research and writing that have been developed in this century by historians influenced by writers such as Michel Foucault, Hayden White, Roger Chartier and others (Rüsen, 1990).

The fourth tendency is for a growing separation between the academic practice of women's history and the interest of the women's movement in women's history (Bennett, 1989, p. 255). In the recent past these two

approaches to women's history stimulated each other even if there were also disagreements, whereas today some of those involved in the field stress the primacy of the 'academic' form and its greater 'objectivity' as against the 'ideological' character of other forms. Women based in academic women's history watch over who is invited to take part in international gatherings such as the German section of the International Federation for Research into Women's History – that is, who is regarded as a 'proper' historian. Of course, this attitude is primarily influenced by the lack of academic jobs and by variations in the promotion and establishment of women's history in different German regions and institutions. However, it also creates a contradictory situation in which, on the one hand, men and women still need to fight for the academic recognition of women's studies and gender studies, while, on the other hand, those who have achieved this may find themselves subject to the need for voluntary self-restraint, and so depoliticised. In sum, the price for professional and institutional acceptance is an increasing loss of political impact (Kuhn, 1989, p. 81).

It was my experiences of research into women's history, of established academic conventions, and of women's discourses on the character of women's history, which set my investigation going. Increasingly I realised the need for thorough consideration of the connection between our current need to establish a historical context for women and our lack of a tradition in women's history. There is a further need to examine historical knowledge, both as an element in ordinary life and as an academic discipline. We need ongoing self-reflection in order to avoid a dangerous backward move in our ideas, our practice and our outlook.

Readers should be aware of my own respectful but critical attitude to academic women's studies, despite my professional involvement in the discipline known as history. I value rational and scholarly methods in so far as they enable me to organise and express my arguments, while at the same time maintaining my participation in the new social movements. It follows that my intellectual interests and activities are also influenced by my experience in the women's movement, as well as by the ordinary concerns of my daily life.

Questions of 'objectivity' and 'subjectivity' or of 'validity', 'truth' and 'interests' are affected by the specific situations under study, a problem which is central to the self-comprehension of social scientists generally and for the development of historical scholarship in particular. A feminist approach raises this issue in its own new and distinctive way and needs informed and up-to-date answers. It is on this basis that I have chosen to continue climbing the rough rockface of meta-theoretical thought, and to confront the sacrosanct claims of history to be a scientific discipline.

My argument is that partisanship – in the sense of placing scholarship within actual social reality – and objectivity – in the sense of the need for scholarship to be professionally valid – are not mutually exclusive. Historical knowledge can be based on the following functionally related fundamentals: interests, concepts, methods, narratives, functions in orienting human beings in time. The first and last of these are part of the practice of living, while the others are part of the professional practice of history as a discipline. This meta-theoretical model is derived from that of the German historian, Jörn Rüsen (Rüsen, 1986, p. 29). He sees history as a synthesis of (1) human interests in the past; (2) people's ideas about past experience; (3) methods of empirical research; (4) forms of presentation of the past; and (5) the role of historical knowledge in orienting human beings in time. He takes it for granted that there is a functional relation between people's need to orient themselves in the world and the need of an academic discipline to validate itself, and a similar link between people's desire to locate themselves in time and the need for scholarly standards. Such links are very important for the construction of a feminist view of history that goes beyond the old hierarchical distinction between life and scholarship. His model is a useful attempt to develop a specific concept of historical thought, and, by systematic discussion of guidelines and essentials for historical understanding, his approach opens up the possibility of a feminist treatment both of history as 'that which has been done' and of history as 'the account of that which has been done'.

Both male and female critics may accuse me of considerable inconsistency in making use of concepts drawn from a male historian, working within the recognised male-dominated tradition of historical writing, to reconstruct historical thinking, study and awareness in non-androcentric feminist forms. How can one justify robbing Peter to pay Paul(a)! However, there are some persuasive arguments for my use of Rüsen's model. A leading contributor to discussions on history and theory in Germany, Rüsen is one of the few male historians who are involved in feminist discussions about the relationship between partisanship and objectivity within historical scholarship (Rüsen, 1988). In my view we should pay attention to a sophisticated position, like his, which is committed to the 'human qualities of human beings in a changing world and time' (Rüsen, 1986, p. 52), and also includes women in its view both of the past and of the present. Rüsen establishes key elements of historical awareness, understanding, research and presentation in a dynamic structure which is, to use Thomas Kuhn's terms, a 'disciplinary matrix' (Rüsen, 1986, p. 25, note 11). This matrix offers the possibility of enabling us to define feminist positions on his-

torical scholarship and discuss the connections between life and scholarly knowledge.

Nonetheless, I do not agree with every aspect of Rüsen's meta-theory. I reject his concept of 'identity' and am critical of a matrix, such as this, which intentionally overlooks the problem of power. Each time he introduces important topics he forecloses discussion and prejudges the issue by his facile manner of taking crucial questions for granted. For example, he states that no human being can live without imagining/imaging things which are not 'given', without any explanation of the meaning of the term 'given' (Munz, 1985, pp. 93f). Last, but not least, he has an astonishingly naive, childlike faith in the convincing power of 'good argument'. Still, *critical* use of Rüsen's model can help establish links between the intellectual dimension of feminist engagement with historical scholarship, the social character of feminist involvement in daily life in the present, and its historical position in changes over time. The concept of a matrix enables us to make connections, distinctions and explanations of these different aspects of the 'feminist perspective' on history. My analysis will consider in turn the practical, methodological and theoretical dimensions of this perspective.[2]

## PRACTICAL ELEMENTS OF THE FEMINIST PERSPECTIVE

In this section I will suggest the position and direction to be taken by a feminist perspective, conceptualising the past as a mirror of experiences revealing and reflecting present-day concerns, and features of society in the present (Rüsen, 1989, p. 39). My definitions will be based solely on the accepted concepts of historical scholarship, so that everyone is clear that feminist views are an integral part of contemporary historical thought and debate. These definitions will give to the actual experiences of women and femaleness, and of men and manliness, a temporal location, a position from which purposeful action can make use of historical memory (awareness) (Kocka, 1986). In modern thought the concept of 'history' is rooted in our human existence, and human demands on history arise from our need to situate ourselves in a changing world. Reclaiming this notion of human history for women, I would argue specifically that women *make* history, since they act intentionally in the world, that women *experience* history, because they live through temporal changes, and that women *need* history in order to satisfy the particular demands they have on androcentric and

misogynistic societies. This argument invalidates the traditional universalist claims that man is the measure of all things and that this does not change over time. Precisely because established tradition offers no useful starting point for women in history, women need to respond to the tradition with their own self-aware perspective on the past.[3]

I could define women as human beings by using existing, recognised historical concepts but, as critics like Friederike Hassauer have shown, in fact women are not part of the discourse on mankind/humanity established in eighteenth-century thought. The 'anthropological' tradition begun then, established the paradigm of a 'science of man' around a set of male-defined qualities which made 'man' the only representative of 'mankind', the subject of study which leaves women as objects. As I reclaim the category 'human being' for women, I see the double standard of historical scholarship which claims to speak for humans in general but actually concentrates on a male-centred model of humanity. Obviously men are defined as human beings, but it has not yet been really accepted that women also represent humanity (Hassauer, 1988, p. 281). Thus, in formulating the egalitarian demand that women be seen as human beings, the limitations of the apparently universalist historical approach are burst apart. Friederike Hassauer calls this demand a 'process of using gender-specific analysis to break down generalisation' (Hassauer, 1988, p. 281). In my view this process offers a constructive method to feminist critics of existing ideas and practices.

Thus we can establish a positive basis for feminist perspectives by use of the concept of the female human being. Although this involves using arguments which subvert established theory, it has neither moral nor political dimensions, that is, it draws on no arguments or themes from outside the historical discipline itself. Thus, this critique must be taken seriously within the discipline, since it would now be impossible to dismiss feminist arguments without explicitly and conservatively rejecting the insights of modern historical scholarship.

## METHODOLOGICAL ELEMENTS OF THE FEMINIST PERSPECTIVE

I now wish to turn to the specific rules and methods suggested by a feminist view of history, emphasising the relationship between the concerns and interests of historians and the sources they use. The central question is how

a feminist perspective can be valid both in terms of women's experiences and interests, past and present, and in terms of the scholarly, scientific character of historical research and learning. Although much of the stimulus to historical awareness comes from ideas and interests arising from our present circumstances, we need to address the *academic* character of a feminist perspective if feminist concerns with the past are to be linked to concepts of scholarly value.

This argument must not be misunderstood. I would explicitly reject the view that a feminist perspective implies the use of a particular methodology. A feminist perspective uses all the methods and approaches available to historians, including biography, cultural, economic, anthropological and political history, the history of mentalities and ideas, oral history, and the established methods of social history such as historical demography, mobility studies and family history (Bock, 1989, p. 8). It draws on anthropology, psychology, archaeology and philosophy as well as on literary and cultural studies, as illustrated in the work of Natalie Zemon Davis (Davis, 1976, 1987; Chartier, 1986, as noted in Hassauer, 1988, p. 269). The original distinctive methodological character of the feminist perspective lies not in any of its methods but in its questions and viewpoint. 'As in the rest of history, questions and perspectives are not neutral and their choice is based on preliminary conscious or unconscious political or theoretical decisions' (Bock, 1989, p. 8). The originality of the feminist perspective lies in the particular links made by feminist historians between their contemporary views of the human past and the historical evidence provided by sources. My exposition of the methodological essentials of a feminist approach to history will focus on three key principles.

## (a)  Partisanship and Objectivity

On the one hand, in German academic women's history 'gender' is accepted as an analytical category:

> When we speak of gender as a 'category' in this context, the term refers to an intellectual construct, a way of studying peoples, an analytic tool that helps us to discover neglected areas of history. It is a conceptual form of socio-cultural enquiry that challenges the sex-blindness of traditional historiography. It is important to stress that the category gender is, and must be perceived as context-specific and context-dependent.
>
> (Bock, 1989, p. 11)

Unfortunately this development has also produced the curious result that the validity of a gendered approach to history depends on the extent to which feminist engagement disappears.

On the other hand, feminist discussions of women's history have been dominated up to now by the methodological principle of partisanship. In this discussion the definition of 'validity' is based on a more-or-less typical readiness of women to identify with suffering and oppression and to take a supportive partisan view of the oppressed. Here, the concept of truth is linked to the idea of a specific female access to that truth, and the concept of valid knowledge is based on the female experience of misogyny shared by women historians and women in the past. Its value is measured by the extent to which it comprehends society as a totality of exploitation and suppression and contributes to real change in society (e.g., Mies, 1984; Göttner-Abendroth, 1983; Nagl-Docekal, 1991). Once again we should note that women's studies are not defined solely within an academic discipline, but are also often formed outside the academy in projects relevant to the women's movement.

I must stress again that, while these principles are understandably influenced by the political claims of the women's movement, they are of no use as methodological concepts. They take 'female consciousness' or 'female solidarity', like notions of 'oppression' and of women as victims, for granted, when in fact they need examination as historical constructs. Such principles treat present-day experiences of oppression as though they were fixed and universal, and use concepts of 'objectivity' and 'partisanship' in which women are seen only as victims. This approach and fixed view produces a reverse sexism which asserts that only women with a 'proper' sense of oppression will produce 'valid' knowledge. Such views ignore uncomfortable facts which cannot be fitted into the self-image of modern feminism without causing problems, and make it impossible to address questions such as the character of and reasons for women's active participation in totalitarian regimes. With such concepts, progress in feminist history is unlikely.

In my view, the subjectivity of historians is a necessary source for and link to the questions they ask, and in that sense partisanship is one constitutive element of historical scholarship. People's experiences as women and with women, or as men and with men, shape their views of the world and develop into perspectives which influence their involvement in the present, their engagement with the past and their approach to the future. In this way subjectivity and partisanship affect the assumptions, forms, processes and content of historical knowledge and research. As I see it, partisan and

objective elements are both present in historical scholarship and under-
standing, each requiring the other in order to exist.

My concern is not just to point out the regular recurrence of subjective
elements in historical works, but to show how this can be part of a feminist
objectivity, by which I mean, not a 'correct' ( = female) identification with
past evidence or experience, but an ongoing complex self-reflexivity. If
feminist values, experiences and ideas are to generate useful historical
methods, I would suggest that we need a four-fold form of reflection; first,
reflection about ourselves; secondly, reflection about historical material;
thirdly, reflection about the conceptual or political choices which shape
one's way of thinking about history; fourthly, consideration of how far
the histories we write enable us to focus on, and end, the problems of
patriarchy.

This process establishes a new and continuing theme for historians, that
which concerns their relationships to their material. We need to doubt,
question and distance ourselves from concepts or definitions in order to test
and examine them closely. This approach involves feminist historians not in
focusing on the negative position of women as a suffering collective sub-
ject, but in a readiness to analyse the norms, ideas and experiences which
shape our thinking, whether consciously or unconsciously. The point of this
process is that it offers a method whereby gender is consciously recognised
as a key factor in historical understanding; and the feminist character of
this method stems from its relationship to past and present experiences
of patriarchy and efforts to change it.

**(b) Distance and Affinity**

Another methodological issue important to a feminist perspective on his-
tory concerns the relationship of feminist historians to their subject matter
(close or distant?). Many feminists insist on the fundamentally *un*historical
assumption that women's subordination has been continuous and unchang-
ing, and that, therefore, they share a common framework of oppression with
the women in the past whom they study. Such a view is relevant at best to
certain limited areas of the human past and collapses as soon as we encoun-
ter the 'otherness' of any history which has no direct connection to the
present. Can we, for example, research the fall of the Roman Empire or the
visions of Teresa of Avila using this approach? (Veyne, 1986, p. 135). Even
if Christine de Pizan, the writer I discussed earlier, might, like myself, have
a critique of the misogyny and androcentrism of her culture and its ideas,
we have little else in common. How would she understand or approve of

my living, at the age of 30, with a man who is neither husband, brother, father or uncle?

I reject the view that continuity and affinity are of primary importance, and argue that concepts of unity or uniformity among women are illusory, and that there is no universal agreed basis for understanding (Veyne, 1986, p. 135). Instead, I would want to use paradigms from recent work in anthropology, psychoanalysis and archaeology to develop the concepts of 'difference', 'distance', and 'strangeness' (Geertz, 1983; Davis, 1976; Medick, 1984; Becker-Schmidt, 1984; Chartier, 1989; Hassauer, 1990; Certeau, 1991). What is needed is a sense of the constant interaction of similar and contrasting experiences: between 'like' and 'unlike' and between 'self' and 'other' in the relationship between the past and the present. This requires a lasting modification of our favourite forms of historical understanding and judgement. A feminist perspective on history demands 'spirals' of interpretation, which in Boon's phrase are 'bumpy and uneven', hunting difference/differences like an Agatha Christie detective (Boon, 1983, p. 234; Ginzburg, 1983, p. 61). How would we conceive such 'spirals of interpretation'? First, we need to establish the strange, untypical aspects of any historical problem or interpretation and reject any unquestioned assumptions before they affect our whole way of thinking. We also need to reject the dualistic thinking which works in terms of 'yes/no' and 'either/or'. As far as gender is concerned, we need to resist the assumptions which flow from accepting 'man' or 'woman' as fixed substantive categories. This is a normal practice in everyday speech, which, although it does not need to be rejected, needs to be self-consciously treated if gender is to be a useful historical category or framework (Hassauer, 1990, p. 68).

In general we can use self-reflection to grasp our own bias, resistance and fears, which deeply influence our understanding of history. We need to recognise both the hidden aspects of our present selves, which emerge when we study others in the past, and also 'the other', as a distinctive part of that hidden area. This is particularly important since it is not a matter of simply including such elements in our enlightened self-awareness; our contact with difference does not make it disappear.

I see this methodological emphasis on difference as essential for the three main forms of communication used by historians; the first is a process of self-reflection, which regularly re-assesses the implications of our ideas, values, norms and choices in the light of our encounters with the past; the second is a form of communication between the various views of different historians, which are discussed, influence each other and collectively enlarge our perspectives on the past; the third is the discourse between his-

torians and human beings in the past, using both their explicit and implicit statements. We must not allow ourselves to reduce the women and men of the past to mere expressions of our contemporary concerns, with present-day aspirations and assumptions.

## (c)  Complexity and Interaction

The third methodological theme in a feminist history which I wish to emphasise concerns complexity and interdependence.[4] We need to stop looking for one one place to locate women and their historical experiences, and perhaps to follow French feminist arguments, which have rejected 'misogyny' as the only possible explanation for women's segregation in and separation from the mainstream of historical scholarship (Perrot, 1989b, p. 25). We should address the contradictions and grey areas, giving them more attention than facts that seem more glaringly obvious, which means speaking in terms of 'more' and 'less' rather than absolutes, and engaging *with* our historical subjects rather than talking *about* them. We need to conceptualise relations within and between the sexes, relations between subjective and objective dimensions of social experience, between manifest and latent issues, and between planned and unplanned historical processes, whether political, economic or cultural. Similarly, we need to look at the interactions of different forms of power based in gender, race, class or religion (Perrot, 1989a, p. 225), just as we should explore relationships between social engagement and social distance (Elias, 1983) or different time frameworks and rates of change in time (Braudel, 1977); not to mention the complex links and tensions between our present-day search for direction or coherence in our understanding, and the discourses of the past, or of course those between material and cultural constructs. And so on . . .

What has been sketched out here suggests that it is methodologically crucial to incorporate in our feminist historical work an awareness of the interactions and contradictions among the complex elements both of past experience and of our own perceptions of that experience. For this purpose, concepts like Foucault's notions of 'archaeologies of knowledge', of multipolar interaction and fusion, and of 'immanent' approaches to historical meaning creating an 'inventory of open routes' (Foucault, 1988, pp. 15, 61), may help us to create our historical study, analysis and writing.

## THEORETICAL ELEMENTS OF A FEMINIST PERSPECTIVE ON HISTORY

This section will offer my own view of the theoretical components of a feminist approach to historical work. There are numerous writings which have established gender as a category in feminist thought. However, I find such writings open to serious criticism in that they deal with gender as an object of feminist thought, whereas I would consider that if gender is really to fulfil a role as a category of historical analysis it must also be used as a means for historians to position themselves (individually and collectively) in time. Not only must the concept of gender be made a key element in historical narrative, but it must also form part of the epistemological relationship between researching subjects (i.e. historians) and researched objects (i.e. historical phenomena). If it is to meet the criteria for a historical category, gender should be recognised as a guiding influence on human actions in the past and also be present at every level of historians' thought, research, interpretation and presentation.

From its inception historical scholarship has treated gender relations as an ontological problem, and, as such, not an issue for which historians need to take responsibility. There is, we could say, no tradition of historical practice which recognises gender as a key element which shapes historical research and writing. By contrast, I want to show how the concept of gender can help us to transform the unfamiliar experiences of human beings as they change through time into 'history', and to organise the topics we research and write about. In order to give a more concrete character to the argument, I shall use an autobiographical approach to theoretical activity.[5]

My starting point was the doubts and questions raised by my interest in meta-theory. Other people asked why I wanted to explore such an issue (rather than working on a more typical subject such as medieval book-ownership, on which I had done some work earlier). I myself began to worry that it was too ambitious a project, and to question my own motives for engaging with it. I tended to keep quiet about my feminist views of history when talking to male colleagues for fear they might think I was anti-men, which created real contradictions between my life as a feminist and my thinking as a historian, and between my academic life and my feminist ideas. As I thought about these problems I became increasingly aware that my fears arose from my socialisation as a female, and that I was involved in complex inconsistencies as a historian, as well as at the personal and social levels.

This immediately plunged me into a mass of controversial and complex issues which stimulated me to ask the kinds of questions about gender

posed by Jane Flax. What is gender? How does it relate to anatomical sexual differences? How is it constructed and sustained in the life of an individual, and, more generally, as social experience over time? Does gender shape historical narratives? How does it relate to other kinds of social relations? Does it have one history or many and what causes it to change over time? What are the relationships between gender, sexuality and individual identity, or between heterosexuality, homosexuality and gender? Are there only two genders? And so on . . . (Flax, 1986, p. 198).

As I began to explore the historical aspects of my own experience and to look for affirmative historical evidence I was disappointed. Of course there were women in history but accounts of their experiences have been shaped by male-centred value systems which define the female as static/passive/natural in opposition to the male as dynamic/active/historical (Lerner, 1977, p. xxi). I discovered many representations of women and of femininity but very few presentations of female experiences in the past as the experiences of actual women. At the same time I realised that the term 'gender' refers to a complex set of relations and processes and to social constructs which are both cultural and material. I saw that the history of women is both closely linked to the history of men and at the same time crucially distinct from it. It follows that we need at least three kinds of historical narrative, 'hers', 'his' and 'ours'. However, until recently, 'her' story has been told in the same way as 'his'.

I began to examine both symbolic and actual elements of gender, sexuality and reproduction in specific social contexts. By focusing on the complex configuration of the many traits of gender, I came to see that people's relations to their own sex and to the other sex, and conflicts arising from such relations, would shape both the individual and the collective experience of women and men. This can be illustrated historically from, say, the writing of Christine de Pizan.

> Ah God, why did you not cause me to be born into the world as one of the masculine sex, so that my inclinations would all be towards serving you better, and so that I should not err in anything and would be of such great perfection as a man is said to be? But since your benevolence has not been so extended towards me, then pardon my negligence in your service, Lord God, and do not be displeased, for the servant who receives fewer gifts from his Lord is less beholden in his service.
>
> (Christine de Pizan, *The Book of the City of Ladies*)[6]

Such relationships inform political culture, traditions and institutions (Negt and Kluge, 1983, p. 314) and ideas on law and rationality, as well as

people's ways of appropriating past, present and future (Mead, 1985). Thus, both the material and symbolic organisation of gender relations constitute important points of structure and change in any society. In this sense they are as important as class relations and differences, since processes of division of labour are also always processes in which gender is involved. Gender relations produce specific forms of differentiation and hierarchy which have been insufficiently explored up to now. These relations will differ in every society according to its particular structure, which means that actual forms of gender relations vary over space and time as well as in their connections to class or race relations (Ortner and Whitehead, 1981, pp. 1–27). Thus they have a crucial influence on social and historical change, and indeed one could rewrite the *Communist Manifesto* and claim that all history is the history of gender.

The centrality of gender to actual historical processes stands in continuing and apparently unresolvable contradiction to our own society's dominant ideological construction of gender as a marginal issue. Such a marginalising view prevents us recognising how far gender relations in fact shape changing reality, even though we actually deal with these relations every day. How is it, then, that we cannot recognise their importance in a historical context?

Every society constructs its own norms for talking, or not talking, about gender, sexuality and reproduction, which in modern Western society takes the specific form of treating gender relations as private, intimate and trivial. Gender relations enter the social context only after being distorted by having discussion of them confined within social restrictions. They are treated not as an essential element of social and historical structures and processes but as no more than an issue for individuals, which is exactly why gender becomes so hard to establish as a major historical category. This ideological, but very real, marginalisation is one of the most basic biases in modern, bourgeois, androcentric societies and helps to maintain the hierarchy of power between women and men.

In its traditional form history has been a form of knowledge which legitimises existing conditions by using its definitions of what is or is not important in the historical process to conceal or misrepresent aspects of reality, and in particular to deny gender relations any central role in historical change. This tradition of removing gender as a significant ingredient of historical change flows logically from the self-image of androcentric societies, and forms a deeply rooted essential bias which needs to be maintained in order to ensure the continuance of established power relationships.

Historical thought and practice treat gender relations as a problem of ontology, and therefore not their concern.[7] Historians deal with topics

which they, apparently, see as more 'important', which in the German context means the topic of class. An eminent German historian like Hans-Jürgen Puhle can argue that historical scholarship ought to concentrate on those criteria of power and influence which define social values, without providing any evidence that gender differences in society carry less weight in the historical process than others (Puhle, 1981, p. 388). Such arguments play a role in legitimising androcentrism and confirm the view that history is a male-dominated discipline which manipulates its interpretations in such a way as to confirm and preserve male supremacy. One key epistemological strategy for feminist historians involves recognising, confronting and transforming this dialectic tension between the centrality of gender relations in history and their marginalisation by historians. Fundamental to that approach are the experiences of female historians in our androcentric bourgeois society. Our interests as historians arise from the real importance of gender in our daily lives and its lack of importance in historical discourse.

These gender-based questions of mine reveal the outdated character of traditional historical interpretation, analysis and writing. Returning to historians' conventional assumptions about 'power', we can see their inadequacy as explanatory tools in, for example, an analysis of women's massive achievements during and after the Second World War; since we all know that the growth in women's waged work and other responsibilities in that period was not accompanied by changes in their social status or in the gendered division of power, we cannot explain the processes involved in terms of 'women's power'. Traditional definitions hinder rather than help us to construct a satisfactory interpretation (Kuhn, 1989, pp. 35–46). Perhaps, like some French feminist historians, we can use a concept of diverse, informal, plural forms of power(s) to make sense of the curious dual character of the condition of women in wartime and postwar Europe (Perrot, 1989a, p. 225). In doing this, we problematise the dichotomy 'power/powerlessness' as traditionally used in social science or political economy, while our analysis of the duality of that historic experience also logically problematises the notion of 'progress' which is so central to modern historical scholarship.

This suggests that a feminist perspective on history needs new and clearly defined epistemological approaches if it is to remove androcentric biases in historical scholarship and reveal the gendered experiences of men and women which have been concealed in existing historiography. We need to develop an approach which recognises the gender-specific implications and sexist distortions in the accepted ways of seeing and evaluating the world. Such approaches will enable us to make sense of our empirical knowledge about the human past as experienced by men and women in

terms of both their differing specificities and their interdependence. The
project can only succeed if women's history is publicly recognised as the
history of women *as women* (that is, as gendered subjects) (Kelly-Gadol,
1976, p. 809).

Women's history, as 'history of their own', is the terrain on which the
varied individual and collective voices of women can be heard, where we
find material about hidden memories and traditions, and where knowledge
about how women act and are acted upon becomes visible. The term
'history of their own' explicitly defines women as historical subjects, and
emphasises that 'women' and 'men' are two distinct categories, neither of
which can represent the whole of humanity and its experiences of temporal
change, or indeed the whole historical process. Neither of these two hier-
archically defined concepts of (unequal) human beings can serve as model
or paradigm for the other, and all gender characteristics need separate
treatment in terms both of their distinctive aspects and of their interdepend-
ence with other characteristics. The basic concept of 'gender' enables us
to present 'history' as including both histories created by and belonging to
women and those created by and belonging to men. Like Friederike
Hassauer, I see this concept as 'an archaeology of historical anthropology,
an archaeology which looks for the historic repertoires of gender roles and
gender specificities which shape social production and social practice'
(Hassauer, 1988, p. 269).

If we agree on the need for a historiography which, in contrast to
traditional practice, expresses more clearly the specific experiences of
women and men, we also need to ask whether the concept of gender works
in historical narrative, and, if so, whether it produces more convincing
historical accounts. Some examples may illustrate what the possibilities are;
Natalie Zemon Davis's book *Fiction in the Archives: Pardon Tales and
their Tellers in Sixteenth-Century France*, shows how female narrators
organised the stories they used, to seek mercy from the courts, in a different
way from male narrators (Davis, 1987); returning to my own favourite case
Christine de Pizan, I can show how she relies on her gendered experience
as a source of knowledge which gives her writing a genuine feminine
character (Schmidt, 1987); another German historian, Lutz Niethammer, in
his book *Post histoire: Ist die Geschichte zu Ende?* is able to convey his
awareness as a male author and to analyse existing discussions of post-
modernism and post-history as a discourse of male authorship, male inter-
ests and male problems; last, but not least, his conclusions are presented in
a sophisticated way for both a female and a male readership who are
concerned with these issues (Niethammer, 1989). These examples suggest
that it is by keeping hold of gendered experiences and gendered narratives

that we can create genuinely human forms of historical writing, theory and method, or relevant directions for everyday life.

This conclusion itself raises new and complex theoretical questions about feminist concepts of communication, of narrative, of gendered discourse, and of memory, for which there is unfortunately insufficient space here to develop a discussion.

CONCLUSION

I hope that my discussion of the practical, methodological and theoretical aspects of a feminist perspective on history has demonstrated and clarified some of the key characteristics of that perspective. My emphasis on continuing and multi-sided self-reflection may be criticised as a sketchy restatement of an old accepted truth about the essentials of scholarly thought, but it has been my intention to reshape that accepted view by giving it the feminist dimension which is needed if its claims to rationality are to be sustained. I also want to revitalise the theoretical discussions which are needed if feminist thought in general (not just on history) is to respond to current intellectual and cultural developments. More specifically, I hope that my arguments that gender shapes, and is shaped by, both social and historical processes and by the thought, research, opinions, interests and writings of historians, will contribute to the final acceptance of the concept of gender as a central category in German historical scholarship.

NOTES

This text is a revised version of a paper given at a conference on 'Research, Concepts and Methods in Women's Studies' organised by York University Centre for Women's Studies with the Goethe-Institut York, at York University in June 1990. I would like to thank Vera Bagaliantz, Mary Maynard and Joanna de Groot for their invitation, Vera Bagaliantz of the Goethe Institut who made the contact possible and Ulla Bock who recommended me to the Goethe-Institut. I would also like to thank Benjamin Goldmann for help with translation and for his important comments on my argument.

1.    On the origins, meanings and traditions of 'feminism', see Offen, 1988a, b; Pusch, 1983; Studer, 1989; Nagl-Docekal, 1991.
2.    Unfortunately there is insufficient space here to discuss the linguistic structures of historical writing from a feminist viewpoint and ask if there are specific narrative forms of prose.

3.   I would prefer to use the German term, 'Sinnhaftigkeit', which is difficult to translate into English.
4.   My concept draws on the notion of 'configuration' defined by the sociologist Norbert Elias (Elias, 1983).
5.   I was inspired to this style of theorising and presenting the issue by the book *Geschlechtertrennung–Geschlechterdifferenz* (Becker-Schmidt and Knapp, 1987), which uses the term 'social learning', which I have adapted to 'historical learning'.
6.   The editors are grateful to Karen Hodder, of the Centre for Medieval Studies at the University of York, for the translation.
7.   See, for example, the work of Reinhard Koselleck, an acknowledged German expert on 'theoretical–historical anthropology', which looks for meta-historical (i.e. universal) conditions for being human, and gives gender relations no significance at all. Yet sex is a precondition for human reproduction, which is one of the meta-historical features of human identity. In principle, Koselleck's system deals with three directions of change – *temporal*, i.e., from earlier to later; *spatial*, i.e., inside and outside; and *hierarchical*, i.e., up and down social strata – although the dualistic bent of his argument might force the inclusion, also, of the relation between male and female (Koselleck, 1989, p. 658).

## REFERENCES

Becker-Schmidt, Regina (1984), 'Probleme einer Feministischen Theorie und Empirie in den Sozialwissenschaften', in Zentraleinrichtung zur Förderung von Frauenforschung und Frauenstudien an der FU Berlin (ed.), *Methoden in der Frauenforschung* (Frankfurt-am-Main: FU Berlin).

Becker-Schmidt, Regina, and Gudrun Alexi Knapp (1987), *Geschlechtertrennung– Geschlechterdifferenz* (Bonn: Neue Gesellschaft/Librif).

Bennett, Judith M. (1989), 'Feminism and History', in *Gender and History*, vol. 1, no. 3, pp. 251–72.

Bock, Gisela (1989), 'Women's History and Gender History: Aspects of an International Debate', in *Gender and History*, vol. 1, no. 1, pp. 7–30.

Boon, James A. (1983), *Other Tribes, Other Scribes: Symbolic Anthropology in the Comparative Study of Cultures, Histories, Religions and Texts* (Cambridge: Cambridge University Press).

Braudel, Fernand (1977), 'Geschichte und Socialwissenschaften. Die longue durée', in Marc Bloch, Fernand Braudel, Lucien Febvre et al. (eds), *Schrift und Materie der Geschichte. Vorschläge zur Systematischen Aneignung Historischer Prozesse* (Frankfurt-am-Main: Suhrkamp).

Certeau, Michel (1991), *Das Schreiben der Geschichte* (Frankfurt/New York: Campus).

Chartier, Roger (1986), 'Intellektuelle Geschichte und Geschichte der Mentalitäten', Part 1, in *Freibeuter*, vol. 29, pp. 22–37; Part II, in *Freibeuter*, vol. 30, pp. 21–35.

Chartier, Roger (1989), *Die Unvollendete Verganenheit* (Berlin: dtv Allg. Reihe).

Davis Natalïe Zemon (1976), 'Women's History in Transition: The European Case', *Feminist Studies*, vol. 3 (Spring/Summer 1976) pp. 83–103.

Davis, Natalïe Zemon (1987), *Fiction in the Archives: Pardon Tales and their Tellers in Sixteenth-Century France* (Stanford, Calif.: Stanford University Press).

Elias, Norbert (1983), *Engagement und Distanzierung* (Frankfurt-am-Main: Suhrkamp).

Flax, Jane (1986), 'Gender as a Problem: In and For Feminist Theory', *Amerikastudien/American Studies*, no. 31, pp. 193–213.

Foucault, Michel (1988), *Archäologie des Wissens* (Frankfurt-am-Main: Suhrkamp).

Geertz, Cliffort (1983), *Dichte Beschreibung: Beiträge zum Verstehen Kultureller Systeme* (Frankfurt-am-Main: Suhrkamp).

Ginzburg, Carlo (1983), *Spurensicherung* (Berlin: dtv Allg. Reihe).

Göttner-Abendroth, Heide (1983), 'Wissenschaftstheoretische Positionen in der Frauenforschung', in Halina Bendkowski and Brigitte Weisshaupt (eds), *Was Philosophinnen Denken. Eine Dokumentation* (Zurich: Ammann).

Hassauer, Friederike (1988), 'Gleichberechtigung und Guillotine: Olyme de Gouges und die Franzosische Menschenrechtserklärung der Französischen Revolution', in Ursula A. J. Becher and Jörn Rüsen (eds), *Weiblichkeit in Geschichtlicher Perspektive* (Frankfurt-am-Main: Suhrkamp).

Hassauer, Friederike (1990), 'Grenzgänge. An den Rändern der Frauenforschung. Ein Gespräch mit Friederike Haussauer', in *Die Philosophin. Forum für Feministische Theorie und Philosophie*, vol. 1, no. 2 (October 1990) pp. 58–76.

Kelly-Gadol, Joan (1976), 'The Social Relations of the Sexes: Methodological Implications of Women's History', *Signs*, vol. 1, no. 1 (Summer 1976) pp. 809–23.

Kelly-Gadol, Joan (1977), 'Did Women have a Renaissance?', in Renate Bridenthal and Claudia Koonz (eds), *Becoming Visible: Women in European History* (Boston: Houghton Mifflin).

Koch, Friedrich (1885), *Leben und Werke der Christine de Pizan* (Goslar: Ludwig Koch).

Kocka, Jürgen (1986), *Sozialgeschichte. Begriff – Entwicklung – Probleme* (Göttingen: Vandenhoeck-Ruprecht).

Koselleck, Reinhard (1989), 'Sprachwandel und Ereignisgeschichte', in *Merkur*, vol. 43, no. 8, pp. 657–73.

Kuhn, Annette (1983), 'Das Geschlecht – eine Historische Kategorie?', in Ilse Brehmer, Juliane Jacobi-Dittrich et al. (eds), *Frauen in der Geschichte, IV* (Düsseldorf: Patmos).

Kuhn, Annette (1989), 'Power and Powerlessness: Women after 1945', *German History*, vol. 7, no. 1, pp. 35–46.

Lerner, Gerda (1977), *The Female Experience: An American Documentary* (Indianapolis: Indianapolis University Press).

Marx, Karl and Friedrick Engels (1970), *Ausgewählte Werke in Sechs Banden, Band 1* (Frankfurt-am-Main: Verlag Marxistische Blätter).

Mead, Margaret (1985), *Mann und Weib: Das Verhältnis der Geschlechter in einer sich Wandelnden Welt* (Reinbeck: Rowohlt).

Medick, Hans (1984), ' "Missionare im Ruderboot"? Ethnologische Erkenntnisweisen als Herausforderung an die Sozialgeschichte', in *Geschichte und Gesellschaft*, vol. 10, pp. 295–319.

Mies, Maria (1984), 'Methodische Postulate zur Frauenforschung', in *Beiträge zur Feministischen Theorie und Praxis*, vol. 7, pp. 7–25.

Munz, Peter (1985), 'Rezension von "Historische Vernunft", by Jörn Rüsen', in *History and Theory*, vol. xxiv, no. 1, pp. 92–100.

Nagl-Docekal, Herta (1991), 'Feministische Geschichtswissenschaft ein Unverzichtbares Projekt', in *L'Homme ZFG*, vol. 1, no. 1, pp. 7–18.

Negt, Oskar and Alexander Kluge (1983), *Geschichte und Eigensinn* (Frankfurt-am-Main: Zweitausendeins).

Niethammer, Lutz (1989), *Posthistoire: Ist die Geschichte zu Ende?* (Reinbeck: Rowohlt).

Offen, Karen (1988a), 'Defining, Feminism: A Comparative Historical Approach', *Signs*, vol. 14 (Autumn 1988) pp. 119–57.

Offen, Karen (1988b), 'On the French Origin of the Words Feminism and Feminist', *Studies in Women's Literature*, vol. 7, no. 2, pp. 45–51.

Ortner, Sherry and Harriet Whitehead (1981), 'Introduction: Accounting for Sexual Meanings', in Sherry Ortner and Harriet Whitehead (eds), *Sexual Meanings: The Cultural Construction of Gender and Sexuality* (Cambridge: Cambridge University Press).

Perrot, Michelle (1989a), 'Die Frauen, die Macht und die Geschichte', in Alain Corbin, Arlette Farge, Michelle Perrot et al. (eds), *Geschlecht und Geschichte: Ist eine Weibliche Geschichtsschreibung Möglich?* (Frankfurt-am-Main: S. Fischer).

Perrot, Michelle (1989b), 'Vorwort', in Alain Corbin, Arlette Farge, Michelle Perrot et al. (eds), *Geschlecht und Geschichte: Ist eine Weibliche Geschichtsschreibung Möglich?* (Frankfurt-am-Main: S. Fischer).

Puhle, Hans-Jürgen (1981), 'Warum gibt es so Wenig Historikerinnen?', in *Geschichte und Gesellschaft*, pp. 374–93.

Pusch, Luise (1983), 'Zur Einleitung. Feminismus und Frauenbewegung – Versuch einer Begriffsklärung', in Luise Pusch, *Feminismus: Inspektion der Herrenkultur* (Frankfurt-am-Main: Suhrkamp).

Rendall, Jane (1991), 'Uneven Developments. Women's History, Feminist History and Gender History in Great Britain', in Ruth Roach Pierson, Karen Offen and Jane Rendall (eds), *Writing Women's History: International Perspectives* (London: Macmillan, and Indiana University Press).

Rüsen, Jörn (1986), *Rekonstruktion der Vergangenheit: Grundzüge einer Historik II: Die Prinzipien der Historischen Forschung* (Göttingen: Vandenhoeck and Ruprecht).

Rüsen, Jörn (1988), ' "Schöne" Parteilichkeit. Feminismus und Objektivität in der Geschichtswissenschaft', in Ursula A. J. Becher and Jörn Rüsen (eds), *Weiblichkeit in Geschichtlicher Perspektive* (Frankfurt-am-Main: Suhrkamp).

Rüsen, Jörn (1989), 'The Development of Narrative Competence in Historical Learning – An Ontogenetic Hypothesis Concerning Moral Consciousness', *History and Memory*, vol. 1, no. 1, pp. 35–59.

Rüsen, Jörn (1990), *Zeit und Sinn* (Frankfurt-am-Main: Fischer Taschenbuch).

Schmidt, Uta C. (1987), 'Christine de Pizan. Hatten Frauen eine Renaissance?', in *Geschichte Lernen*, vol. 1, no. 1, pp. 51–5.

Schmidt, Uta C. (1988), 'Wohin mit Unserer "Gemeinsamen" Betroffenheit', in Ursula A. J. Becher and Jörn Rüsen (eds), *Weiblichkeit in Geschichtlicher Perspektive* (Frankfurt-am-Main: Suhrkamp).

Schmidt, Uta C. (1989), 'Zwischen "Abscheu vor dem Paradies" und Suche nach dem "Absoluten": Historische Kategorien in der Feministischen Theorie und Praxis', *Beitrage zur Feministischen Theorie und Praxis*, vol. 12, no. 24, pp. 15–24.

Studer, Brigitte (1989), 'Das Geschlechterverhältnis in der Geschichtsschreibung und in der Geschichte', in *Feministische Studien*, no. 1, pp. 97–121.

Veyne, Paul (1986), 'Wörterbuch der Unterschiede: Über das Geschichtemachen', in Ulrich Rauliff (ed.), *Vom Umschreiben der Geschichte* (Berlin: Wagenbach).

Wagner-Hasel, Beate (1988), 'Das Private Wird Politisch: Die Perspektive "Geschlecht" in der Altertumswissenschaftt', in Ursula A. J. Becher and Jörn Rüsen (eds), *Weiblichkeit in Geschichtlicher Perspektive* (Frankfurt-am-Main: Suhrkamp).

# 6 Looking from the 'Other' Side: Is Cultural Relativism a Way Out?

FATMAGÜL BERKTAY

> The Orient is not as distant from us as we think.
>
> (Gerard de Nerval, *Journey to the Orient*)

At present, feminist theory is faced with a double challenge. As a form of critical consciousness, it is certainly not immune to the theoretical debates that have been going on for the last decade, and the problems raised by these debates lead to a process – healthy, I would say – of self-doubt and self-reflection. However uneasy this intellectual climate might be, it could still lead to a deeper understanding of gender relations, and to the development of strategies of communication and action which take into account difference and diversity between women.

In our post-Marxist and post-modernist era, where all evolutionist and totalising discourses, and even theory as such, are being called into question, feminist theory has to cope with the accusation that it is just another 'grand narrative'. This challenge, moreover, is not only posed from the 'outside': the internal development of feminist theory itself has lead to self-doubts that a growing awareness of differences between women has let in. For a long time feminism had focused, as the basis for a general theory, on the unity of women's experience and the 'common oppression' they suffered. Paradoxically, however, this emphasis has given rise to an increasing perception of the many differences between women, and this has shattered 'woman' as a unitary notion. It is no longer easy to believe in the cosy and comforting concept of 'sisterhood'.

The challenge of pluralism from the inside confronts feminism with the difficult task of developing theories and strategies which embrace difference and which can (still) provide a framework for the commensurability of cultures and values. It is true that we live in a culturally fragmented world, but also in a world which is One – shared by all of us who are marginalised and oppressed, whatever our differences. Marginalised people need to reclaim knowledge, the right to name themselves, and the capacity to envis-

age a future – all of which they have long been denied. It may well be that a single grand theory of feminism will not do. But a return to empiricism based on purely local experience is no way out either. The combination of bland political pluralism with relativism leads to a live-and-let-live attitude, an uncritical acceptance of women's experiences in different contexts. As a result, nobody really listens to, and takes, anyone else seriously. But if women, as a marginalised group, are to be able to transform existing power relations, they have to communicate, to hear each other's voices, to learn about each other, and to forge alliances. And, as Ramazanoglu (1989, p. 144) has put it, this raises the

> need to distinguish between cultural relativism which leaves each culture as acceptable on its own terms and offers women no common ground between them, and respect for each other's cultures which leaves us to understand, evaluate, compare, and choose but without a need to condone indiscriminately.

This perspective then leads us, inevitably, to discuss the nature of modernity as well as of post-modernity, its antithesis – the former with its glorification of unitary and universal development; the latter, a trend in Western thought which values difference. And indeed, in the present intellectual climate, universalist methods, discourses and visions are under attack everywhere. Modernity, which seems to be in crisis at both a global and a local, national level, appears exhausted, and it is across a whole front that its doctrines are being challenged. The project of modernity owes a lot to Enlightenment thinkers, who were convinced that human Reason could provide an objective, reliable and universal foundation for knowledge. This mentality took it for granted that there was only one possible answer to any question. It followed that the world could be controlled and rationally ordered if we could only picture and represent it correctly. 'Modernity was about conquest – the imperial regulation of land, the discipline of the soul, and the creation of Truth', says Bryan Turner (1990, p. 4); but after Foucault, who dramatically challenged the 'rationalist pretensions of modern systems of power', the last element is not as legitimate as it once used to be: the quest for Truth, for the one and only possible answer to any question, is now seen to be linked to the quest for power. This is why, for example, feminists – and French feminists in particular – are very reluctant to claim a truth-status for their writing, regarding it, rather, as something between fiction and theory. Moreover, the Enlightenment 'Reason' itself has also been called into question, as the 'wisdom' of a white, male, collective elite; it has been pointed out that, as an 'instrumental rationality', it leads not to the

concrete realisation of universal freedom but to the creation of an 'iron cage' of bureaucratic rationality from which there is no escape (Harvey, 1989, p. 27).

It is not surprising, then, that the history of modernism should be fraught with contradictions: between internationalism and nationalism, between universalism and local and class privileges, between globalism and parochial ethnocentrism. This ambivalence of modernism was bound to produce its counter-trends and counter-movements. Thus, both cultural relativism and post-modernism, its 'modern' form, may usefully be regarded as reactions to this line of thought and mode of life – but in their turn they, too, are beset with their own contradictions.

## CULTURAL RELATIVISM: ITSELF RELATIVE TO WESTERN CULTURE

From the Enlightenment view flows a desire to discover universals: the idea of natural law, the concept of deep structure, the notion of progress or development, and the image of the history of ideas as a struggle between reason and unreason, science and superstition. The term 'modernity' has been attributed a significance both normative and distortive by the myth of progress which has shaped Western thought since the Enlightenment (Berger, 1984, p. 335).

But against this perspective there has also always been – especially in anthropology – a 'romantic rebellion', which may be regarded as the predecessor of today's post-modernist thought. Romanticism, a term used loosely in both an historical and an aesthetic sense to designate the changes in art and literature during the century or so from 1760 to 1870, was already reacting against the Age of Reason. While 'the romantic suspicion' of will, reason, knowledge and tradition, and the emphasis on feelings and the unconscious, have been very important, this tendency has also given way to cultural relativism (Shweder, 1984). According to the romanticist anthropological account, a social order is a self-contained 'framework' for understanding experience, a self-sufficient 'design for living'. 'Governed by their own rules, different frameworks for understanding, different designs for living *do not lend themselves to comparative–normative evaluation*' (Shweder, 1984, p. 28).

Cultural relativists insist on the uniqueness of each culture, regarding it as the symbolic expression of a people who share a history, and as something that endows each apparently universal aspect of human life with a

unique pattern of meaning derived from that history. Cultural relativists, therefore, tend to reject transcultural categories, and even comparative methods, as based on *superficial* similarities (LeVine, 1984, p. 80). According to normative cultural relativism, there are no transcultural standards by which the variable propositions of particular cultures can be evaluated in valid fashion, no way by which their relative worth can be judged. No standards worthy of universal respect are capable of dictating what to think or how to act; alternative 'cultural frames' are neither 'better' nor 'worse', but only *different* (Spiro, 1984, p. 336). For the cultural relativist, differences are not related to one another; they are not even commensurable. Culture is what accounts for difference; that is, difference accounts for difference (Friedman, 1987, p. 168).

However, as again Jonathan Friedman (1987, p. 168) immediately points out, relativism, universalism and evolutionism are equally part of our construction of the world:

> Cultural relativism is part of the cosmology of Western capitalist civilization, expressive of an internal struggle against developmentalism, but assuming a universal notion of the laws of something called culture – an abstract corpus of rules, programs and information. Cultural relativism is itself relative to our 'Culture', just as relative as its complementary opposite, absolutist evolutionism.

## POST-MODERNISM: CAUGHT UP IN A FROZEN 'DIFFERENCE'

Current post-modernist thought has picked up where anthropology's so-called romantic rebellion and its relativisation of the world left off. In its concern for difference, for 'otherness', for the complexity and diversity of interests and cultures, post-modernism exercises a positive influence the importance of which is not to be denied. Its emphasis on difference and its scepticism regarding autonomous 'spheres' of culture or separate fields of specialised knowledge open up to a deeper critique of the unitary, totalising discourse of modernity, and contribute to the idea that all groups have a right to speak for themselves, in their own voice, and to have that voice accepted as legitimate. Moreover, post-modernist theory has helped to expose the conflictual nature of male practices; it has thus initiated a deep questioning of the stability of male culture, leading to the faltering of masculine resolve (Nye, 1988, p. 231).

There is no doubt that the meta-theories and meta-narratives of modern-

ism have glossed over and ignored crucial differences emanating from gender, class and culture. Liberal notions of equality and the universal discourses about the 'rights of man' have evidently not taken women, blacks and other marginal and powerless groups fully into account. This is why post-modernist thought has had such appeal for the various radical social movements that came into being during the 1960s. The radical aspect of post-modernism is generally associated with the feminist critique of male notions of sameness and hierarchy, for post-modernist epistemology celebrates heterogeneity and provides a powerful case against unitary notions of 'man' and 'woman' (Turner, 1990, p. 11). As Jane Flax (1987, p. 626) has noted, feminist notions of the self, of knowledge and of truth are too contradictory to those of the Enlightenment to be contained within its categories:

> Feminist theorists enter into and echo post-modernist discourses as they begin to deconstruct notions of reason, knowledge or the self and to reveal the effects of gender arrangements that lay beneath their 'neutral' and universalizing façades.

Indeed, feminism – and especially radical feminism, which uses the idea of difference as a political weapon – has a close affinity with post-modernism in its concern with 'otherness' and difference. It is in this sense that 'feminism is immersed within and helps to produce the problematic of post-modernism' (Kirby, 1991, p. 397) – a stance which has been particularly important in acknowledging multiple forms of 'otherness'.

Post-modernism, therefore, by acknowledging the authenticity of other voices, opens up radical vistas; as David Harvey (1989, p. 116) has observed, however, there is also the danger of shutting off these 'other' voices from access to more universal sources of power by ghettoising them 'within an opaque otherness, the specificity of this or that language game'. In a world of unequal power relations, this is a serious danger indeed. Post-modernist thinking tends to lose track of social structures, and instead to focus solely on how individuals experience and exercise power. There is a real – and frightening – possibility that this might avoid confronting the realities of global power, and thus disempower the political contents of radical ideologies and movements. 'Post-modernist discourses are all 'deconstructive' . . . and the post-modernist philosophers are all obsessed with delegitimating every form of argument they encounter so that they end up in condemning their own validity claims to the point where nothing remains of any basis for reasoned action', Harvey (1989, p. 116) comments. Deconstruction is an indispensable initial phase for any intellectual/ideo-

logical effort aiming at criticising existing power relations and structures. However, it is not sufficient, by itself, to transform them. If we are not to abandon the project of creating a new and better society, we cannot be satisfied with just 'deconstruction'; we need a transformative and re-constructive vision – and action – too.

Modernistic meta-theories ground and legitimate the illusion of a 'universal history of mankind' which erases the different 'histories' of each particular group. Universalist discourses allow men – white, dominant, male – to represent themselves as humanity; this is indeed a *man*kind, which excludes and marginalises women as well as colonialised peoples, races and ethnicities. But does this mean that we should plunge into particularism, and discard 'universalisation' and theory once and for all? Could we do this even if we chose to? Here one must lend an ear to what Gayatri Spivak (1984, p. 184) has to say:

> I think it is absolutely on target to take a stand against the discourses of essentialism, universalism as it comes to terms with the universal – of classical German philosophy or the universal as the white upper class male . . . etc. But *strategically* we cannot. Even as we talk about *feminist* practice, or privileging practice over theory, we are universalising. Since the moment of essentialising, universalising, saying yes to the onto-phenomenological question is irreducible, let us at least situate it at the moment; let us become vigilant about our own practice and use it as much as we can rather than make the totally counter-productive gesture of repudiating it.

Disempowered and marginalised people need to change existing relations of power and domination, therefore to act; to act they need a common basis for reasoned action, and to communicate with each other. This gives rise to the need for a common discourse. The problem, of course, rests in creating a common discourse which will take into account the uniqueness of each particular group and situation without erasing their respective differences. As Val Moghadam (1989, pp. 91, 96) points out, particularist paradigms cannot fully communicate with each other, and cannot, therefore, even identify differences systematically. They can only proclaim absolute difference, thus turning various differences into a single, frozen Difference. We do live in a fragmented world, which, paradoxically, is becoming more global with each passing day. Post-modernism succeeds dramatically in capturing the image of the fragmentation of our world – but this picture, inevitably, leaves out the other side of the coin.

Ironically, moreover, post-modernist thinkers themselves are faced in

the end with making some universalising gesture. As Nancy Hartsock (1987, p. 108) notes, even Michel Foucault, whose empirical critiques have served so powerfully to unmask coercive power, does so, on the one hand, by making use of those values of humanism that he claims to be rejecting. That is to say, the project actually derives its political force from the readers' familiarity with and commitment to modern ideals of autonomy, dignity and human rights. In a similar vein, Habermas argues that Foucault is caught in the paradox of 'the performative contradiction' because he is ultimately forced to use the tools of reason which he wants to overthrow (Turner, 1990, p. 12).

One tends to agree with D. Harvey (1989, p. 12) when he argues that 'post-modernists simply push meta-theory underground, where it continues to function as a "new unconscious affectivity"' – an idea that is also supported by Bryan Turner (1990, p. 12), who claims that post-modernism is a form of post-liberalism or hyper-liberalism, because the post-modernist critique of hierarchy, of grand narratives, of unitary notions of authority, or of the bureaucratic imposition of official values, has a certain parallel with the principles of toleration of difference in the liberal tradition. This point, besides drawing us into a discussion of the difference between bland pluralism and a theory – or theories – that embrace(s) diversity while also paving the way for a common ground and discourse, requires us to direct our thoughts to those aspects which might seem to be worth retaining in the 'notorious' grand project of the Enlightenment.

## FRAGMENTED CRITIQUES: FALLING VICTIM TO FRAGMENTATION

As the discussion above has sought to show, the idea of universalism and of universal human rights is central to the debate around modernity as well as to its critique by post-modernity, and an indiscriminate rejection of modernity is quite problematic. 'How can one blandly dismiss modernity's gains; on the other hand . . . how can one blithely endorse these gains without naivety or callousness?', asks Fred Dallmayr (1989, p. 377), I think quite justifiably. The history of modernity is so loaded with negative meanings that we sometimes tend to dismiss in too offhand a manner the civil rights and other gains that have emerged as a result of the Enlightenment process. We are finally persuaded, in our post-modern era, that history is not a teleological evolution inevitably leading to an egalitarian society

marked by 'eternal harmony'. But does this mean that we should give up all hope of freedom and equality for everyone, that we should abandon the Enlightenment project entirely?

One has to bear in mind, at this point, that, its negative aspects notwithstanding, the rationality of the Enlightenment, of bourgeois civilisation, was a radical challenge to the traditionalism of feudal society. People who live under capitalism in the West might retain no memory of how suffocating life can be within the narrow confines of a traditional community which, to a great extent, denies individuals self-determination and personal autonomy. The individual, indeed, is itself a product of modernity. This is not to deny that the personal identity of the liberal paradigm is an abstract, falsely universal and neutral 'human being' stripped of class, gender, race and sexuality. But, in à society dominated by communal ideology and by an all-subsuming state, it is always traditionally powerless groups such as women, ethnic minorities or political dissidents that suffer most, precisely because society regards the control exercised over them as legitimate, sometimes in the name of 'the interest of the state', sometimes in the name of 'protecting public morality and purity'. In all these cases, women's right to an autonomous existence and to individuality is the easiest to be trampled on. Although Turkey, for example, boasts of being a modern secular state, not only male heads of families but government authorities, too, see nothing wrong in imposing periodical 'virginity checks' on women.[1] While capitalism, pushing individualism to the extreme, brings with it atomisation and the alienation of the individual, at the other end of the scale lack of individuality means strict control over and repression of, particularly, women and children. And women's movements, which have introduced a variety of changes, including the questioning and altering of gender arrangements, are themselves the outcome of modernisation. How can we deny that the efforts of the oppressed towards individuality are a step along the road to liberation?

It goes without saying that, while even within Western societies there are different conceptions of emancipation, and while ethnocentric biases are being challenged, a 'universal model for emancipation cannot arrogantly assume for itself a Western point of view' (Moghadam, 1989, p. 93). It is necessary and legitimate to reject the imperialism of an enlightened modernity that has, in the past, presumed to speak for 'others' in a unified voice. But while discarding the Western, white, male bias of this unitary narrative, and acknowledging and legitimating difference, I do not believe we should be locking ourselves in fragmentation behind solid walls of absolute difference. As Grimshaw (1986, p. 171) argues,

We do not have to be positivists – committed to the view that it is possible to give an objective, value-free description of the world simply by observing the appropriate scientific method – in order to believe that there is an objective reality, often masked by ideology, but ultimately knowable.

Although any criterion for judgement is in some sense relative, our criteria can at least be grounded in shared ideas about objective reality and about what is helpful or harmful for human beings. Our awareness that our constructions of reality are, inevitably, value-laden and socially defined, should not lead us to remain silent in the face of what we think to be evil from our standpoint. We know that our claims are perspectival; but this perception also helps us to have views *and* keep them in perspective, preventing us from making absolute truth-claims for all people and all times. Post-modernist thinking has taught us, if nothing else, that eternal and universal truth-claims reflect many of the characteristics of the social setting from which they arise. Unless power relations deriving from personality, race, class, gender, etc. are explicitly acknowledged, the knowledge gained from studying another culture is distorted. But does this mean that all 'outsiders' should refrain from studying other cultures and taking stances when they do so, that experience does not yield itself to comparison, or that working out a theory based on communication and interaction is impossible? The task of formulating a general theory – or theories which relate to each other, if you like – that values different groups and cultures is a difficult and challenging one. But it is worth taking the challenge. The fragmentation of the world is an objective reality; however, all reality is a product of social and historical circumstances, and therefore lends itself to critique and change. Why should the critique of fragmentation fall victim to a 'reality' which, by definition, cannot be absolute and eternal?

## 'GOING NATIVE': THE MIRROR IMAGE OF 'GOING ETHNIC'

Faced with the difficulty of coping with fragmentation and diversity, as well as with the challenge of pluralism from the inside, some feminist authors, looking outward from developed industrial nations to the conditions of women in developing countries, seek a theoretical refuge in cultural relativism as a kind of functionalist anthropological attitude. Such authors make a point of trying to avoid passing what they are worried will be 'value judgements' from their 'privileged' position. While this may be sensitive,

the fear that their own feminism may amount to some sort of 'cultural imperialism' leads many feminist activists to distance themselves from women's movements in the Third World [I use this term reluctantly, and hope to explain myself in the coming sections]. On the other hand, there are many Third World feminists who keep trying to distance themselves from 'Western feminism' in the name of authenticity, and who claim that the problems faced by women in the Third World are more serious and vital than the 'personal' – therefore, by innuendo, 'frivolous' – preoccupations of Western women.

Not that the need to relativise monolithic and imperialist universal representations of knowledge is not understandable: 'Westerners had long assumed that they can see and judge the people of the Third World more clearly than they do themselves just as women have been traditionally evaluated by the male gaze. In both cases the gaze has been myopic, selective, reifying', notes Helen Carr (1988, p. 153). The Eurocentric gaze of Orientalism is the gaze of a dominant, white, male ruling class, and the concern with 'otherness' and 'difference', the process of acknowledging 'different histories', testifying to a profound shift in the intellectual climate, have certainly been very important in the delegitimation of this built-in bias. Today's concern for the validity and dignity of the 'other' in ethics, politics and anthropology is truly refreshing. However, it is also important to perceive the difference between a critique of Eurocentrism, on the one hand, and, on the other, a cultural relativism which refrains from criticising oppressive social relations when they occur in 'other' cultures, and which focuses solely on describing or defending existing local traditions and customs.

The critique of ethnocentrism is, in part, about recognising cultural difference, but it should also be about trying to overcome such difference. The cultural relativist, on the other hand, sets up absolute cultural differences, and refrains from criticising and analysing the 'other' culture in the fear of passing value judgements or lapsing into 'cultural imperialism'. But, as bell hooks (1989, p. 47) points out, not being critical and analytical of a different experience (ethnic, racial, Third World, etc.) because (implicitly) it is so removed from one's own, may well reinforce racism. Cultural difference is not absolute, and similarities between cultures are as important as differences. Recognising ethnocentrism instead of establishing absolute differences should help to break down the barriers to cultural understanding. Learning about other groups can indeed be a way to unlearn racism, orientalism and ethnocentrism (hooks, 1989, p. 46). The alien 'other' may prove to be not so other after all!

Feminist researchers, with a fresh awareness against ethnocentric bias,

keep making an effort to see the world through the eyes of the women they happen to be studying, in the hope of getting rid of the voyeurism of an outsider. They are sensitive about an 'understanding of the cultural context', which is indispensable for any appreciation of women's mentalities and subjectivities under different circumstances. However, it is very easy to slip from 'understanding in order to change' to 'understanding in order to tolerate'. The latter tendency may easily create an atmosphere in which 'anything goes', including acceptance of the dominant mental and material structures of women's subordination. As a consequence, some female scholars in the West have started to regard as 'natural' or even 'beneficial' those forms of subordination or dependence that they observe, for instance, in some Muslim societies – forms which they would never dream of rationalising for their own situations. Thus, cultural relativism becomes a banner under which oppression may be made to appear tolerable, as Tabari (1986, p. 356) points out.

Susan S. Davis, for example, in her study of women's lives in a Moroccan village, says that 'instead of accepting the common idea that men's status is high and women's low in Muslim societies', she has tried to see status in the same way as village women did:

> For them, you do not compare women to men; that is like comparing apples and oranges. In a society in which the sexes function quite separately and sex roles are very differentiated, it is only reasonable to expect two separate status hierarchies, which is just what I found.
>
> (Davis, n.d., p. 178)

'The sexes function separately' throughout the world, though the degree might vary, and sex roles are everywhere differentiated; but this would probably not deter Susan Davis from objecting to, and criticising, oppressive gender arrangements in her own society. She appears, however, more than willing to accept and rationalise male domination and the existing hierarchy just because it takes place in a different culture, although the fact that this domination has been internalised by women themselves does not change its nature. Davis's position may seem to be a nicely benevolent attitude; but one has to remember that 'benevolence' always involves two parties which are not equal.

Charis Waddy (1980, pp. 5, 7), another benevolent cultural relativist, claims that what Muslim women bring with them into public life is not 'self-centred claims of power' but 'conviction of the potential collective force of women, *which is available for national action*' (my emphasis). She

continues: 'We in the West often forget how repulsive to the outside view much of our life has become. We tend to judge other people's societies by certain 'freedom' we consider important. The Muslim women I know have other criteria, other aims.'

We are made to understand that these 'other' criteria and aims are much more serious than those of eccentric and frivolous demands for emancipation, autonomy and individuality. Besides establishing opaque cultural differences and legitimising the use of women for ends which do not have any direct relevance to their self-interest, Waddy's rationalisation serves to maintain and propagate existing gender relations as well as to protect male dominance from any possible threat by dismissing women's demands for change and liberation as 'self-centred claims to power'. This is an accusation which feminists in the Third World hear very often, and it is through this kind of rationalisation that women's rights are trampled upon. Women's demands for equality are regarded either as 'frivolous fantasy' or – at best – as a 'quest for mechanical equality'; and there are always more serious and pressing problems to deal with that keep postponing delegitimation of the male control of women's bodies and behaviour.

In the current intellectual climate of the Middle East, 'going native' in the search for an 'authentic identity' not contaminated by Westernisation is very much the fashion. There is a feeling in some circles that the ideologies of modernity – democracy, socialism, secularism, etc. – have all failed, and this surrenders an entire arena to the uncontested claim of Islamic ideology to 'authenticity' in the face of the 'imported' ideologies of the West. In actual fact, this trend of 'going native' is nothing but the mirror image of 'going ethnic' – the romanticisation of the 'other' – in the West; it provides a new image of what is supposedly the 'essence' of one's own 'real' culture, as Val Moghadam (1989, p. 88 and *passim*.) points out. This is just another essentialist discourse.

In many Islamic countries in the Middle East, Turkey included, the fundamentalist argument today is based on this kind of cultural particularism, which sets up Islam as the only indigenous solution to an alienated social environment. For radical Islam, modernism/Westernism is the root cause of the 'contamination' that has beset Muslim society – and, as usual, women's position and behaviour become the touchstone of this contamination. Women are thought to be more susceptible to the loose and corrupting influences of the Western way of life. In Turkey, a new generation of radical Islamists argues that, burdened with wage-work and family responsibilities, women have lost their female identity and have been transformed into commodities by Western capitalism.

This obviously essentialist, nativist discourse is, interestingly, echoed in the Western perception of the 'spiritual' East versus the 'materialistic' West. Even Foucault (1978; quoted by Moghadam, 1989, pp. 91, 96), for example, in the aftermath of Khomeini's rise to power in Iran, could claim that 'the revolutionary forces created by religious spiritualism' had marked a new stage of resistance against modern rationalism and a power based on science and technology. This, of course, is quite misleading, because, like fundamentalists in Turkey and elsewhere in the Middle East, Iranian fundamentalists, too, are not in the least against 'power based on science and technology' (Mardin, 1977; Baykan, 1990). On the contrary, they seek to utilise every single product of modern technology for achieving their own ideological and organisational ends. This is a phenomenon which some authors sum up as 'rejection of modernity while retaining modernisation', and it has crucial consequences in terms of social relations and gender arrangements. For, while fundamentalists accept a scientific and techno-logical modernisation almost wholesale, they resolutely oppose the demo-cratisation of social relations that modernity may bring; in particular, they conjure up an image of amorality, sexual depravity and corruption in the West to justify their rigid moral codes and gender segregation.

The present reconciliatory trend towards apologetics in Middle Eastern women's studies, which attributes the subordination of women to a 'misrep-resentation' of Islam, may best be appreciated as a side product of 'reversed ethnocentrism'. Azar Tabari (1982, p. 20) notes that the attempts to differ-entiate between a reactionary and a progressive Islam reflect the over-whelming pressure exerted by Islam, as a living political force, on all women liberationists and socialists active in Muslim societies.

Attempts to differentiate between Islam and tradition are not based on solid ground either. Freda Hussain (1984, p. 2), for example, argues that there are no 'real' Islamic societies in today's world, and that the restric-tions imposed on women in Muslim societies are the historical product of the feudal states ruling those societies. Now the subordination of women certainly cannot be taken as the product of religion only; it depends on the interaction of social, economic, historical and ideological circumstances specific to each society. It remains the case, nevertheless, that Islam is the dominant ideology in all these countries – though there may be variations in the way it is expressed and practised – and as such it reinforces both class and male dominance. This stable complementarity between Islam and pre-Islamic or non-Islamic systems of male dominance is itself significant; why Islam has served 'feudal states' so well as a 'superstructure', is what Freda Hussain should really have to explain. It seems, therefore, that the powerful

pressures of the current intellectual and ideological climate, which are affecting women deeply, also lead to internalised religion, to privileged difference and to the setting up of absolute cultural oppositions; they thereby account, moreover, for the spread of the 'different-but-equal' argument that usually denotes an uncritical stand on the possible role of religion in legitimating the subordination of women (Kandiyoti, 1987).

Although, both in Third World countries and in some Western circles, the glorification of communal values and social structures is on the rise, Rana Kabbani being a case in point,[2] at least some women in the Middle East, and feminists in particular, know only too well how suffocating these idealised traditional bonds and moral codes can be. The feminist movement in Turkey, for example, has come to locate women's 'bodies, labour and identity' as the site of its struggle; and, perhaps not surprisingly, the most widely sold novel by a woman author has been *Kadinin Adi Yok* (*The Woman Has No Name*), which tells the story of a woman who wants to stand on her feet, to live by herself, and who of course pays the price for such impertinence (Sirman, 1989, p. 21).

This benevolent cultural relativism on the part of Western feminists sometimes goes so far as to extend a rationalisation of the segregation of women to accepting and condoning even veiling for their Middle Eastern 'sisters': 'Although universally perceived in the West as an oppressive custom, it [veiling] is not experienced as such by women who habitually wear it', writes Leila Ahmed (1982, p. 523). Leaving aside the strength of the argument about the social construction of experience and feelings, and about how misleading it therefore is to claim a special 'authenticity' for (only some among) them, one wonders whether Western feminists, who know perfectly well that these practices spring from a theology of the maintenance of so-called female purity, would ever accept 'veiling' for themselves – and not as an 'alternative' way of life, but as something compulsory, from which there is no possibility of opting out.[3]

## WOMEN OF ONE WORLD

All forms of thought and representation dealing with the alien, the 'other', are problematical. And in the process of making interpretive statements about foreign cultures and traditions, dichotomizing and re-structuring are inevitable.

Thus warns Val Moghadam (1989, p. 87). While this is quite justified, studying other cultures and learning about other experiences sometimes holds interesting surprises which teach us that the 'other' (in my case 'the Westerner') is not so removed from 'us' after all. It may also open up new insights into analysing oneself and one's own cultural context.

I first read Sheila Rowbotham's book *Woman's Consciousness, Man's World* in the early 1980s, when I was deeply questioning myself and my affiliation to a leftist organisation in Turkey, an affiliation dating back to 1970. I already knew that I was feeling uneasy, that I had a strong sense of not belonging, and that I and other women were being treated as inferior and subordinate; but I had not yet found the language to express these feelings. In the formal discourse of the Turkish Left, men and women were equal; but of course this theoretical norm was seldom put into practice, and, when it was trampled upon, the 'real culprit' was never this or that specific person and certainly not the organisation in question, but always those very abstract survivals of 'feudalism'. 'Unfortunately', you see, Turkey was still a backward country, and even the most advanced people (meaning *men*) in the vanguard party were 'occasionally' affected by the 'negative consequences' of this socio-economic structure. So there was really nothing to be done until that social structure was changed by the victory of the revolution. And anyway, there were always problems that were *so much* more important and serious than these 'psychological and personal' questions! In the meantime, 'woman comrades' should be patient and *prove* that they were good revolutionaries. It did not occur to anyone for a long time to ask why it was always women who had to 'prove' themselves. But, as Rowbotham (1973, p. 30) put it, we were to 'step forward now dears, let's see you perform': 'We clowned, mimicked, aped our own absurdity. Nobody else took us seriously. We did not even believe in ourselves. . . . It was evident that we were intruders.' These were the words of a socialist militant from an 'advanced' capitalist country that was supposedly far removed socially and culturally from my own; and yet she was giving expression to precisely the same uneasy feelings that I was just trying, myself, to bring to consciousness and language. 'Women have come to revolutionary consciousness by means of ideas, actions, and organizations which have been made predominantly by men', says Rowbotham, and certainly the Turkish Left was/is no exception. Although there are differences in the way in which male dominance is exercised and articulated, this is not sufficient to turn it into an absolute difference.

This attitude of the Turkish Left towards women is also an interesting example of cultural continuity, and serves to demonstrate how persistent an

element religious ideology has been of culture, including Leftist subculture. For although the Left has traditionally been ardently secularist – to the point of ignoring the fact that secularism itself is just another ideology – it has simultaneously regarded women as a source of disruption that has the dangerous potential of destroying the unity and solidarity of a revolutionary organisation. This is exactly how Islam regards women – as *fitna*, capable of destroying the solidarity of the [male] community of believers by leading men astray from *sharia*, the path that takes men to God!.[4] That is why women's behaviour, and the way they dress etc., is so strictly controlled in Leftist organisations, too. Women should behave modestly, it is said, 'because they are the "front window" of the movement'.[5] Here it becomes especially interesting to ponder what Moghadam (1989, p. 92) has to say about the aftermath of the Khomeini-led revolution:

> In Islamic Iran the preoccupation with women's appearance and the obsession with women's bodies signifies the central responsibility assigned to women in the Islamist restructuring of power, of culture, and of society. It is women who are made to be the carriers of cultural values and indigenous norms.

This view of women as symbolic markers of identity is, of course, nothing new. Deniz Kandiyoti (1988, p. 239) has pointed this out in a Turkish context:

> There is one persistent and underlying concern which unites nationalist and Islamic discourse: it is an eagerness to establish beyond doubt that the behaviour and position of women, however defined, is congruent with the 'true' identity of the collectivity and constitutes no threat to it.

One might easily add that the discourse and practice of the Turkish Left has been no different. In a socialist context, too, women, without any change in their gender role and burdens, had to become modest, pure and self-sacrificing sisters-in-arms. Stripped of their femininity, they were required not to laugh too much – no silly giggling please, not to talk too loudly, not to dress 'too much like a woman', not to make a real presence (know thy place – knowing our place also meant not daring to engage in theory; 'real' intellectual activity was no plaything for women). And women were counted among the 'vices' that revolutionary men had to avoid, along with drugs and alcohol. Imagine my astonishment, therefore, in reading Rowbotham (1973, p. 19) on 'what the man from *Militant* solemnly told

everyone: that drugs, drink and women were a capitalist plot to seduce the workers from Marxism'. The break with dominant ideology, it seems, is most difficult in the sphere of gender arrangements.

Perhaps I should not have been that surprised, however, for we know that there are correspondences between feelings which 'are not substances to be discovered in our blood but social practices organised by stories that we both enact and tell. They are structured by our forms of understanding' (Rosaldo, 1984, p. 143). And our 'forms of understanding', our 'subjectivity', depend largely on the socio-historical circumstances we are situated in. Here the point which does not cease to fascinate is that apparently different social and historical conditions should lead to more or less similar forms of subjectivity for women – this would seem to imply some sort of similarity in their material existence, too. I will not go so far as to argue that these similarities are sufficient in themselves to guarantee the existence of a 'global sisterhood'; but there would appear to be a strong case for maintaining that the commonalities women share make it possible for them to develop a common discourse which may facilitate communication – and solidarity, why not? – between women despite their differences. As long as we do not insist on speaking in a single voice and on trying to base our theorising on a unitary category of 'woman', it is quite legitimate to try to work out a common conceptual framework.

Experience lends itself to comparison and comprehension – something which I learned well while doing a course in women's studies in Britain that was attended by women from very different societies. Yet we had a common basis of understanding and managed to find a language with which to relate our thoughts and emotions to each other. Comparison is about searching for similarities as much as differences, and it is only through communication and a process of learning from each other that we come to understand them, thereby reaching a deeper understanding of ourselves.

In this context, the approach adopted by women who have founded an institute in Nuremberg, Germany, to do research on women's daily lives acquires major significance. In an effort to get rid of concepts based on hierarchical notions, they have named their research centre *Women of One World* (*Frauen in Einen Welt*) because they reject the term Third World as yet another of those hierarchical concepts. They aim to create an environment where women from different cultures can meet and come to know each other, work together, and cooperate. In a multi-cultural society this is the only way to overcome cultural prejudice, they argue. Instead of resorting to cultural relativism, this sort of approach, that is truly sensitive to difference, seems much more plausible and effective for building a common discourse and overcoming ethnocentric parochialism.

## WHO'S AFRAID OF THEORY?

The post-modernist questioning of universalising theories, as well as the self-doubt brought in by the awareness of difference between women, have dovetailed into a suspicion about theory which has been furthered by the Foucauldian stress on the power effects of knowledge. However, even within Foucault's analytical framework, it seems that a distinction can be drawn between discourses whose power strengthens existing modes of domination, and those that work to undo them, because the very mode of domination gives rise to contradictions which in turn open the way to 'the creative response of the oppressed to their conditions of life' (Godelier, 1982, p. 37).

From a post-modernist viewpoint, it is not difficult to see feminist theory as just another 'meta-narrative'. Yet feminism has an undeniable political content and cannot afford to ignore power. As Toril Moi (1990, p. 101) puts it,

> if we don't want to have anything to do with power, then somebody else will. The question then becomes one of defining different structurations of power, different approaches to it. Just to take over power as it is now would clearly not be satisfying for us, yet we must say that we want power because we certainly don't want the patriarchs to keep it. Feminism, among other things, is about the need to reconceptualize power, understand it differently, see the creative potential in power.

Studying power relations in each specific case, historically and culturally, begs for a theory that takes differences and the lived experience of different groups of people (in this case, women) into account, and which, while studying the oppression of women, also makes room for the possibility of a counter-culture and of resistance. Women, as an oppressed group, have the right to establish themselves not only as 'objects' but as 'subjects' of history, to *name* themselves, and to form their own (counter) theories about the world, about resistance, and about the struggle for change and liberation. One may even argue that women themselves are better situated to search for 'modes of resistance' because of their peripheral or marginal position in society. People who are peripheral to the central loci of power and authority are incorporated only weakly into the central structure of the society they live in. It is this lack of strong central articulation that provides the marginalised with the ability to criticise existing power relations, and leads them to seek alternative, utopian forms of expression (Douglas, 1973, pp. 114–27). As Hartsock (1987, p. 116) puts it, women's history of

marginalisation could work against creating a totalising discourse; and building an account of the world and human relations as seen from the margins may serve to transform those margins into the centre, changing, perhaps, the notion of the centre itself.

Trying to think and theorise through difference is obviously no easy task. But this should not discourage feminists, or cause them to avoid engaging in the effort to reclaim 'knowledge'. Knowledge and its systematic form, theory, have the potential to pave the way for resistance and subversion. Let us not forget that God punished Woman for seeking the knowledge that was Man's privileged possession. Women need to reclaim the right to knowledge and to theory, precisely because the possessors of the right to name, to define and to theorise, are also the possessors of power:

> Our non-being was the condition of being of the One, the Center, the taken-for-granted ability of one small segment of the population to speak for all our efforts to constitute ourselves as subjects (through struggles for colonial independence, racial and sexual liberation struggles, etc.) were fundamental to creating the preconditions for the current questioning of universal claims.
>
> (Hartsock, 1987, p. 116)

The understanding of the theoretical effort by the hitherto marginalised, indeed, may contribute to shattering the Enlightenment's totalising Theory, with its monolithic and falsely universal representations of knowledge. Why not take the challenge and indulge ourselves in the pleasure of eating the forbidden fruit? The disempowered cannot be blamed for raising 'the principle of hope'.

## NOTES

1.  The last of these 'virginity checks', which took place in July (1991), has been an 'unfortunate' one for the Turkish government. This time it was imposed on a German woman spending her holiday in Urla, a small town on the Aegean, by the local authorities, in the name of protecting 'public morality'. When there was quite a flow of protest the authorities had to make some sort of an apology. But women who are Turkish nationals are not as 'lucky' as tourists. Only a few months earlier, in Bakırköy Psychiatry Clinique (Istanbul), all the female patients were forced to undergo this 'check', which was said to have been done 'to protect them against any possible sexual abuses'!

2.  This is what Kabbani (1989) says: 'Unlike Westerners, they [Muslims] are, for the most part, too poor and insecure to afford the luxury of individual feelings; instead, their reactions to events are strongly shaped by communal memories.'

3.  I know there are strong arguments against my type of approach; but I stick to the feminist understanding that means and forms are just as important as any 'ends' in question. The veil is a form and a symbol of women's seclusion – in spite of the different meanings women may attach to it. The question is, can it be used by women for emancipatory ends? The Iranian women who wore the veil as a gesture of cultural authenticity during anti-Shah demonstrations (I am not referring to women who had always worn it) learned the answer to this question very quickly. By turning to this symbol and using it when it was not yet compulsory, Iranian women seem to have acknowledged the legitimacy of their subsequent seclusion.

4.  This approach, of course, has been described in detail by Fatima Mernissi (1975).

5.  For a wider discussion of this issue, see Fatmagül Berktay (1991).

# REFERENCES

Ahmed, Leila (1982), 'Western Ethnocentrism and Perceptions of the Harem', *Feminist Studies*, vol. 8, no. 3.

Baykan, Ayşegül (1990), 'Women Between Fundamentalism and Modernity', in *Theories of Modernity and Postmodernity*, ed. Bryan S. Turner (London: Sage).

Berger, Peter L. (1984), 'Toward a Critique of Modernity', in *Religion and the Sociology of Knowledge*, ed. Barbara Hargrove (London: Edwin Mellen Press).

Berktay, Fatmagül (1991), 'Eine zwanzigjahrige Geschichte – Das Verhältnis der türkischen Linken zur Frauenfrage', in A. Neusel, S. Tekeli and M. Akkent (eds), *Aufstand im Haus der Frauen* (Orlando: Frauenverlag).

Carr, Helen (1988), 'In Other Words: Native American Women's Autobiography', in *Life/Lines* (Cornell University Press).

Dallmayr, Fred (1989), 'The Discourse of Modernity: Hegel, Nietzsche, Heidegger (and Habermas)', *Praxis International*, vol. 8 (January).

David, Susan S. (n.d.), *Patience and Power: Women's Lives in a Moroccan Village* (Rochester: Schenkman Books).

Douglas, Mary (1973), *Natural Symbols* (London: Barrie and Jenkins).

Flax, Jane (1987), 'Postmodernism and Gender Relations in Feminist Theory', *Signs*, vol. 12, no. 41 (Summer).

Foucault, Michel (1978), 'A quoi rêvent les Iraniens', in *Le Nouvel Observateur*, 16 October 1978, pp. 48–9.

Friedman, Jonathan (1987), 'Beyond Otherness or the Spectacularization of Anthropology', *Telos*, no. 73.

Godelier, Maurice (1982), 'The Ideal in the Real', in Raphael Samuel and Gareth Stedman Jones (eds), *Culture, Ideology and Politics* (London: Routledge and Kegan Paul).

Grimshaw, Jean (1986), *Feminist Philosophers: Women's Perspectives on Philosophical Traditions* (London: Wheatsheaf).

Hartsock, Nancy (1987), 'Foucault on Power: A Theory for Women?' in Monique Leijenaar (ed.), *The Gender of Power – A Symposium* (Leiden: Vakgroep Vrouwenstudies/Vena).

Harvey, David (1989), *The Condition of Postmodernity* (Oxford: Basil Blackwell).

hooks, bell (1989), *Talking Back* (London: Sheba Feminist Publishers).

Hussain, Freda (1984), 'Introduction', in Frieda Hussain (ed.), *Muslim Women* (London: Croom Helm).

Kabbani, Rana (1989), 'Letter to the Guardian', *Weekend Guardian*, 14–15 October.

Kandiyoti, Deniz (1987), 'Emancipated but Unliberated? Reflections on the Turkish Case', *Feminist Studies*, vol. 13, no. 2.

Kandiyoti, Deniz (1988), 'From Empire to Nation State: Transformations of the Woman Question in Turkey', in *History of Women: Changing Perceptions*, ed. S. Jay (Kleinberg: Berg/Unesco).

Kirby, Vicky (1991), 'Comment on Mascia-Lees, Sharpe and Cohen's "The Postmodernist Turn in Anthropology: Cautions from a Feminist Perspective" ', *Signs*, vol. 16, no. 2.

LeVine, Robert A. (1984), 'Properties of Culture: An Ethnographic View', in R. A. Shweder and R. A. LeVine (eds), *Culture Theory* (Cambridge University Press).

Mardin, Serif (1977), 'Religion in Turkey', *International Social Science Journal*, vol. 29, no. 2.

Mernissi, Fatima (1975), *Beyond the Veil* (Cambridge University Press).

Moghadam, Val (1989), 'Against Eurocentrism and Nativism: A Review Essay on Samir Amin's *Eurocentrism* and Other Texts', *Socialism and Democracy*.

Moi, Toril (1990), *Feminist Theory and Simone de Beauvoir* (Oxford: Basil Blackwell).

Nye, Andrea (1988), *Feminist Theory and the Philosophies of Man* (London: Croom Helm).

Ramazanoglu, Caroline (1989), *Feminism and the Contradictions of Oppression* (London: Routledge).

Rosaldo, Michelle Z. (1984), 'Toward an Anthropology of Self and Feeling', in R. A. Shweder and R. A. LeVine (eds), *Culture Theory* (Cambridge University Press).

Rowbotham, Sheila (1973), *Women's Consciousness, Man's World* (Harmondsworth: Penguin).

Shweder, Richard A. (1984), 'Anthropology's Romantic Rebellion Against the Enlightenment, or There's More to Thinking Than Reason and Evidence', in R. A. Shweder and R. A. LeVine (eds), *Culture Theory* (Cambridge University Press).

Sirman, Nükhet (1989), 'Feminism in Turkey: A Short History', *New Perspectives on Turkey*, vol. 3, no. 1.

Spiro, Melford A. (1984), 'Some Reflections on Cultural Determinism and Relativism', in R. A. Shweder and R. A. LeVine (eds), *Culture Theory* (Cambridge University Press).

Spivak, Gayatri (1984), 'Criticism, Feminism and the Institution', *Thesis Eleven*, vol. 10, no. 11.

Tabari, Azar (1982), 'Islam and the Struggle for Emancipation of Iranian Women', in A. Tabari and N. Yeganeh (eds), *In the Shadow of Islam* (London: Zed Press).

Tabari, Azar (1986), 'The Women's Movement in Iran: A Hopeful Prognosis', *Feminist Studies*, vol. 12, no. 2.
Turner, Bryan S. (1990), *Theories of Modernity and Postmodernity* (London: Sage).
Waddy, Charis (1980), *Women in Muslim History* (London: Longman).

# 7 Equality and Difference: Approaches to Feminist Theory and Politics

CHRISTINE KULKE

## 1. INTRODUCTION

One of the features of modern Western civilisation is that it lays claim to the concept of individual equality. This does not mean that discrimination and domination have come to an end; only that the legitimation of oppression has become more problematic because the concept of equality identifies oppressive (inhuman) acts as offences against political morality and justice. This seems to apply to all varieties of violence and domination, with the exception of gender relations. The gender hierarchy has not been fundamentally altered by the equality discourse of modern times. Though there have been changes in women's situation in the Western world over the last fifteen or twenty years, few changes have been the direct result of this discourse.

The aim of this chapter is to show how concepts of equality and gender differences have been formulated and constrained by the form of patriarchal rationality within which they are embedded. I argue that these concepts are much more enmeshed in the structure and standards of dominant modern rationality than is often supposed and that they share a common genealogy with patriarchal norms. Both, historically and systematically, are aspects of the same process of modern development and both have their roots in the heritage of the French Revolution and the Enlightenment. One of the consequences of the Enlightenment was a change in the parameters of legitimation from God-given manifestations to 'natural' criteria of reason; from religious belief to arguments based on rationality. Ideas of equal rights and equal opportunities for all human beings are also offshoots of the Enlightenment concept of freedom, as are arguments for a rational legitimation of 'natural' differences between the sexes. Yet the promise of freedom and emancipation for the individual has not been fulfilled, since women have been excluded from rationality and knowledge, and also from substantially equal opportunities. It is, therefore, necessary to explore the implications of this in the context of current interests, which are concerned with

fundamental changes in the discourses of, and new approaches to, equality and difference. These focus, in particular, on new democratic structures and the politics of resistance.

## 2.  EQUALITY, DIFFERENCE AND DICHOTOMISATION

Discussions among feminist social scientists in Germany and Austria, and their research on equality and gender difference, tend to concentrate on a critique of formal equality and on problems of equal rights and unequal conditions (Gerhard et al., 1990; List and Studer, 1989; Nagl-Docekal and Pauer-Studer, 1990). But experience with politics, especially gender politics, indicates that to insist on equality is not enough to eliminate discrimination and domination. Demands for equality in actual socio-political conflicts are not a guarantee of emancipation, as we can see, for example, in women's experiences of employment and labour-market policy. Equal qualifications or professional training are not sufficient to provide equal opportunities for women in the labour market generally or in the competition for professional positions. Because their professional biographies tend to be very different from men's, women often have to insist on special quota systems in order to attain equal opportunities with men. Also, in other fields, we often find that support for equality, and the declaration of equal opportunities and chances, function to deny diverse needs and interests, to compel women's adaptation to male norms, or to advance only a formal egalitarianism.

Numerous examples relating to these problems with equality may be found in actual political conflicts between the genders, among multicultural interests, and also in the East–West conflicts within the German unification process, for instance. Here, it can be shown that the standards of equality in the old Federal Republic of Germany, when applied to women's interests in the old German Democratic Republic, lead to unequal chances in the labour market, and the modification of standards in the latter to the sexist norms of the former. It seems, in many cases, that difference is not acknowledged, either in gender relations between the sexes or among women themselves, as an issue of diverse interests and rights. So, in the East and West German situation, for example, existing differences are taken by policy makers and employers as a legitimation for discrimination or degradation, especially in the professional arena and in that of family policy. For example, the emphasis on the restrictive West German abortion laws is indicative of a strong discrimination against women's interests and powers of self-destination.

Further examples may be found in the legislation protecting working mothers and maternity leave, which is based on laws stabilising equal conditions for women but which are now being abused and used in repressive ways to curtail the job opportunities of women. This can again be seen in the territory of the former German Democratic Republic, where a lot of mothers who had been working are now losing their employment opportunities.

Taking all of these issues into account, one might argue that an insistence on a concept which includes diversity, as well as equality, would seem to be crucial for human existence and survival, and not merely comprise a theoretical problem. Further, a focus on gender issues makes it necessary to become aware of the way in which equality and difference relate to the dominant concept of rationality. The relationship between equality and diversity is not, in fact, a dichotomous one; each is a different aspect of a complex process. Both concepts developed out of Enlightenment philosophy and politics as guarantees of the freedom of the rational individual. Gender differences, however, were never at issue in that equality discourse, with the result that women have largely been excluded from modern political discussion and policy formation, and concepts of freedom and the rational society have merely come to serve as a legitimation – and an ostensibly objective one – for female exclusion and male domination.

This line of argument indicates just how all-encompassing the concept of dominant rationality has become. Underlying its construction is a separation of thinking from feeling, rationality from sensuality, which derives from the Cartesian division between mind and body, and which serves to identify and stabilise its universalistic logic. This can be seen in the writings of classical philosophers, such as Kant and Hegel. The distinctions between subject and object, between male and female, have not only shaped scientific thought but have determined the formation of modern discourses, including that on equality and difference (Benhabib and Cornell, 1987). These divisions imply domination, and a hierarchical order in which the categories of body and nature, sensuousness and feeling, are traditionally associated with women and femininity (Horkheimer and Adorno, 1947). Mind, understanding and reason are not only regarded as masculine preserves, but are also placed on a higher level of social and moral value.

If we accept this line of argument, we might well reach the resigned conclusion – as some feminists do – that since all concepts of rationality, science and philosophy are fundamentally patriarchal, women should realise that they have been excluded from the discourse and therefore completely reject male-dominated objectivity and universalism (see Fox Keller

in her early work, 1984, and the discussion by Moi, 1989). These pessim-
istic options seem to bear no seeds for change, serving instead to reinstate
the old dichotomies of rationality and sensuality, reason and emotion.

A helpful contribution to this debate is made by the literary theorist
Toril Moi, in her analysis of the causes and implications of such feminist
positions. Moi points out that, 'Feminists have long criticized a phenom-
enon variously labelled 'male science', 'male theory', or 'male rationality',
arguing that such forms of structured thought are inextricably linked with
traditional sexualised – and sexist – categories of dominance and oppres-
sion' (Moi, 1989, p. 189). She also discusses the familiar facts of identifi-
cation – of the male with rationality, activity and intellect, and of the female
with irrationality, passivity and nature. In her critique of Evelyn Fox Keller's
book, *Reflections on Gender and Science*, she agrees with the author's
'denunciation of the logic of domination and objectification' (Moi, 1989,
p. 190), and would like to see emotion and feeling introduced into science.
However, she cannot follow Fox Keller's 'decision to label the new mode
of knowledge (which will include feeling) "female"' (Moi, 1989, p. 190).
Toril Moi asks why we could not just call it 'the way to do science'?

In *Reflections on Gender and Science*, Keller gives an explanation of the
development of an individual's scientific skills which relates them to emo-
tional and sexual development. In Moi's view, this approach derives from
Nancy Chodorow's object-relations theory, which explains gender differ-
ences by an early identificatory process of young girls with a mother's care,
emotion and connectedness and of young boys with a father's rationality
and separateness. Since Keller relies on this conception of the development
of different male and female personality structures, and because of 'her
Chodorovian belief in fundamental sexual differences in male and female
personality', Moi criticises her for advancing what she feels is a 'cultural
(as opposed to biological) essentialism. . . . The consequences for femi-
nism', Moi goes on to state, 'are . . . an essentialist and quasi-biological
belief in fixed gender identities' (Moi, 1989, p. 191). In this, Moi detects a
reproduction of patriarchal projections of a 'specific female nature', which
leads her to doubt the efficacy of a construction of gender differences based
on Chodorow's theoretical approaches to a male experience of separation
and autonomy, as opposed to female individual histories of an experience
of connectedness and (inter)relatedness.

The crucial issue for Toril Moi is that gender differences are assumed to
be constituted by the early mother–child relationship, and that 'female
modes of knowing' – empathy, connectedness etc. – are seen as the out-
come of a girl's socialisation process. I tend to agree with Moi's critique of

the essentialist position as regards sex differences, and feel that a corrective exists in the shape of psychological and psychoanalytical interpretations that do not focus on gender differences as binary oppositions. We find, in reality, more and more women who are striving to enhance their self-esteem and who want to define their own roles, independently from traditionally female or male traits. In analysing gender differences, it is also helpful to take sociological explanations into account, because issues relating to the division of labour also influence what we call femininity and masculinity. In short, then, my interest concentrates on theories which point up the tensions and contradictions that exist within patriarchal logic. I am particularly concerned with those that are helpful in analysing the consequences of dichotomies in thinking for concepts of equality and difference, viewed from the perspective of gender relations and gender politics.

## 3.   INSTRUMENTALISATION AND RATIONALISATION

In discussing concepts of equality and gender difference in the context of patriarchal rationality it is useful to draw on the *Dialectic of Enlightenment* (*Dialektik der Aufklärung*) and discussions from the Critical Theory of the Frankfurt School (Horkheimer and Adorno, 1947), as well as some aspects of Weber's concept of rationalisation in Western society (Weber, 1922). Classical Critical Theory reflects on the relationship between human reason, embodied in social structures, and political power in society. It does so by focusing on the tensions and contradictions between them. The idea of reason has been a fundamental category in classical philosophical thought. The issues for the Frankfurt School are in the shifting of reason from its critical potential to represent the highest possibilities for human existence in the Enlightenment, to a functional, pragmatic or instrumental rationality within the social changes brought about by industrialisation. Rationality is seen as the legitimation of patriarchal civic society. Max Weber's understanding of rationalisation is based more on social and economic processes of bureaucratisation.

The Frankfurt School writers, Horkheimer and Adorno, characterise the process of the division and separation of rationality from sensuality as an instrumentalisation of reason in modern thought, which is associated with the rationalisation of modern civilisation (Horkheimer and Adorno, 1947). The prevalence of instrumental rationality in Western thinking, by divorcing rationality from sensuousness, has constituted binary oppositions such as human reason as opposed to nature, which are then conceptualised as

being dominant or subordinate spheres. In Adorno and Horkheimer's critique we find the relationship between reason and domination characterised in a similar way to that of Foucault, who stated that the increase of (political) rationality in Western civilisation inevitably resulted in individualisation (separateness), totalisation, and the abuse of power (Foucault, 1977). The 'disenchantment of the world', of the medieval world, its purging of myth and superstition, which initially claimed to establish reason as a means to human self-determination (see, for example, Voltaire's speeches), has in fact established the rule of a specifically functionalistic or instrumental concept of reason (Horkheimer and Adorno, 1947). With the aid of this concept, the processes of marginalisation of particular groups, which amount to an exercise of power, are both set in motion and legitimated. One manifestation of this, I argue, can be seen in the establishment of a gender hierarchy. Horkheimer and Adorno argue that, with the instrumentalisation and formalisation of reason, which means a legitimation of power, the mastery of society and of nature became the *raison d'être* of social power and its source of self-perpetuation (Horkheimer, 1947). Within this process, power relations became more 'rational' not just in societal terms but also in the consciousness of people. To understand what is at stake here we need to consider some rough details of the background to their thinking.

In the 1940s, Horkheimer and Adorno found evidence of a 'demise of the Enlightenment' and a 'reversion to barbarism' in the Fascist rule of violence, in anti-Semitism, and in the devastation of mechanised war (Horkheimer and Adorno, 1947). They traced the cause of this 'regression of progress' to the processes of the Enlightenment itself – to the development of an instrumental rationality adapted to deal only with facts and force of circumstance and their inherent necessities, and leading to a utilitarian organisation and mastery of society and nature. According to Horkheimer and Adorno, this rationalistic mode of thought and action, legitimated by the emancipation of the bourgeoisie in the eighteenth century, has since constituted itself as the sole valid basic principle of the modern era. This is a rationality of economic 'end-and-means' thinking and calculability (Horkheimer, 1947). It relegates such other dimensions of human thought and experience as religion, utopian ideas, dreams and desires to the realm of myth, grudging them a place in art and aesthetics at best, and at worst excluding them altogether as irrational.

I would agree with Horkheimer and Adorno and with the Critical Theorists that division and dichotomies are the essential core of modern instrumental rationality and, I would add, its patriarchal structure. Critical Theory, indeed, implicitly describes this interaction of reason and domination as a

patriarchal phenomenon. While the authors certainly did not point this out explicitly, their thinking leads to the conclusion that the logic of the oppositions previously mentioned – mind versus nature, reason versus feelings – implies a gender hierarchy. The domination of one sex over the other, male over female, is indeed an essential element both of the social structures and of the symbolic systems of Western cultures.

The link between reason and domination, if we follow Horkheimer and Adorno (1947) and also Marcuse (1955), is expressed both on a sociocultural level, in the hierarchy of the sexes, and on the micro level, in the suppression of men's (and also women's) 'inner nature', their drives and instincts, and in the deformation of the individual personal relations between the sexes. One of the highlights of Critical Theory is the way it describes the formation of the autonomous (male) subject (Horkheimer, 1947). This is characterised as a process of repression, which is required to produce the patriarchal male character and identity, and which is repeated in every individual male's biography (Horkheimer and Adorno, 1947). The suppression of drives and of sensuality is a process associated with the history of civilisation which might be characterised, as by Max Weber (1922), as a concomitant of the rationalisation of individual achievement and responsibility that accompanied industrial development. Similarly, Horkheimer and Adorno describe the Protestant Ethic, with its injunction to asceticism, as 'an Industrial Revolution in body and soul' that bolsters the principle of instrumental reason and provides it with historical roots.

Yet Horkheimer and Adorno's thinking is based on an androcentric, male-dominated understanding of logic and of rationality; both are seen as characteristics of male subjects. Their approach contains certain classical stereotypes, such as patriarchal representations of womanhood and androcentric metaphors of femininity (Kulke, 1988b). For example, they describe the reality of women's lives in bourgeois society in terms of stereotyped qualities such as 'pure nature' and 'the guardian of virtue', with dualities like housewife versus whore, or with essentialist manifestations of femininity as the deformed opposite to masculinity, and female chaos versus male reason. The manifestation of femininity is identified with eccentricity and vice, or is characterised by a hysterical figure who revenges the fate of her gender (Horkheimer and Adorno, 1947).

These theoretical and philosophical conceptions act both to analyse and to cement the gender hierarchy, despite the fact that their inception lies in a critique of patriarchal domination. The concept of instrumental rationality includes a decided critique of the power relations associated with patriarchal social structures (Horkheimer, 1947). But there is a paradox here,

for although we can use Critical Theory to illustrate the structure of male power, this critique has its gender blindness as well. This is because it interprets gender differences in terms of essential dualities and polarisations. Nevertheless, the concept of instrumental rationality, together with the dichotomies arising from it in connection with the critique of patriarchy, are useful in finding explanations as to how the socio-political mechanisms for an exclusion of women work. We find this exclusion in the most important social, economic and cultural domains, and, with the concept of instrumental rationality, we may explain it in terms of both the sexual division of labour *and* the symbolic order of our culture.

Horkheimer and Adorno's approach contains contradictions, dissonances, breaks and fissures, but these seem to me to represent more of a challenge than a disadvantage for feminist thinking about a dialectic of equality and difference. After all, rationality as defined by Horkheimer and Adorno does refer to sensuousness, feelings, emotion, and to the energy of drives (Marcuse, 1955), at least to their absence and negation. This, of course, is not to plead for 'another' female rationality, with gynocentric intentions, which is different from that of men. Still, for an analysis of the meanings of differences between the sexes and among women, these non-instrumental rational dimensions could be necessary for critical thought (Moi, 1989).

In discussing the epistemological capacity of the concepts of equality and difference, it might also be useful to consider the method of thinking of 'definite negation', which is – in the heritage of the philosopher Hegel – a critique which reflects the relation of thinking and social existence (Ideologiekritik) in terms of keeping contradictions, conflicts, ambivalences and openness. It seems to me that this way of thinking might be a worthwhile approach for studying gender differences and discrimination against women in the context of power relations and the generation of women's resistance. For example, the concept of 'definite negation' could be used to provide a new and profound dialectical interpretation of women's suffering under, and resistance to, discrimination. This method of thinking would not proceed in conventional either/or terms of success or failure, but might instead suggest new and non-ontological approaches to a dynamic relationship of equality and difference. Additionally, and on a more concrete level, it can be argued that, if reason is reduced to utility, economic calculation and technological advance, then every other experience and interpretation automatically becomes unreasonable or irrational – for example, the need for happiness and justice or for utopian visions.

Rationality, as a reduced and deformed form of what reason could be, implies a concept of human equality which ignores all social, psycho-

logical, ethnic and cultural differences. What this instrumentalisation means, in the context of social existence itself, becomes more specific in Max Weber's analysis of the logic of utility and economic calculation, which he also found to be characteristic of Western social organisation (Weber, 1922). In this way his work complements that of Horkheimer and Adorno. His concept of rationalisation clarifies why mainstream thinking and acting focuses on equality more than on diversity.

Max Weber, unlike the classical exponents of Critical Theory, did not fundamentally question the efficacy of Western rationality, for he wrote against the background of the enormous expansion and modernisation of industrial capitalism at the end of the nineteenth and beginning of the twentieth centuries (Weber, 1922). His interest, however, did focus on the ambivalence caused by the *increasing* social rationalisation of the Western world. By this he meant the raising of utilitarian rationality to a general principle that *both* governed human behaviour (based on the example of entrepreneurial behaviour) *and* structured the organisational framework of society, from the daily life of individuals to the conduct of the state. But he was also conscient of rationalisation as an organising principle for conformism and for the limitation of differences (of needs, interests and strategies). This was because the rationalisation process tends to put political, social and economic interactions and decisions on a scientific basis, with the corresponding 'logical' and thorough-going application of legal regulations and norms. Key terms in Weber's analysis were bureaucratic order and rule, which he saw as indicators of Western rationalisation. He was enthralled by their precision, calculability, discipline, and incorruptibility, as like a 'living machine'. At the same time, however, Weber asked at what cost to social and cultural life, that is to individual liberty and diversity, this highly efficient, utilitarian, and rational business-making and administration, this hegemony of money and power – all male domains – had been achieved? He conceded that modern rationalisation had brought a positive result to the political sphere, since power was now no longer legitimated by traditional elites but by democratic control (what he termed the rational type of rule). But Weber also realised that this development had its problematic aspect since, with the Enlightenment, the political emancipation of the bourgeoisie, and the emergence of social equality and of the modern nation-state, the legal exercise of power had become a monopoly of the state. The latter did not hesitate to use it in the interest of maintaining order – the rule of reason in hard fact.

In Weber's conception of the development of modern Western rationalisation, the fields of state affairs and warfare, and with them technology and

business, were the arenas of modernity in which the rational type of behaviour and action, as opposed to the traditional, emotional and affective type, had achieved its most characteristic form. Now, these domains are indeed structured along utilitarian, rational lines, and they are male domains. It is easily demonstrated, on the basis of Weber's arguments, that structural links exist between the principles of utilitarian or instrumental rationality and patriarchal domination throughout history, because these principles have been constituted in those areas (power, economics, politics), which exclude women (Kulke, 1988b). And if we follow Horkheimer (1947), who, with reference to Weber, conceives of instrumental rationality as a logical system which is reduced to a pure pragmatic utility and economic calculability and efficiency, then it becomes clear, again, that this logic excludes the emotional and sensual aspects of human behaviour. It relegates them to the feminine realm, which amounts to a generalisation of the masculine principle. This dichotomy establishes a scheme of activity and passivity, of culprit and victim, in which women are powerless because they are excluded from the reigning sphere of rationality.

Weber's approach to rationalisation focuses on the socio-political dimensions and conditions of Western logocentrism, and its outcomes for social developments. Individual, social and cultural differences and specific characteristics are merely tolerated, if at all, in their supportive functions for modern systems, and for bureaucracy and administration. They may be considered part of Weber's conceptual framework for modern democracy, only in the sense of being implements for rationalisation. For example, the specific multicultural or ethnic diversities of minorities, or the special needs and interests of classes or groups in society, that is 'differences' have no relevance to this conception.

Rationalisation insists on formal equality alone as an efficient, rational principle for a pragmatic democracy. Not even gender differences are explicitly at issue in modern, efficient organisations. Indeed, Weber's concept of rationalisation tends to cement the gender hierarchy, because of the high value his theories place on the domains of modernity, the public and power.

I view the Weberian tradition as one of the landmarks in exploring and legitimating the division between the public and the private spheres, in subordinating the private to the public realm, and in devaluing reproduction and all activities associated with it, most of which are performed – traditionally – by women. In this regard, the rationalisation concept contains a legitimation of the division of labour between the sexes and so of traditional gender differences.

## 4.  THE PROSPECTS FOR FEMINIST CRITIQUE AND POLITICS

It has been my intention to show how the proponents of Critical Theory, in their classical critique of dichotomous thinking and of the separations (thinking from feeling) implied by rationality, dealt with the problematic issue of equality as a topic of philosophical discussion and of social and political structure, without dealing with gender issues in any meaningful way. On the contrary, their arguments tended to equate women with patri-archal views about femininity and with the myth of nature. Still, the con-cepts of instrumental rationality and rationalisation do critically illustrate the precedence given by Enlightenment rationalism and the dualism of Western thought to a purely formal definition of equality, and show that this both constitutes and legitimates social uniformity and egalitarianism. Both tendencies are implied in the concept of formal equality, which appears, at first sight, both pragmatic and efficient, for gender as well as for other equality issues. Yet, there is also another meaning of equality, which involves focusing on equality of opportunity by taking diversity into ac-count, rather than concentrating on a homogenised equality, although this formulation is not adapted to current forms of rationalisation in thinking and social action. The dominant discourse on democratisation in present-day Western nations is not, for example, oriented to pursuing different equality laws for different groups, nor to recognising that different groups may have divergent needs and interests. Neither the different needs of women from men, nor diverse interests among women themselves, com-prise a topic of serious debate within the discourse on democracy.

But nor can an acknowledgement of difference on its own provide the guarantee of a democratic order, especially where these differences have been constructed through suppression and oppression. Rather, difference might be characterised in terms of a negation (of democracy), mainly by showing what social compulsion and institutional and symbolic power was necessary in order to conceal, in the case of women, the historicity of the social construction of differences and roles. This could be taken to imply, for instance, that the historically constructed division between public and private, which is a source of gender difference, can no longer be cited as an explanation for, and legitimation of, the status quo.

The critique of instrumental rationality also advanced philosophical arguments to justify its scepticism with regard to equality. According to classical Critical Theory, the notion of formal equality arose from a kind of thinking that operated with a logic of identity (*Identitätslogik*); that is, thinking that, instead of countenancing contradictions and diversities – 'non-identicals' – focused entirely on creating identities or similarities

(Horkheimer, 1947). As an alternative to this thinking in terms of identities, Critical Theory advanced the notion of the self-reflexivity of reason. The crux of the logic of identity might be considered to lie in the issue of the violence of identification – the violence it does to the differences between, and the specific characteristics of, individuals and social groups. For an approach to gender differences, and also differences among women, which takes contradictions into account, thinking in terms of non-identity may have relevance for critique, for interaction, and for political practice. It can also be useful for conceptualising subjectivity as regards shifting chances, opportunities, occasions and contingencies – a subjectivity understood without reference to fixed and rigid schemes of identity, but as a concept of multiple identities. Such ideas are not as new as they might seem to be. They are involved in classical dialectical thinking about the relation of individuals to society, and can be found in the writings of the Critical Theorists. The increasing concentration on non-identity thinking can be seen in Adorno's *Negative Dialectic* (1966), in which he attempted to develop a revised Hegelian method of dialectical thinking and analysis. This could also prove central to a dynamic and pluralistic conception of subjectivity and could be a fruitful project for future feminist research.

Adopting a non-identical approach implies, in the present context, the possibility of a critique of formal equality as *impeding* central conditions for emancipation. But to change thinking in identity terms would not be associated with an automatic exchange of concepts; new epistemological and political issues cannot be developed simply by substituting one concept for another. Nor would the inclusion of notions of individual and social differences in a critical investigation and analysis of equality actually change the social reality of discrimination and oppression; it would merely put these in a clearer light. Inferiority, discrimination and oppression can be truly understood, and fought, only when a concept of substantive equality becomes possible, in which diversity is accepted and differences of gender and culture have (special) equal rights. Can, then, social justice with reference to gender relations be better realised on the basis of diversity?

In this context it is useful to recall the emphasis placed by the Italian left-wing politician Rossana Rossanda, and by other Italian feminists, on theories of gender difference as a justification or basis for demands for the autonomy of both sexes (Rossanda, 1990; Cavarero, 1990). She and the women of 'Libreria delle donne', in Milan, and the philosophers' group 'Diotima', at the University of Verona, argue that equality in present legislation – *per definitione* – ignores different needs and interests. So, the politics of equal opportunities are oriented to male norms and standards, and equal rights on their own are not sufficient for women's liberation

and for providing women with a voice. The aim of these Italian feminists is not only to reformulate feminist theory. It is also to articulate women's issues and to develop methods for the deconstruction of the symbolic order of traditional male-oriented politics. One strategy they have adopted, *affidamento*, is designed to develop confidence, networks and support among women, through 'symbolic mothers', who provide encouragement for those with less experience. The focus is on a new form of gendered politics, one which is rooted in separatism.

Although I would question their fundamental criticism and rejection of equal rights *per se*, I follow, to some extent, these Italian feminists' scepticism about formal equality and the apparent equality of opportunity supposedly found in many Western and socialist countries. These feminists claim that the principle of equality can no longer be the goal of the feminist political project, because the equality paradigm merely camouflages the continued existence of sexist domination, and because the formal, legal equality of women has no effect on the patriarchal, symbolic order of society. The politics of sex difference is not to be resolved by equality demands, but is defined as the nucleus around which an 'autonomous' (political) subjectivity for women can be constituted (Cavarero, 1990, p. 96). The arguments and political demands of these feminist groups follow the idea, advanced by Luce Irigaray, for a genderisation (their term is 'bisexualisation') of rights and law, based on the existence of two different subjective positions and modalities which are ignored and eliminated by equal-rights policies and laws (see Irigaray, in Gerhard et al., 1990). A concrete example, here, is the current discussion in Germany about equal rights for women, which has led to them doing night-work like men. In addition, the Italian feminists state that, while legislation is based on exchange-value and embodied in abstract moral principles, women embody experiences of use-value, because they are closer to real elements of living, such as feelings and intuitions, and less close to abstract regularities and rules. This, however, is a problematic dichotomy because it separates the female realm from the power relations of the gender hierarchy in society.

The methodological difficulties for these groups, especially the Milan group and 'Diotima', have been pointed out in discussions about the justification of gender differences and the concepts of autonomy and subjectivity. The German and Austrian writers I have in mind criticise the tendency of these groups to generalise about differences between the sexes (Nagl-Docekal et al., 1990). Nevertheless, I do not think we can afford to ignore the fact that the Italian feminists' critique of the continuing discrepancy between formal and substantive equality does lead in a politically relevant direction, in that it attacks the universalistic assumptions about equality

found in the politics of leftist parties, particularly in that of the Italian Communists (Cavarero, 1990).

Other European feminists have also, and repeatedly, argued that the traditional concept of equality has served to hinder a complete and non-hierarchical acceptance of 'female differences' (List and Studer, 1989; Gerhard et al., 1990; Maihofer, 1990). They have pointed out that this circumstance has historical roots, for in numerous attempts, in the past, to justify women's equality, their difference from men was again and again declared to be unimportant or irrelevant, while what they shared in common was emphasised, with the best emancipatory intentions. However, when gender differences tend to be defined in absolute terms, we immediately find ourselves in the midst of a tradition that goes back to Rousseau, among others, and that is characterised by an essentialist and hierarchical under-standing of gender differences. Those who argue in these terms are con-cerned not so much with processes of differentiation as with universals, even though, unlike Rousseau, they emphasise the positive manifestations of femininity. The position of such 'difference feminism' (Moi, 1989) runs the risk of establishing a new metaphysics of gender differences. In this context, Kristeva has warned against the danger of essentialism and marginalisation which arises when women are stylised into an 'incarnation of difference' (Coole, 1990, p. 101).

I would further agree with Kristeva that differences are not a property of women, but, as Coole emphasises, represent a challenge to the divisions and separations of thinking and to the laws of the symbolic, since they are subversively directed against logocentrism and the patriarchal symbolic order (Coole, 1990; Kristeva, 1986). In this context, however, I would not give as much weight as Kristeva does to motherliness as a subversive difference, since in my view motherliness represents only one possible facet of femininity. The extent to which motherliness is bound up with patriarchal projections should also be investigated. However, Kristeva's contribution goes further than Coole's characterisation of 'beyond equality and differ-ence', and to my mind offers a stimulating approach to a pluralisation of the concepts of equality and difference as well as to their critique.

Of relevance to my approach would be Coole's interpretation of Kristeva's project as a 'politics of negativity', in which negativity is not only a method of thinking but is linked psychically and politically with processes of subversion, deconstruction and resistance (Coole, 1990). This establishes a relationship between political action as a critical, rational operation and political action as stimulated by emotions and non-cognitive experiences. This means, also, that physicality and the body come into play – at least in the preliminary stage of semiotics – aspects which are not merely rational-

istic and which go beyond what I have termed 'sensual reason' (Kulke 1988b). The intention here is not to create a counter-system based on body dimensions, with a separate counter-logic, but to suggest an open and pluralistic perspective which involves the semiotic with the symbolic, and questions the latter (Kristeva, 1986). It might be outlined as follows.

The traditional systematic and political context of (formal) equality can best be described in terms of an abstraction from peculiarities and diversities. But the context of the differences between and within the sexes can best be characterised in terms of concrete diversities. This conception of difference, then, does not exclude what Kristeva calls semiotics. So the politics of negativity could point to a link between rationality and eros, that is, body experiences; hence drives, dynamics and the psychic unconscious are not longer ignored. This reference to abstraction and concretion should not be understood as an attempt to reintroduce a binary system.

What I wish to suggest is that if feminist theory and politics considers transformative politics as embracing not only social structures but individuals as well, then the dimension of the female human body needs to be taken into account. Indeed, the 'speaking (female) subject' may be considered a body in this sense. I sympathise in this regard with Toril Moi, in that what interests me about this conceptual framework of physicality and the body is the relevance of desire, dreams and utopian visions as useful dimensions of reason. It seems to me that a pluralistic conception of a substantive equality which encorporates differences has to contain those dimensions. Nor can Moi be accused of idealising the body, for, with reference to Freud and Lacan, she emphasises that the body is the very factor which restricts rationalistic discourse. Moreover, as she continues, 'if reason is always shot through with the energy of drives, the body, and desire to be intellectual, it can no longer be theorised simply as the 'opposite' of being emotional or passionate' (Moi, 1989, p. 203).

REFERENCES

Adorno, Theodor W. (1966), *The Negative Dialectic* (London: Routledge).
Benhabib, Seyla and Druscilla Cornell (1987) (eds), *Feminism as Critique* (Minneapolis: University of Minnesota Press).
Cavarero, A. (1990), 'Die Perspektive der Geschlechterdifferenz', in U. Gerhard, M. Jansen, A. Maihofer, P. Schmid and I. Schultz (eds), *Differenz und Gleichheit: Menschenrechte haben (k)ein Geschlecht* (Frankfurt-am-Main: Ulrike Helmer Verlag).

Chodorow, Nancy (1979), *The Reproduction of Mothering* (Berkeley: University of California Press).
Coole, Diana (1990), 'Beyond Equality and Difference: Julia Kristeva and the Politics of Negativity', in H. Nagl-Docekal and H. Pauer-Studer (eds), *Denken der Geschlechterdifferenz: Neue Fragen und Perspektiven der Feministischen Philosophie* (Vienna: Wiener Frauenverlag).
Foucault, Michel (1977), *Madness and Civilisation* (London: Tavistock).
Fox Keller, Evelyn (1984), *Reflections on Gender and Science* (New Haven, CT: Yale University Press).
Fraser, Nancy (1987), 'What's Critical about Critical Theory? The Case of Habermas and Gender', in Seyla Benhabib and Druscilla Cornell (eds), *Feminism as Critique* (Minneapolis: University of Minnesota Press).
Gerhard, U. (1990), *Gleichheit ohne Angleichung: Frauen im Recht* (Munich: C. H. Beck).
Gerhard, U., M. Jansen, A. Maihofer, P. Schmid, and I. Schultz (eds) (1990), *Differenz und Gleichheit: Menschenrechte haben (k)ein Geschlecht* (Frankfurt-am-Main: Ulrike Helmer Verlag).
Gould, C. C. (1989), 'Private Rechte und Öffentliche Tugenden: Frauen, Familie und Demokratie', in E. List and H. Studer (eds), *Denkverhältnisse: Feminismus und Kritik* (Frankfurt-am-Main: Suhrkamp).
Horkheimer, Max (1947), *The Eclipse of Reason* (Oxford: Oxford University Press).
Horkheimer, Max and Theodor W. Adorno (1947), *Dialektik der Aufklärung* (Amsterdam: Querrido).
Kristeva, Julia (1986), 'Women's Time', in Toril Moi (ed.), *The Kristeva Reader* (Oxford: Oxford University Press).
Kulke, Christine (ed.) (1988a), *Rationalität und Sinnliche Vernunft. Frauen in der Patriachalen Realität* (Pfaffenweiler: Centaurus).
Kulke, Christine (1988b), 'Von der Instrumentellen zur Kommunikativen Rationalität Patriachaler Herrschaft', in Christine Kulke (ed.), *Rationalität und Sinnliche Vernunft. Frauen in der Patriarchalen Realität* (Pfaffenweiller: Centaurus).
List, E. and H. Studer (eds) (1989), *Denkverhältnisse: Feminismus und Kritik* (Frankfurt a. M.: Suhrkamp).
Mackinnon, Catherine (1989), *Towards a Feminist Theory of the State* (Cambridge, Mass.: Harvard University Press).
Maihofer, Andrea (1990), 'Gleichheit nur für Gleiche?', in U. Gerhard et al. (eds), *Differenz und Gleichheit. Menschenrechte haben (k)ein Geschlecht* (Frankfurt a. M.: Ulrike Helmer Verlag).
Marcuse, Herbert (1955), *Eros and Civilization* (Boston, Mass.: Beacon Press).
Moi, Toril (1989), 'Patriarchal Thought and the Drive of Knowledge', in Teresa Brennan (ed.), *Between Feminism and Psychoanalysis* (London: Routledge).
Nagl-Docekal, H. and H. Pauer-Studer (1990) (eds), *Denken der Geschlechterdifferenz. Neue Fragen und Perspektiven der Feministischen Philosophie* (Vienna: Wiener Frauenverlag).
Rossanda, R. (1990), 'Differenz und Gleichheit', in U. Gerhard et al. (eds), *Differenz und Gleichheit: Menschenrechte haben (k)ein Geschlecht* (Frankfurt a. M.: Ulrike Helmer Verlag).
Weber, Max (1922), *Gesammelte Aufsätze zur Religionssoziologie,* vol. 1 (Tübingen: J. C. B. Mohr).

Young, Iris Marion (1987), 'Impartiality and the Civic Public: Some Implications of Feminist Critiques of Moral and Political Theory', in Seyla Benhabib and Druscilla Cornell (eds), *Feminism as Critique* (Minneapolis: University of Minnesota Press).

# 8 Facing the 1990s: Problems and Possibilities for Women's Studies

JOANNA DE GROOT and MARY MAYNARD

This chapter draws on our experiences as teachers, writers and researchers in Women's Studies to reflect on its current state and position epistemologically, theoretically and methodologically. After two successful decades of second-wave feminist research and scholarship, the 1990s have emerged as a moment of self-reflection and doubt. We sense something of a *loss of confidence* in the viability of the Women's Studies project. This arises largely from the challenges which have been made to the idea that there can be a universal feminist approach or a generally valid framework for feminist analysis or politics. The early concerns with the ways in which men exercise power over women have been complicated by the increasing awareness that women comprise a diverse and varied group. It is no longer appropriate to talk about 'women' in the homogeneous way that Women's Studies previously did.

There is also a feeling of *discouragement* around. We are told that feminism has had its day; that we now live in a post-feminist society in which any possibility for decreasing inequalities or widening opportunities for women have largely been attained. A further issue relates to the *contradictions* experienced by those involved in feminist and Women's Studies activities. Here, we are thinking about the ways in which some of their most observable and measurable achievements have gone unacknowledged or have been appropriated and marginalised. Relevant feminist work has been ignored in discussions of postmodernism, for instance, and feminist thinking has been largely excluded from so-called mainstream social science theory (Maynard, 1990; Morris, 1988). All of this seems to have drawn some writers into a pessimistic mood, with terms such as 'impasse' (Ramazanoglu, 1989, p. 95) and 'crisis' (Delmar, 1986, p. 29) being used to describe the situation.

Our purpose in this chapter is to explore some of the issues which we see as being the most central that Women's Studies has to face at the present moment, with a view to suggesting how they might be more positively confronted and overcome. More specifically, we have three main aims. In

149

the first part of the chapter we ask 'what are the problems?', by identifying five aspects of the current debate which appear to comprise the most serious intellectual and political challenges. The second part asks 'what questions are raised?' and explores some of the underlying issues for feminist political and academic practice which emerge from the initial challenges. The third part of the chapter puts forward strategies for moving forward and engaging with the difficulties which have been identified. We conclude by arguing that the capacity of Women's Studies to respond to the intellectual challenges of its critics is both a condition and proof of its continued vitality, viability and visibility as an important and established field of work.

## WOMEN'S STUDIES AND ITS DISCONTENTS: FIVE CHALLENGES

At the beginning of the 1990s there seem to be five major challenges which Women's Studies has to face. We have chosen to call these: 'The Challenge of "Diversity"'; 'The Challenge of Gender Studies'; 'The Challenge of Postmodernism'; 'The Challenge of "Doing" Theory'; and 'The Challenge of Feminist Scholarship'. As will be seen, these challenges come from a range of intellectual sources which both exist inside of, and are external to, Women's Studies. They are concerned with a variety of issues, such as the nature of the appropriate subject matter to be the focus of study, the methodological approaches to be used, the relationship with other disciplines and intellectual perspectives, and the kind of scholarship to be produced. These issues do not fall neatly under particular headings, and arise in more than one of the challenges we have highlighted for treatment.

### (a)   The Challenge of 'Diversity'

Our understanding of diversity has two components, and it should be noted that we are deliberately using 'diversity' and not the more widely used term 'difference' here.[1] The first of these is an acknowledgement of *differentiation*. This refers to the significant, but often overlooked, fact that not all women's lives are structured in the same kinds of ways or necessarily take the same forms. Dissimilarity as well as similarity has to be taken into account. Attention must be paid to characteristics and circumstances which women do not all share (poverty or sexual orientation, for example), as well as to those that they do.

The second element to diversity is that of *variation*. Even where wo-
men's lives appear to take similar forms and to be structured in similar
ways, their experiences of this may well vary. For instance, women the
world over may be assigned a mothering role, but the significance and
meaning of this differs depending on its historical and cultural location.
'Variation' thus draws attention to different levels of experience. It signifies
the multiplicity of circumstances which may be embedded within apparent
structured uniformity.

The significance of an understanding of diversity, to the Women's Stud-
ies project, has come from a number of sources. All argue that they have
been excluded as subjects in feminist work. The most well-known and most
sustained articulation of the arguments has come from Afro-American and
black British women, who have criticised the ways in which Women's
Studies speaks only of a white, eurocentric, middle-class world. Black
women[2] have pointed to their *invisibility* in much of the literature and to its
inherent racism (hooks, 1984 and 1989; Spelman, 1988). They have shown
how Women's Studies has suppressed the ideas of black women and ig-
nored their contribution to debates around the issue of oppression, so that
little of this material has found its way into what would be regarded as the
mainstream of Women's Studies work (Collins, 1990; Davis, 1981).

A focus on race and racism, however, is not the only way through which
a concern with diversity has become manifest, as attention has been drawn
to the manner in which other factors, such as class, heterosexism, disability
and age can have a profound effect on how women see themselves, how
they are viewed by others, and the opportunities and possibilities which are
open to them. In terms of academic work, for example, the 1980s witnessed
a growth in the study of women and development. By focusing on the
differentiation and variation in women's economic and social experiences,
in a wide range of societies other than those of the 'advanced' industrial
countries, this work underscored the plurality of meanings, in women's
lives, of phenomena such as family, work, nation and citizenship (Afshar,
1985 and 1987; Momsen and Townsend, 1987; Sen and Grown, 1987). It
pointed to the consequences and implications for women of being involved
in anti-colonial and anti-imperialist struggles, thus illuminating and extend-
ing the debate which the critique mounted by black Western women had
raised (Liddle and Joshi, 1986; MacDonald et al., 1987; Mernissi, 1984;
Spivak, 1988 and 1990; Yuval-Davis and Anthias, 1989).

Other writers have drawn attention to the homophobia and heterosexism
which lesbians continually have to face (Jeffreys, 1990). In the United
States, in particular, lesbians have been critical of the ways in which lesbian
issues are marginalised in Women's Studies or treated in a cursory way.

They have argued the significance of a lesbian perspective, and for the development of Lesbian Studies as one way of acknowledging the importance of differences in sexuality when discussing diversity (Cruikshank, 1982).

The argument about diversity, however, is not just confined to the realms of academic feminism and Women's Studies. Instead, it surfaced early on in the politics of the Women's Movement, as may be seen, for instance, in the debates about class differences and the relative status of mothers versus childless women (Coote and Campbell, 1982; Rowbotham, 1990). This was also supported by developments in other arenas, for example in women's creative and autobiographical writing, which gave less privileged women from differing backgrounds space to find a voice with which to describe their lives (Angelou, 1984; Barker, 1984; Steedman, 1987). Yet, although an awareness of what diversity means for women has been gradually filtering into the Women's Studies arena, it is only recently that this has been consciously and explicitly acknowledged within the established mainstream. The implications of this are, of course, well known.

It questions, for example, the legitimacy of many of the universalising and generalising statements made, which are premissed on the experiences and views of only a small minority of women. It undermines the cosy notions of homogeneity, sharedness and sisterhood which characterised the early years of second-wave feminism. It suggests that women's subordination can no longer be regarded as relatively straightforward and to be analysed in a non-contradictory way (Amos and Parmar, 1984). The challenge of diversity points to the fact that women's lives are structured, mediated and experienced through a variety of oppressive forces. Subordination to men is only one such form, although it undoubtedly affects the relationship of one to the others. Moreover, not only do women 'differ', they are also capable, depending on their position in the web of 'interlocking' (hooks, 1989, p. 21) or 'intermeshed' (Ramazanoglu, 1989, p. 128) systems of oppression, of exercising power and privilege over other women. Thus, although all women may be oppressed, they do not share a common oppression. This raises problems for Women's Studies in a number of ways. It raises the whole question of employing the concept 'woman' as a pre-given universal category. Indeed, the acceptance that women are divided, white from black, third-world from first-world, has been regarded in some quarters as sufficient reason for jettisoning the term as an analytical tool altogether (Delmar, 1986; Mitchell, 1986). Further, the challenge of diversity makes it difficult to talk in unqualified terms about women's oppression and the shared sisterhood that was supposed to arise from it. Yet, if this is the case, it becomes difficult to see what the foundation of a Women's

Studies approach to the social world might be, nor what could serve as a basis for women coming together politically. The idea of diversity is radically challenging for Women's Studies because it undermines the very assumptions and 'historical identity on which feminist politics has traditionally been based' (Barrett, 1987, p. 29).

## (b)  The Challenge of Gender Studies

Increasingly, from the mid-1980s, there has been a flourishing of texts, research and publications which use the term 'gender' rather than that of 'women' as their focus. This is despite the fact that a lot of this work appears, when subjected to detailed scrutiny, not to be concerned with problematising and analysing the relationships between the sexes, as the word 'gender' implies. Rather, it is about women. Yet to talk about women, or certainly to advertise the fact that this is what one is doing, now appears, as Mary Evans has pointed out, to have become somewhat controversial and less acceptable (Evans, 1991). Instead, 'gender' is being used as a substitute for 'women', with the consequence that, once again, women's lives as legitimate subjects for research disappear from view.

A further development of concern here is the increasing interest in the study of masculinity and the development of men's studies. The argument for such work is that, although it is the case that men, historically, have been the main subjects of academic research and discussion (and indeed this was the very reason for the development of Women's Studies), it was men in a genderless sense who were being given attention (Hearn and Morgan, 1990). There was little direct focus on the social construction of 'men'. It was as if the nature of manhood and the qualities associated with this were irrelevant to understanding the social world. It has been argued, therefore, that in focusing on men, researchers are giving due regard to an area of study which is long overdue. Now that the significance of women's experiences and lives has been subject to scrutiny, it is time for a similar exercise to be repeated for men.

It seems to us self-evident that we cannot deny the importance of studies of gender, where these comprise properly constituted analyses of the relationship between the sexes. Nor can we refute the significance of understanding the social construction of masculinity. After all, once we have accepted the argument that there is no such thing as essential femininity, a similar position must be accepted for masculinity. Further, to understand women's oppression and subordination, and the processes through which this operates, it would seem helpful, if not mandatory, to have some idea of the roles, attitudes and ideas of those who do the oppressing. Indeed it can

be argued that some of the most useful Women's Studies literature is precisely that, as in Cockburn's study of patriarchy in the workplace, or analyses of violence towards women, which has explored male privilege and power (Cockburn, 1983; Hanmer and Maynard, 1987). Moreover, have not feminists argued that men should take responsibility, themselves, for their sexism and oppressive masculinity? What then is at issue?

The problems, as we see them, are as follows. First, there is the obscuring of work on women by referring to it in terms of gender, and the question of the legitimacy of focusing on women only, to which this gives rise. Secondly, much of that work on gender which is about relations between the sexes allows for difference but not for *unequal* difference. There seems to be the assumption that the interests of the sexes have now converged, that it is possible to consider gender relations without confronting men's power and how this may be used against women in certain circumstances. Whereas the focus on 'women', and the emergence of Women's Studies, signalled an awareness of the *political* significance of the label and of focusing on this group, the rhetoric of *gender* is increasingly being used in a benign and neutral fashion without addressing questions of power, privilege and women's subordination. We suggest that it is becoming fashionable to use the term gender to imply that feminist questions have been taken on board. The result is a defusing and depoliticisation of the issues which have formed the core of feminist and Women's Studies concerns.

The same is true for a lot of the work on men and masculinity. The work produced so far has been both varied in nature and patchy in quality. It ranges from a consideration of male sexuality and violence to a focus on fatherhood and parenting (Ford and Hearn, 1988). With a few notable exceptions, little of this is particularly theoretically sophisticated.[3] Most of it is pitched at an individual level of analysis, concentrating on questions of identity, personality and socialisation. The emphasis seems to be on uncovering the essential characteristics of who men *are*, rather than on looking at what men *do*, and the consequences of their actions. There seems to be little interest in the assymetricality of power relations and in men's position as a dominant and domineering group. The discussion lacks concern with how male collective privilege is established over women, and the ways in which individual men collude in this. Such work may problematise masculinity for men, but, on the whole, it does not do so from the point of view of women.

The challenge to Women's Studies, therefore, is that, as presently constituted, both gender studies and men's studies appear to overlook the specific circumstances of women's position, and particularly their subordination. The danger is that this may become assimilated with an anti-

feminist or post-feminist stance. We cannot refute the significance of analyses of gender and of masculinity, but how can these developments be accommodated without politically defusing the concept of 'woman' and undermining the Women's Studies project? As seemed also to be the case with the challenge of diversity, both of these would appear to be under threat.

## (c) The Challenge of Postmodernism

There is currently much discussion about the implications of postmodernism for feminism and Women's Studies. Is this some new and transient intellectual fad, or are there issues within it which feminists need to take seriously? The problem with answering this question in a straightforward way is that there is no consensus, between those who subscribe to postmodern views and those who are critical of them, as to what the term means and whose work should be included in it.[4] In its most basic sense, postmodernism may be seen as challenging the Enlightenment thinking associated with modernism. The Enlightenment pictured the human race as engaged in an effort to find universal moral and intellectual self-realisation. Important here was the notion that reason, as employed philosophically and scientifically, could provide an objective, reliable and universal foundation for knowledge (Flax, 1987). Such knowledge would then be used to improve the quality of life (whether seen in moral, social or political terms). It would enable societies to develop and progress to higher forms of civilisation. Postmodernists object to such a notion on three counts. First, it does not work, in that modernity has singularly failed to improve the human condition. Secondly, to continue with such aims in current circumstances is historically outmoded. Thirdly, such attempts are both 'sinister' and 'misguided' because we can no longer regard history as progressive or as having direction (Lovibond, 1990). The main theoretical protagonists of such postmodern views are usually taken to be writers such as Jean Baudrillard, Jean-François Lyotard and Frederic Jameson, although numerous others have also contributed to the debate.

Some feminists have argued that feminism and Women's Studies have much to learn from postmodernism (Alcoff, 1988; Flax, 1987; Hekman, 1990; Nicholson, 1990), and there are certainly significant ways in which their concerns converge. For example, both are critical of the universalistic grand theories and metanarratives to be found in the modernist thought of writers such as Marx and Freud. Feminists have adopted this stance because of such theorists' gender-blindness, while postmodernists argue against their rationalism and essentialism. Both feminism and postmodernism share

an emphasis on cultural construction. For the former, this is in terms of the ways in which gender roles and relations are historically and culturally contingent. For the latter, this is expressed via analyses of the ways in which discourse creates subjectivities and identities, of the manipulative tendencies of the mass media, and of the growth of information technology in the knowledge and communications revolution. Women's Studies and postmodernism are both preoccupied with issues of difference and diversity, which has led to critiques of fixed a-historical concepts such as 'self', 'truth', 'sexuality', 'science' and oppression. They have both grappled with the relationship between theory and analytic thought, on the one hand, and the seriousness of social, cultural and political issues, on the other. Is it possible to relate theory and praxis; to envisage the possibility of social change and to engage in progressive political projects to bring such change about? While we are not suggesting that feminist scholarship and postmodernism treat such issues in the same kinds of ways or draw similar conclusions, it is the case that they each have had all the above as central components of their agendas.

Despite the existence of such overlapping terrain, however, we believe that there are other ways in which postmodernism poses a number of problems and threats to feminism and Women's Studies, and that these need to be treated very seriously. The challenges occur at two levels: the intellectual and the political.

First, although feminism has been critical of the grand theorising of male writers, it has, as was noted in the earlier discussion on diversity, also been guilty of creating its own metanarrative, one based on a homogenising of womanhood. This is to be seen, for instance, in its theorising of patriarchy as a unified system, or in work which discusses the sexual division of labour without acknowledging its historical and social specificities. Postmodernist arguments, therefore, would appear to reinforce, and lend further support to, those who contend that the feminist and Women's Studies project is historically outmoded because it is premised on a unified subject, 'woman', who can no longer be seen to exist. A further consideration here is the postmodernist challenge to the position of feminists that gender is to be regarded as a significant phenomenon in most socio-cultural experiences and practices, and is an ongoing source of inequality and exploitation. Postmodernist thinking discounts arguments for gender having a substantive base in social and individual existence. This is the case because, in its emphasis on the fragmentation of an individual self, a person's multiple identities, and the way in which these emerge from within a multiplicity of discourses, postmodernism effectively dismantles gender (or indeed other concepts such as class and race) as significant and shared socio-political

categories. Such structural and one-dimensional terms find no place within an approach which sees the world as a constantly moving plurality. As with diversity and gender studies, with which it has some intellectual links, it therefore challenges both the *raison d'être* and the legitimacy of feminism and Women's Studies.

The political threat which postmodernism offers also comes from two sources. First, because postmodernism raises doubts about the possibility of grounding socio-political change and betterment in any meaningful social analysis, it poses for feminists the problem of how we are to pursue emancipatory projects sustained by analyses of male power, privilege and oppression. If conceptualising, analysing and theorising inequality in general terms is no longer deemed to be possible, how are we to know where to channel political activity and the forms this needs to take? Postmodernism effectively negates the possibility of any fruitful political interventions. It also breaches the link between politics and scholarship which has formed one of the important bases for the generation of feminist knowledge. Secondly, a direct challenge is made to feminism by the actual hostility expressed by most postmodernist thinkers to feminist thought and activity. This is shown both in their wilful neglect of the substantial body of scholarship which is relevant to their concerns, and in the actual misogyny and chauvinism which is sometimes present in their language and arguments (Morris, 1988). The challenge is, thus, both intellectual and political; covert and overt. It is implicit in the content of their arguments and openly expressed.

### (d) The Challenge of 'Doing' Feminist Theory

The challenges so far discussed, those of diversity, gender studies and postmodernism, raise the question of what constitutes the proper subject matter of feminism and of Women's Studies and how this is to be conceptualised and theoretically approached? The early years of second-wave feminism were typified by some very bold attempts to analyse women's subordinate position in society (for example, Firestone, 1972; Hartman, 1979; Kuhn and Wolpe, 1978; Millett, 1972). Reacting to the invisibility of women in other theoretical texts, these authors were concerned to theorise in generalising terms about the structured nature of the relationships between men and women. By focusing on the way in which men had seized control of reproduction, Firestone argued, in terms derived from Marx and Engels, that women comprised a sex class. Hartman suggested that in order to understand women's subordinate position in society it was necessary to analyse the combination of patriarchy and capitalism. The contributors to

*Feminism and Materialism* attempted to formulate a systematic approach to analysing women's relationships to both production and reproduction, from within a materialist framework (Kuhn and Wolpe, 1978). Millett concentrated on defining the social, political, economic, cultural and ideological factors which constitute a complex and interrelated whole – the system, patriarchy. The concern of each writer was to posit the existence of a second system of exploitation and oppression, one which existed alongside the more usually discussed system of capitalism. Subsequently, a whole series of debates developed as to the relationship between the two.

There has been a tendency to classify these as taking the form of either Marxist Feminist or Radical Feminist or Dual Systems theory (Walby, 1990). In fact, such a formulation is misleading since it suggests that each category is homogeneous when, in fact, each contains writers with quite substantial differences in emphasis (Maynard, 1990). Of interest here, however, is the overarching nature of much of the work produced, together with a tendency, in some quarters, to adopt a very abstract style of writing and analysis. Further, the focus of many writers, whether implicitly or explicitly acknowledged, seems to have centred on the search for *the* key factors which determine women's oppression. The candidates have varied widely, including, for example, women's position as a reserve army of labour, their unpaid labour in the family–household, male violence towards them, compulsory heterosexuality, etc. etc.

There are two points to be made about this kind of feminist theoretical work. First, much of it has adopted precisely that 'grand' approach now challenged by the 'discovery' of diversity and the advent of postmodernism. Secondly, it has taken the same kind of perspective, as to what constitutes theory, as that generally accepted by the male academic mainstream. Until recently this has legitimated the grandiose schemas as being the most prestigeous and powerful forms of knowledge. Feminists have sometimes run the risk of apeing these assumptions, partly, of course, because they have been trying to confront the gender-blindness of much of what passes as theory.

We are now in a situation where we need to confront the question as to what kind of project feminist theory could and should be mounting, in the light of the various issues which have been raised in this chapter so far. How far is the attempt to understand the *structured* nature of inequality undermined by postmodernist arguments? Should the attempt to generate generalisable forms of knowledge be abandoned? Is it still possible to use concepts such as patriarchy, for example, when it is clear that it means different things to different women in different circumstances? Is 'grand' theory the only kind of theory or are there other forms which might prove

useful both analytically and politically? Clearly these questions are not limited to feminism and the Women's Studies field alone. Others are already debating such issues. Our argument is that these debates are highly germane to the issues surrounding the other challenges so far outlined. It is important for feminists to engage with these concerns on two counts. We need to be clear about a strategy for the development of feminist theory in the future. Further, feminism must take seriously the relevant theoretical debates which are taking place in other areas of intellectual life if it is not to become tangential to mainstream concerns, as has so often been the case in the past. This is particularly necessary with theorising which marginalises, negates or attempts to undermine the very central tenets of feminism.

## (e) The Challenge of 'Doing' Feminist Scholarship

In the past, Women's Studies has claimed not only a distinctive theoretical approach and conceptual agenda, through its elaboration of an understanding of concepts such as patriarchy, the sexual division of labour, reproduction etc., but also different strategies for doing feminist scholarship. Two distinctive, but related, formulations may be identified.

First, there is that work concerned with epistemological issues, what constitutes the grounds for adequate knowledge. Much of this shares a focus with the postmodernist analysis discussed earlier. Feminists have been critical of the emphasis afforded to notions of rationality, reason and objectivity to be found in much accepted writing as to what constitutes 'science'. They have argued against dichotomous formulations, such as reason versus emotion, reality versus fantasy, objectivity versus subjectivity, mind versus body, pointing out that while the first part of the equation is taken to be axiomatic of good practice, the second part is devalued. They have questioned whether science is as value-free, neutral and untainted by class, race and gender as is often assumed (Harding, 1986; Harding and Hintikka, 1983; Smith, 1987). Instead, feminists have sought to transform our understanding of what knowledge is and how it is produced and legitimated. They have pointed to alternative forms of being and knowing, particularly emphasising the role of subjectivity, emotions and experience in the knowledge-generating process.

A second way in which there has been a concern with feminist scholarship is found in the challenge to conventional methods of research. This may be seen in the arguments about qualitative versus quantitative approaches, in the attempts to break down hierarchical power relationships between researcher and researched, and in the attempt to go beyond static models of research by developing techniques for incorporating process,

conflict and contradiction (Fonow and Cook, 1991; Reinharz, 1992; Roberts, 1981; Warren, 1988). It had been claimed that developments such as these constituted a new and distinctly feminist methodology (Bowles and Duelli-Klein, 1983; Roberts, 1981). However, it is now recognised that such a phrase is probably not the most appropriate way in which to describe what has been taking place (Harding, 1987; Stanley and Wise, 1990). This is because, whereas methodology refers to the theory and analysis of how research should proceed, most of the discussion has been pitched at the level of data collection or of the ethics of research practice, rather than at that of methodology *per se*. In addition, many of the research techniques used and advocated by feminists (unstructured interviews, ethnography, for example) are not original and specific to them, and arguably should be part of any good research practice.

Such debates on feminist scholarship raise a number of problems as to how it should proceed. One difficulty is that there tends to be a gap between epistemological work, which takes place at quite a high level of abstraction, and the material on issues of method and technique, which is far more concrete and applied in its approach. The question needs to be asked as to what is the relationship between these two ways of thinking about doing research, and what implications do they have for each other? Whereas the writing on feminist epistemology is heavily critical of conventional practice, and although feminists have developed a series of woman-centred and woman-sensitive research tools, at the end of the day these still tend to be rooted in mainstream forms. In addition, discussions of method and research practice tend to use dichotomies (such as qualitative versus quantitative), which are identified as either pro- or anti-woman, as opposite and irreconcilable, a rigid form of polarisation which epistemological arguments reject. At the moment, then, the epistemological challenges are not necessarily taken into account by those engaged in empirical research.

A further consideration relates to the standards of evaluation which feminist research seeks to attain. Feminists have, quite rightly, been critical of scientism, advocating a form of relativism which, as Stanley and Wise put it, while not denying the existence of 'truth' or external material reality, acknowledges that 'judgements of truth are always and necessarily made relative to the particular framework or context of the knower' (Stanley and Wise, 1990, p. 41). Yet this begs the question as to how feminist work is to be evaluated. Against which sorts of standards and criteria is it to be judged? For, although we may wish to reject conventional ways of doing this, nevertheless, feminist work still needs to be rigorous, with the terms in which it is conducted available for scrutiny. The issue appears to be: in what terms should we judge our own work? This is particularly important in

persuading those who may not at first be sympathetic to feminist arguments, of the relevance, legitimacy and credibility of what we have to say. The challenge of feminist scholarship seems, therefore, to require a return to the old, vexed matter of a feminist methodology, which links our theories about the social world with the activity of research practice in it. The challenge may be formulated in the question as to whether there is something distinctive about what feminists do. Is there something which is identifiably feminist involved in it, or is it just distinctive because those who are doing it refer to themselves, or are referred to by others, as feminists?

## EXPERIENCE, AUTONOMY AND JUDGEMENTAL POLARISATION: SOME QUESTIONS FOR REVIEW

In the first part of this article we have drawn attention to five intellectual and political challenges which we feel Women's Studies is facing and which need to be confronted if it is to continue to develop and expand. These have mainly emerged as a result of dealing with issues that are largely external to Women's Studies itself. Although clearly important, they do not necessarily originate from strictly 'inhouse' concerns, which, of course, is one of the things which makes them all the more challenging.

We now want to suggest that one of the effects of these challenges is to sharpen the need to deal with some further questions which arise from within Women's Studies more specifically. There are three questions that will be considered here: the role of experience; the autonomy of Women's Studies; and the effects of polarising judgement.

### (a)  Experience and Analysis in Women's Studies

The last two challenges discussed, in particular (those dealing with theory and with scholarship), both have a significant relationship to a central element in feminist politics and intellectual practice: the link between experience and what this means in terms of analysis and understanding. One of the driving forces of feminism has been the need to challenge the passivity, subordination and silencing of women, by encouraging them to speak about their own condition and, in doing so, to confront the 'experts' and dominant males with the limitations of their own knowledge and degrees of comprehension. As Dorothy Smith so cogently put it: 'The only way of knowing a socially constructed world is knowing it from within' (Smith, 1974, p. 11). Because of women's previous invisibility, feminism

must begin from women's experiences, since it is only from such a vantage point that it is possible to see how their world is organised and the extent to which this differs from that of men (Smith, 1987). Thus, the legitimacy of our own understanding of our experiences is one of the hallmarks of feminism. This has been encapsulated in such phrases as 'finding a voice', 'raising consciousness' and 'making visible'.[5]

An emphasis on experience, however, is not unproblematic. First, as has been indicated in the discussions on diversity and postmodernism, there is the question of authenticity. Whose experience is to be regarded as authentic? Which women are given a voice and on whose terms? When undertaking feminist research, how are women selected for participation, on what basis, and who has power in the decision-making? There has been a tendency for feminists to treat 'experience' as an unproblematic panacea. To claim a grounding in individual or group experiences becomes a smokescreen for avoiding the matters of who our subjects are, who they represent and the processes through which they are selected. Although some feminists have done stirling work in this area, in the main it remains a largely hidden and unrecognised matter for concern (Stanley and Wise, 1990).

Secondly, the feminist political commitment to our own sense of ourselves poses problems if it is not linked to an interpretive and synthesising process which *connects* experience to understanding. To simply let women speak for themselves, and then repeat and describe this, is to celebrate, rather than necessarily to make sense of, their circumstances. This can lead to individuation and fragmentation, instead of analysis. Such an approach may produce interesting descriptive material, but can be less than helpful about what the descriptions might mean. We argue that feminism has an obligation to go beyond citing experience, in order to make connections which may not be visible from the purely experiential level alone. As Alison Jaggar has written: 'Those who construct the standpoint of women must begin from women's experience as women describe it, but they must go beyond that experience theoretically' (Jaggar, 1983, p. 384). In addition, of course, there is in any case no such thing as 'raw' experience. For, as poststructuralist thinking clearly demonstrates, the very act of speaking about experience is to constitute it culturally and discursively (Foucault, 1981 and 1986). This means that we must understand people's accounts of their lives as being culturally embedded. Their descriptions are, at the same time, a construction of the events that occurred, together with an interpretation of them.

A further consideration, here, is that an emphasis on the salience of experience alone makes it impossible for those who exist outside of the parameters of that lived reality to contribute to its visibility. While mindful

of the privileged, and often unrecognised, position which allows some women to comment on others' lives (Spelman, 1988), we maintain that it is important, for those who are able, to create space for the inclusion of those experiences that are different from their own. To be sure, dangers adhere in this. These include attributions of false consciousness; treating others' lives as deficient, pathological or culturally bizarre; over-intellectualisation; and the problems of exclusion and marginalisation inherent in any attempts at schematisation. Nevertheless, we would argue that it is a responsibility of women with privileges, white, middle-class women, for example, to ensure that Women's Studies ceases to be narrowly construed. Given the kinds of women who constitute the female side of the academy at the moment, this does seem important if issues such as that of diversity are to be included within its framework. To take diversity on board we cannot just rely on experience.

Thus, the role of experience in Women's Studies is currently an important issue. We need to think beyond experience alone if we are to be forward-thinking both in our intellectual work and in our politics. Feminism has, quite rightly, argued for women's right not to be silenced. It needs also to be recognised, however, that 'speaking' is itself a process which has to be understood and examined. In particular, questions concerning the representativeness of those chosen as subjects in Women's Studies work, and about the relationship between personal testimony and analysis, need to be addressed.

### (b)   A Matter of Autonomy

The first three challenges we have discussed pose a central problem about the autonomy of Women's Studies. This arises in the context of the relationship of Women's Studies to areas concerned with other forms of difference and inequality (Black Studies or Gay Studies, for instance), with regard to arguments for a more pluralistic, gender-based mode of scholarship, and in connection with feminists' concern about race, ethnocentrism and diversity. Does Women's Studies have its own form of discrete subject matter? Can this be subsumed by other areas of study? What is the relationship of Women's Studies to these other forms of scholarship? These questions, too, are generated from within Women's Studies itself, as well as developing externally to it.

In one sense they may seem akin to questions about a hierarchy of oppression (that it is possible to make judgements as to which is 'worse' between different forms) and the designation of priorities in political and intellectual intervention (Harriss, 1989). But, in the current context, these

issues can no longer be expressed in this way. This is because it is now acknowledged that different forms of oppression cannot simply be added onto each other. Nor is it possible to construct a 'league table' of them. To be black and female, for instance, qualitatively changes the nature of the oppression which is experienced. It is not a case of just multiplying the number of oppressive forces to which a particular individual is subjected. Further, the construction of particular selves and identities is not the mechanistic product of structural processes alone. Rather, as postmodernists have pointed out, these are negotiated in the context of an individual's own particular location within specific sites and discourses. For these reasons it may no longer make sense to relegate different forms of inequality and subordination to separate fields of study.

The issue for Women's Studies, then, is to do with what is distinctive about it and how its boundaries are to be defined and defended. Can our autonomy be maintained, or should we opt for a 'federal' solution by forming alliances with those from other areas in some kind of common project? Perhaps we should adopt a 'spheres of influence' approach, with some agreement about overlapping concerns? Alternatively, a 'critique' relationship could be developed by asserting the significance of feminist questions in other fields of knowledge or study. It may be that, in the spirit of the discussion in the following section, different groups will adopt different solutions to such issues. If its relationship to matters of diversity and gender are to be clarified, these are matters to which Women's Studies also needs to attend.

### (c)  Polarising Judgements

Our concern with polarising judgements is one that is to do with 'political correctness'. It arises from the historic and energising commitment of Women's Studies to sustain a relationship with feminist politics. Women's Studies came into being as the educational arm of the Women's Liberation Movement, and its content and practice have always been informed by feminist concerns (Klein, 1991). For instance, the focus on issues such as heterosexism, pornography and violence towards women has arisen from the struggles of those women involved with them on a practical everyday level. Similarly, the conceptual and theoretical critiques of mainstream academic work have also occurred because of its inability to deal successfully with areas important to women's lives. Yet, in its desire to remain politically informed and not to disassociate theory from practice, Women's Studies has, paradoxically, sometimes found itself tied up in the use of evaluate dichotomous language. This has involved, for example, the

pigeon-holing of ideas as either radical or Marxist-feminist, despite the fact that a wide spectrum of approaches can be found among those to whom one or the other label is attributed. It has led, also, to claims about whether a particular form of work is pro- or anti-woman, and to arguments as to whether a writer is feminist or not feminist in her analysis and outlook (Anon, 1981; Hunt, 1990; Jeffreys, 1990; Segal, 1987).

Whilst appreciating the historical and political legacy from which these debates derive, we feel that such judgemental polarisations can no longer be supported. For one thing, such attempts to designate a correct line of argument inevitably lead to a conceptual and analytical straightjacket, where new data and ideas are simply forced into a pre-existing explanatory mould. For another, the acknowledgement that women's lives are complex, diverse and not solely governed by gender politics forces the acceptance that it is not always easy to determine what is 'right', nor to act in ways which seem in accordance with that. There is debate and disagreement, for example, as to whether the new reproductive technologies are liberatory or oppressive for women. While Western women may demand a woman's right to choose abortion, there are circumstances and cultures where abortion is used against women and as a means of social control. Further, as Barry describes in her discussion of a woman-centred politics in this volume, it is possible to adopt a positive and pro-woman stance whilst rejecting, also, both clearly defined anti-and pro-feminist positions. The issue, then, is that of how Women's Studies can continue to engage politically, at the same time as taking on board the new-found complexities in women's lives. The language of political correctness is far too restrictive, divisive and combative to be useful to Women's Studies in the 1990s.

## STRATEGIES FOR THE 1990s

So far, in this chapter, we have explored five challenges currently facing Women's Studies and considered three more specific questions which arise from them. This has involved drawing attention to a number of problems, queries and difficulties with the current Women's Studies enterprise, to the extent that we could be accused of being too negative and critical in our approach. We do not mean, however, to be unduly pessimistic or full of foreboding. Rather, we view the current state of Women's Studies as a product of its successful maturation towards a coming of age. It is only now, with all the developments that have taken place in extending our know-ledge, both empirically and analytically, that feminist scholarship is in a

position to confront the important issues of the kind we have described. Further, we believe that there are some possible strategies which will help in positively confronting some of the dilemmas raised. There are four in particular we wish to discuss here, although these are by no means exhaustive: a strategy for a diverse Women's Studies; a strategy for dealing with the game of theory; emphasis on the relationship between the material and the cultural; and assertion of the authenticity and autonomy of Women's Studies.

## (a)   A Strategy for a Diverse Women's Studies

A strategy for meeting the challenge of diversity needs to go beyond a guilty acknowledgement of past errors that leaves us trapped in a moralistic discourse from which we cannot escape. Further, we believe it important that everyone involved with Women's Studies takes on responsibility for ensuring that the requirement to understand diversity is met, and that this is not just left to those women who belong to, or identify with, particular groups. This position is not without difficulties, and we are aware of the reverse danger of privileged women speaking on behalf of, and instead of, others. What is required is a much more open discussion of the politics of location and of speaking; who is in a position to speak, about what and where, and which voices are likely to be heard. In this context there is an important distinction to be made between advocation and appropriation. Whereas the former should involve putting forward and publicising the ideas and views of others, the latter signifies making it seem as if they are one's own. Appropriation also connotes the reworking and redefinition of other women's material. It is thus a means of silencing, in contrast to advocation, which is one strategy for providing the means for the silenced to speak out.

Another prerequisite, if Women's Studies is to take diversity seriously, is the need to acknowledge that 'diversity' means just that. We are referring here to the fact that not all aspects of diversity are the same, exist in the same analytical plane or can be dealt with in the same empirical, theoretical or political ways. The tendency in feminist literature, to lump all forms of diversity together, runs the risk that the specificities of the histories, current formulations and contemporary meanings of each will be lost. To refer in general terms to 'diversity' is to adopt a homogenising and universalising concept in which the impact of its various characteristics and forms is glossed over. The idea that women's lives are diverse is meaningless unless the particularities of this can be demonstrated. We are denying, here, the idea that all forms of diversity can be reduced to the same formulation, analysis or conceptualisation.

A further element of the strategy we are advocating relates to the kind of work on diversity which Women's Studies needs to undertake. There are a number of aspects to this. First, although it is important to make the circumstances of all women's lives visible, this should not be taken as sufficient to deal with discrimination and prejudice in our work. To discuss the homophobia experienced by lesbians or the racism by black women is not the same as examining the homophobia and racism built into the assumptions and practices of Women's Studies itself. To be sure, the two are equally important. But we must not allow a focus on women's experiences of discriminatory practices to become a substitute for confronting the prejudice and discrimination often encapsulated in our concepts and frameworks of analysis. The one cannot stand for the other.

Secondly, although there is an urgent need for the experiences of divergent groups of women to be made visible, it is also important for the circumstances of privileged women to be acknowledged. We say this not because we wish to encourage further preoccupation with the white, heterosexual middle classes. We are concerned, however, that the current emphasis on diversity focuses attention away from a supposed norm to those who are different from it, without always making the norm visible and subject to critical scrutiny. We think it important to study privilege and how it works. To fully understand racism and its processes, the power of whiteness and of white supremacy must be confronted. To uncover the roots of homophobia, heterosexism must be faced. Women are implicated in these and other forms of power relations, as Ramazanoglu has argued (Ramazanoglu, 1989). For the same reasons that feminists have focused on the role of male supremacy in the social control of women, it is vital that Women's Studies concerns itself with relationships between different groups of women and the ways in which some are able to exercise control over others.

A final consideration here is our view that a full appreciation of diversity is too complex a matter to be studied simply at the descriptive level of experience, identity and identification. It is not just a question of filling in our knowledge by completing more empirical work or adding in more groups of women. In addition, diversity needs to be theorised if connections between its different forms are to be made. There appear to us to be two significant ways in which such theorising might proceed. The current trend seems to be to extract strands of different oppressions and analyse them independently of other forms. This involves looking at the constitutive elements of each separately, while acknowledging their interrelationship at the level of lived reality. Thus, patriarchy or the structures of racism would be treated as analytically distinct, although it would be understood that in terms of everyday experience the two coalesce (Walby, 1990). Such ap-

proaches, which are rooted in the social science tradition of grand theory, tend to be rather abstract and generalised in outcome.

An alternative, and in our view more preferable, way is to look for how the different elements of diversity interrelate, diverge or conflict in specific instances of women's lives. This means that, as Gordon has pointed out, instead of continually separating gender from race from class, we focus on such issues as the racialised aspects of gender, gender as a concept with class characteristics, the racialised aspects of class etc., etc. (Davidoff and Hall, 1987; de Groot, 1989; Gordon, 1991). We argue that such an approach involves reversing the flow of theory away from the grand abstract theorising of the metanarrative type dismissed by postmodernists. This is necessary because of its distance from the experiences of the real world, its inability to comprehend the complex interlocking structures of diversity and multiplicity, and its emphasis on the systemic, coherent, homogeneous and structured nature of the social world. In contrast, we argue that a focus on diversity requires attention to tensions, contradictions and absences as well, and that this is much more easily done by concentrating on culturally and historically specific circumstances (Kandiyoti, 1988). As argued previously, it is important not only for Women's Studies to start with the experiential, but that it should also theorise the experiential. Our suggestion is, then, that attention be directed to what we refer to as the middle-order approach. It is to an explication of what we mean by this term, and of its implications, that we now turn.

### (b)   The Middle-Order Approach: A Strategy for Dealing with the Game of Theory

Earlier in this chapter we drew attention to the postmodernist arguments against grand metanarratives and to some of the feminist writing which has utilised this approach. We have suggested, above, that Women's Studies might consider adopting a more middle-order style of theorising. This is because it seems axiomatic that Women's Studies should not abandon theory altogether. This last point, of course, is not uncontentious. There has been an ongoing debate within feminism, for many years, about the extent to which it is appropriate to engage in theoretical game-playing, which is often portrayed as elitist, masculinist and mystifying (Kelly and Pearson, 1983; Rich, 1976). In our view this does not necessarily have to be the case. We see theory as important in both the political and the intellectual life of Women's Studies because of its ability systematically to connect various aspects of women's subordinate position in a way that goes beyond the immediacy of individual experience. Theory is important in directing atten-

tion to the various processes through which oppression takes place and to the relationships and contradictions between them. In this way, it informs political analysis and policy making, and can signal the way forward in terms of possibilities for change. We claim that a middle-order approach is most appropriate to this task.

The idea of middle-order theorising is borrowed (although with a good deal of reservation) from the American sociologist, Robert Merton (1968). In his book *Social Theory and Social Structure*, Merton argues against total systems of theory and in favour of those which 'lie between the minor but necessary working hypotheses that evolve in abundance during day to day research and the all-inclusive systematic efforts to develop a unified theory that will explain all the observed uniformities of social behaviour, social organization and social change' (Merton, 1968, p. 39). For Merton, middle-range theory lies between grand theory, which he describes as being remote from real life, and detailed descriptions of particulars that are not generalisable at all. It deals with the delimited aspects of particular social situations in which the empirical and the analytic can be combined.

The specifics of Merton's ideas are not without their problems. In particular we would want to distance ourselves from the quasi-scientific language of hypothesis formulation and testing which pervades his work. It is the principle, rather than the exact nature, of his formulation with which we are concerned. In this connection a number of points need to be made.

First, our conception of the middle-order approach includes the use of inductive and deductive procedures. It provides the empirical circumstances for examining and refining concepts and ideas derived from already existing theoretical frameworks (deductivism). It also encourages the generation of *new* ideas and concepts from the analysis of new empirical situations or the re-examination of old ones (inductivism). Kirkwood's contribution to this book provides an example of the inductive process, since the significance of emotionality emerged as a consequence of the interviews with abused women which she conducted. Barry's chapter contains both deductive and inductive material. She used her research on women in the Labour Party both to explore the significance of existing political concepts and to generate new ones from the empirical work itself.

Secondly, the whole import of middle-order theorising is to generate frameworks of understanding which transcend sheer description or empirical generalisation, but which remain, nevertheless, closely embedded in substantive material. To that extent, this mode of theorising involves abstractions, but ones which can be clearly traced back to the material from which they are derived. Thus, middle-range theory is concerned not with grand historical generalisations but with identifying the social mechanisms

which in particular circumstances construct the social world in a demonstrable kind of way. It is therefore interested in general properties, but not in generalisations *per se*.

Thirdly, these types of theories, while generated separately, do not necessarily remain so. They contain the potential for consolidation into wider networks of theory, ones which will enable the drawing of comparisons and the highlighting of differences and similarities.

The kind of theoretical strategy described above has a number of advantages for Women's Studies. It overcomes the overgeneralising tendencies of grand theory. It permits the interlinking of experience and analysis. It also provides the opportunity for studying the intermeshing of the different strands and elements in women's lives. In making clear the relationship between the empirical world and our understanding of it, such an approach is also suggestive of how Women's Studies might monitor its methodological and epistemological standards with a view to generating criteria of evaluation, as previously discussed.

In arguing for a middle-order strategy, we are aware that there already exist examples of good practice in this regard. Two obvious historical ones are to be found in Steedman's *Landscape for a Good Woman* (1987) and Davidoff and Hall's *Family Fortunes* (1987). The former uses a partly autobiographical approach to theorise two working-class childhoods, which the author argues are marginalised and excluded in other accounts. The latter uses a study of the changing nature of the family and economic and political structures to examine the interrelationship of class and gender from the end of the eighteenth to the middle of the nineteenth centuries. Our claims are, therefore, not necessarily anything new. Rather, we are asking for a recognition and codification of existing practices which can provide a wealth of theoretical insight, but which are rarely acknowledged as doing so since they are not conducted in the grand schema of things which is usually hailed as proper theory. With the middle-range approach we are suggesting a particular avenue of development for Women's Studies theory. It is one which will not only consolidate existing developments, but also confirm the distinctive nature of the things that Women's Studies has to say.

### (c)   Emphasising the Relationship between the Material and the Cultural

In an earlier section we outlined some of questions raised, by postmodernism, to the Women's Studies enterprise. One of the comparisons drawn there, between the two, related to the emphasis on cultural construction which, for

postmodernism, is expressed through a focus on the ways in which different discursive locations create fragmented identities and multiple selves. The implications of this for feminism have been noted by a number of writers (Flax, 1990; Morris, 1988; Weedon, 1987). For instance, it encourages a movement away from the notion of a fixed cultural identity, because identity is never stable or fixed. Rather, identities are created in a dynamic and ongoing process which is never complete. They are also always constituted within, not outside, representation, that is, how they are symbolised or portrayed. A focus on multiplicity, it is argued, also allows the subject an element of choice. It implies that she is able to locate herself within a range of discursive frameworks, each of which will have different implications for notions of self and self-understanding. It has been suggested, for example, that the variety of discourses around femininity open up for women a variety of parameters of what womanhood can mean (Skeggs, 1991; Stacey, 1988; Walkerdine, 1989). Thus, postmodernism seems to laud the active self-searching agent at the expense of the passive and determined subject.

Whilst appreciating some of the advantages in this deconstructionist project, we can also see dangers. In our view the postmodernist account of multiple selves is problematic because it is ungrounded. By this we mean that it lacks both an evidential and an experiential base. More specifically, we are concerned about the lack of attention paid, in a lot of postmodernist writing, to the material structures of power (economic, political and social) within which subjectivities, identities and authors are located. By material, we are referring here to the framework of interactions between human beings, and between human beings and nature, which may involve authority, inequality and the use and abuse of power. On the one hand, postmodernists have rightly emphasised the importance of the personal, discursive, cultural and communicative sides of existence. But, on the other, they do not seem sure as to whether these are *more* central or merely just as central as the phenomena traditionally given weight by social theorists, such a work, money, bureaucracy and state power. With some authors there is a virtual denial of the importance of the material world. This is simply not good enough. Not everything is sign or text, as any rape victim will testify. It is one thing to say that we may be shaped by discourse and text, but this is not the same thing as suggesting there is *only* discourse and text. That is idealism and it is this position that we are anxious for Women's Studies to avoid.

It is therefore important for Women's Studies to intervene in the ongoing debate about postmodernism, in order to reassert the significance of

materiality. Our lived experience is mediated not just through discourse and text but through material structures and relationships also. These may range from family and friends, to access to knowledge and learning, and to the amount of money available to afford consumption. The point is this: poverty, starvation, state repression and forms of inequality, as expressed in male, racist and other forms of power, are experienced daily by peoples around the world. We therefore need to be vigilant in our concern for the material world and how it interacts with culture and the communicative side of social existence. But, and this is the critical point, this relationship needs to be theorised in new ways. Thus we are not advocating, here, a return to the old, and limited, base/superstructure distinction. Nor are we suggesting a crass deterministic materialism of the 'women as victims variety', which has been rightly criticised (Brittan and Maynard, 1984). These make little or no allowance for the ways in which women are active, in both perpetuating and changing circumstances, nor for the ways in which the situation of women changes from culture to culture. We are asserting, however, that the identity of women is not just a matter of negotiation and personal choice, as some postmodernists and deconstructionists seem to imply. Feminism should not relinquish itself to a completely subjectivist position. An acknowledgement of the significance of material circumstances and relationships remains important in coming to grips with the restrictive and emancipatory possibilities in women's lives. This is not a case of arguing about whether it is the material or the cultural which is the most important and deserves prioritising. Rather, it is to underline the importance of analysing the tensions and relationships between the two.

This emphasis on the relationship between the cultural and the material is, happily, one for which there is much precedent in Women's Studies literature. Feminist work has an established practice of moving between the material and cultural aspects of life, although sometimes this is largely implicit and unacknowledged. One example of good practice here might be Kappeler's *The Pornography of Representation*, whose discussion of pornographic representations is framed by a material concern with social forms of power and domination (1986). Another example is Walby's *Theorizing Patriarchy*, which focuses on the material, cultural and ideological sites of male power (1990).

Our argument once again, then, is for an explicit codification of existing feminist practice. An understanding of the complexities of women's lives cannot proceed without an analysis of how this is constrained, tolerated and furthered at a material level. Both a material and a cultural emphasis are required if Women's Studies is to develop both intellectually and politically.

## (d)   The Authenticity and Autonomy of Women's Studies

Our final argument is that the legitimacy and autonomy of Women's Stud-
ies, as a field of intellectual activity in its own right, must be asserted and
maintained in the context of a committed feminist perspective. We have
already explored the possible ways in which this might be undermined, in
the discussions of diversity, of the deconstructionism of postmodernism, of
the growth in gender studies and in the new-found topic of masculinity. We
would argue that the gendered aspects of racism, classism, heterosexism,
disablism and other oppressive forms are too significant, in terms of their
interrelationships and their effect on women's lives, to be left to other fields
of study. Indeed, since these are aspects of experience known to the major-
ity of women, it is absolutely *crucial* that they become the central focus of
the Women's Studies agenda overall. It is only within Women's Studies
that all these elements are likely to be treated as part of a comprehensive
framework. Further, to acknowledge diversity among women is not to deny
the necessity, strength and vitality of a woman-centred perspective. We say
this in the secure knowledge that the existing male-dominated disciplines,
in the humanities and in social sciences, have still done very little in terms
of taking account of feminist and pro-woman concerns. The Women's
Studies project, of bringing women to the forefront of academic analysis
and scholarship and reconstituting its priorities, is thus as valid now as it
has ever been.

In terms of gender and masculinity, we argue that the feminist approach
is the only one which will allow not only for the articulation of difference
between the sexes, but for an acknowledgement that difference also in-
volves inequality. This is because the Women's Studies perspective is
attuned to difference in terms of inequality, with regard, for example, to
resources, legitimacy and authority. It pays attention to oppression by
considering exploitation within gender relations economically, politically
and culturally. It concerns itself with questions of power, an important
aspect of which is to do with conflicts of interest, how and to whose benefit
these are resolved. All of these require that attention be paid to the use of
both material and cultural analysis, as described above.

A final argument for the continuation of Women's Studies has been
eloquently articulated by Mary Evans (1991). Indicating that the world is
not yet post-capitalist, post-racist or post-imperialist, she points out that
women are still paid about three-quarters of the wages of men and are
largely excluded from political power. Evans concludes that 'it is because
of the continuing existence of material differences and inequalities between
women and men . . . that I would argue for the maintenance of Women's

Studies and the use of the category women' (Evans, 1991, p. 68). Since this remains the case despite the divisions between women themselves, we readily concur with her point of view.

## CONCLUSION

Our agenda for Women's Studies in the 1990s is meant to be suggestive and not exhaustive. We hope to have shown that Women's Studies has a contribution to make to several areas of current debate of relevance to women. It has the potential to pursue the practice of a diverse, yet woman-centred, form of investigation. It can intervene in the development of theory, both by engaging with the challenges of postmodernism and by adopting a more middle-order approach designed to connect the empirical and the analytical. This latter strategy also contains the possibility of linking theoretical, epistemological and methodological issues. Finally, we would like to stress that the intention behind these suggestions is political as well as intellectual. They are made with a concern for practical interventions very much in mind. A refinement of Women's Studies scholarship will produce better and increased understandings of women's lives, directing us to how and where improvements in them need to be effected.

Several times during the course of this chapter we have drawn attention to what we have referred to as 'good practice' already existing within the Women's Studies field. The presence of such work, and of its potential for development, makes us confident that Women's Studies can rise to the challenges we have presented. We have demonstrated here its persistent vitality and have argued for its continued viability. This is the position which must be defended as we move through the current decade.

## NOTES

1. We use the term 'diversity' rather than 'difference' because, as Spelman has pointed out, the latter has an 'us' and 'them' connotation. It implies that there is already something established as Women's Studies or feminism that makes reference to 'some' women, so that 'the women' not yet referred to are thus the 'different' ones. It suggests a setting of tolerance, which requires looking but not necessarily seeing; hearing but not necessarily listening; adding voices but not changing what has already been said (Spelman, 1988, p. 162).

The power to decide still resides with the white feminists at the 'centre' (hooks, 1984). In addition, the term 'difference' plays a significant role in the discourses of postmodernism and poststructuralism, although its meaning there is not the same as the one we are presently discussing. We think that it is important to distinguish between the two and we discuss our understanding of 'difference', in the postmodern sense, in the sections devoted to that topic in this chapter. Moreover, we wish to distance ourselves from the position of Barrett, which appears to be that distinctions of race, ethnicity, age, sexual orientation, disability etc. are of limited use, because, she claims, they are based on commonsensical understandings of 'experiential diversity' (Barrett, 1987, p. 30). Rather, along with other feminist writers, we maintain that lived experience must be the starting point for feminist research, although we diverge from some of the arguments put forward in this context in our contention that a focus on experience alone is seldom sufficient for feminist analysis.

2. The term 'black' is not meant to refer to a fixed cultural identity. Instead, it is a political label which acknowledges that the political, social and ideological force of racism creates a gulf between white people and those whom they oppress, on both a face-to-face and an institutional basis. It is not meant to deny the existence of diversity between, and indeed within, each cultural group.

3. Examples of exceptions would be: Brittan, 1989; Hearn, 1987; Morgan, 1992.

4. It should be noted that any attempt to provide a schematic systematisation of postmodernism involves engaging in precisely that form of generalisation and grand theorising which postmodernists themselves reject.

5. This emphasis on challenge, silencing, colonisation and otherisation is paralleled in the writing and politics of other oppressed and dispossessed groups who have attempted to 'find themselves', and has its early history in working-class and labour studies.

# REFERENCES

Afshar, Haleh (ed.) (1985), *Women, Work and Ideology in the Third World* (London: Tavistock).

Afshar, Haleh (ed.) (1987), *Women, Poverty and Ideology* (London: Macmillan).

Alcoff, Linda (1988), 'Cultural Feminism Versus Post-Structuralism: The Identity Crisis in Feminist Theory', *Signs*, vol. 13, no. 3.

Amos, Valerie and Pratibha Parmar (1984), 'Challenging Imperial Feminism', *Feminist Review*, no. 17 (Autumn).

Angelou, Maya (1984), *I Know Why the Caged Bird Sings* (London: Virago).

Anon (1981), *Love Your Enemy?* (London: Onlywomen Press).

Barker, Pat (1984), *Union Street* (New York: Ballantine).

Barrett, Michele (1987), 'The Concept of Difference', *Feminist Review*, no. 26 (Summer).

Bowles, Gloria and Renate Duelli-Klein (eds) (1983), *Theories of Women's Studies* (London: Routledge).

176 *Women's Studies in the 1990s*

Brittan, Arthur (1989), *Masculinity and Power* (Oxford: Blackwell).
Brittan, Arthur and Mary Maynard (1984), *Sexism, Racism and Oppression* (Oxford: Blackwell).
Cockburn, Cynthia (1983), *Brothers: Male Dominance and Technological Change* (London: Pluto).
Collins, Patricia Hill (1990), *Black Feminist Thought* (London: Allen and Unwin).
Coote, Anna and Beatrix Campbell (1982), *Sweet Freedom* (London: Picador).
Cruikshank, Margaret (1982), *Lesbian Studies* (New York: Feminist Press).
Davidoff, Leonore and Catherine Hall (1987), *Family Fortunes* (London: Hutchinson).
Davis, Angela (1981), *Women, Race and Class* (London: Women's Press).
de Groot, Joanna (1989), '"Sex" and "Race": the Construction of Language and Image in the Nineteenth Century', in Susan Mendus and Jane Rendall (eds), *Sexuality and Subordination* (London: Routledge).
Delmar, Rosalind (1986), 'What is Feminism?', in Juliet Mitchell and Anne Oakley (eds), *What is Feminism?* (Oxford: Blackwell).
Evans, Mary (1991), 'The Problem of Gender for Women's Studies', in Jane Aaron and Sylvia Walby (eds) (1991), *Out of the Margins* (London: Falmer).
Firestone, Shulamith (1972), *The Dialectic of Sex* (London: Paladin).
Flax, Jane (1987), 'Postmodernism and Gender Relations in Feminist Theory', *Signs*, vol. 12, no. 4.
Flax, Jane (1990), *Thinking Fragments* (California: University of California Press).
Fonow, Mary Margaret and Cook, Judith A. (eds) (1991), *Beyond Methodology* (Indiana: Indiana University Press).
Ford, David and Jeff Hearn (1988), *Studying Men and Masculinity* (Bradford: University of Bradford).
Foucault, Michel (1981), *The History of Sexuality*, vol. 1 (Harmondsworth: Penguin).
Foucault, Michel (1986), *The History of Sexuality*, vol. 2 (Harmondsworth: Penguin).
Gordon, Linda (1991), 'On Difference', *Genders*, no. 10 (Spring).
Hanmer, Jalna and Mary Maynard (eds) (1987), *Women, Violence and Social Control* (London: Macmillan).
Harding, Sandra (1986), *The Science Question in Feminism* (Milton Keynes: Open University Press).
Harding, Sandra (1987), *Feminism and Methodology* (Milton Keynes: Open University Press).
Harding, Sandra and Merrill Hintikka (eds) (1983), *Discovering Reality: Feminist Perspectives on Epistemology, Metaphysics, Methodology and Philosophy of Science* (Dordrecht: Reidel).
Harriss, Kathryn (1989), 'New Alliances: Socialist Feminism in the Eighties', *Feminist Review*, no. 31 (Spring).
Hartman, Heidi (1979), 'The Unhappy Marriage of Marxism and Feminism: Towards a More Progressive Union', *Capital and Class*, no. 8 (Summer).
Hearn, Jeff (1987), *The Gender of Oppression* (Brighton: Wheatsheaf).
Hearn, Jeff and David Morgan (1990), 'Men, Masculinities and Social Theory', in Jeff Hearn and David Morgan (eds), *Men, Masculinities and Social Theory* (London: Unwin Hyman).
Hekman, Susan (1990), *Gender and Knowledge* (Cambridge: Polity).
hooks, bell (1984), *Feminist Theory* (Boston: South End Press).
hooks, bell (1989), *Talking Back* (London: Sheba).

Hunt, Margaret (1990), 'The De-eroticization of Women's Liberation: Social Purity Movements and the Revolutionary Feminism of Sheila Jeffreys', *Feminist Review*, no. 34 (Spring).

Jaggar, Alison (1983), *Feminist Politics and Human Nature* (Brighton: Harvester).

Jeffreys, Sheila (1990), *Anticlimax* (London: Women's Press).

Kandiyoti, Deniz (1988), 'Bargaining with Patriarchy', *Gender and Society*, vol. 2, no. 3.

Kappeler, Susanne (1986), *The Pornography of Representation* (Cambridge: Polity).

Kelly, Liz and Ruth Pearson (1983), 'Women's Studies: Women Studying or Studying Women?', *Feminist Review*, no. 15 (Winter).

Klein, Renate D. (1991), 'Passion and Politics in Women's Studies in the 1990s', in Jane Aaron and Sylvia Walby (eds), *Out of the Margins* (London: Falmer).

Kuhn, Annette and Anne-Marie Wolpe (1978) (eds), *Feminism and Materialism* (London: Routledge).

Liddle, Joanna and Rama Joshi (1986), *Daughters of Independence* (London: Zed).

Lovibond, Sabina (1990), 'Feminism and Postmodernism', in Roy Boyne and Ali Rattansi (eds), *Postmodernism and Society* (London: Macmillan).

MacDonald, Sharon, Pat Holden and Shirley Ardener (1987) (eds), *Images of Women in Peace and War* (London: Macmillan).

Maynard, Mary (1990), 'The Re-Shaping of Sociology? Trends in the Study of Gender', *Sociology*, vol. 24, no. 2 (May).

Mernissi, Fatima (1984), *Doing Daily Battle* (London: Women's Press).

Merton, Robert (1968), *Social Theory and Social Structure* (New York: Free Press).

Millett, Kate (1972), *Sexual Politics* (London: Abacus).

Mitchell, Juliet (1986), 'Reflections on Twenty Years of Feminism', in Juliet Mitchell and Ann Oakley (eds), *What is Feminism?* (Oxford: Blackwell).

Momsen, Janet and Janet Townsend (1987), *Geography of Gender in the Third World* (London: Hutchinson).

Morgan, David (1992), *Discovering Men* (London: Routledge).

Morris, Meaghan (1988), *The Pirates Fiancée* (London: Verso).

Nicholson, Linda (ed.) (1990), *Feminism/Postmodernism* (London: Routledge).

Ramazanoglu, Caroline (1989), *Feminism and the Contradictions of Oppression* (London: Routledge).

Reinhartz, Shulamit (1992), *Feminist Methods in Social Research* (Oxford: Oxford University Press).

Rich, Adrienne (1976), 'Women's Studies – Renaissance or Revolution?', *Women's Studies*, vol. 3, no. 2.

Roberts, Helen (ed.) (1981), *Doing Feminist Research* (London: Routledge).

Rowbotham, Sheila (1990), *The Past is Before Us* (Harmondsworth: Penguin).

Segal, Lynne (1987), *Is the Future Female?* (London: Virago).

Sen, Gita and Caren Grown (1987), *Development Crises and Alternative Visions, Third World Women's Perspectives* (New York: Monthly Review Press).

Skeggs, Beverly (1991), 'Challenging Masculinity and Using Sexuality', *British Journal of Sociology of Education*, vol. 12, no. 1.

Smith, Dorothy (1974), 'Women's Perspective as a Racial Critique of Sociology', *Sociological Inquiry*, vol. 44, no. 1.

Smith, Dorothy (1987), *The Everyday World as Problematic* (Milton Keynes: Open University Press).

Spelman, Elizabeth (1988), *Inessential Woman* (London: Women's Press).

Spivak, Gayatri Chakravorty (1988), *In Other Worlds* (London: Routledge).

Spivak, Gayatri Chakravorty (1990), *The Post-Colonial Critic* (London: Routledge).

Stacey, Jackie (1988), 'Desperately Seeking Difference', in L. Gamman and M. Marshment (eds), *The Female Gaze: Women as Viewers of Popular Culture* (London: Women's Press).

Stanley, Liz (ed.) (1990), *Feminist Praxis* (London: Routledge).

Stanley, Liz and Sue Wise (1990), 'Method, Methodology and Epistemology in Feminist Research Process', in Liz Stanley (ed.), *Feminist Praxis* (London: Routledge).

Steedman, Caroline (1987), *Landscape for a Good Woman* (Rutgers: Rutgers University Press).

Walby, Sylvia (1990), *Theorizing Patriarchy* (Oxford: Blackwell).

Walkerdine, Valerie (1989), 'Femininity as Performance', *Oxford Review of Education*, vol. 15, no. 3.

Warren, Carol (1988), *Gender Issues in Field Research* (London: Sage).

Weedon, Chris (1987), *Feminist Practice and Poststructuralist Theory* (Oxford: Blackwell).

Yuval-Davis, Nira and Floya Anthias (eds) (1989), *Woman–Nation–State* (London: Macmillan).

# Index